COLOMBIA

from the air

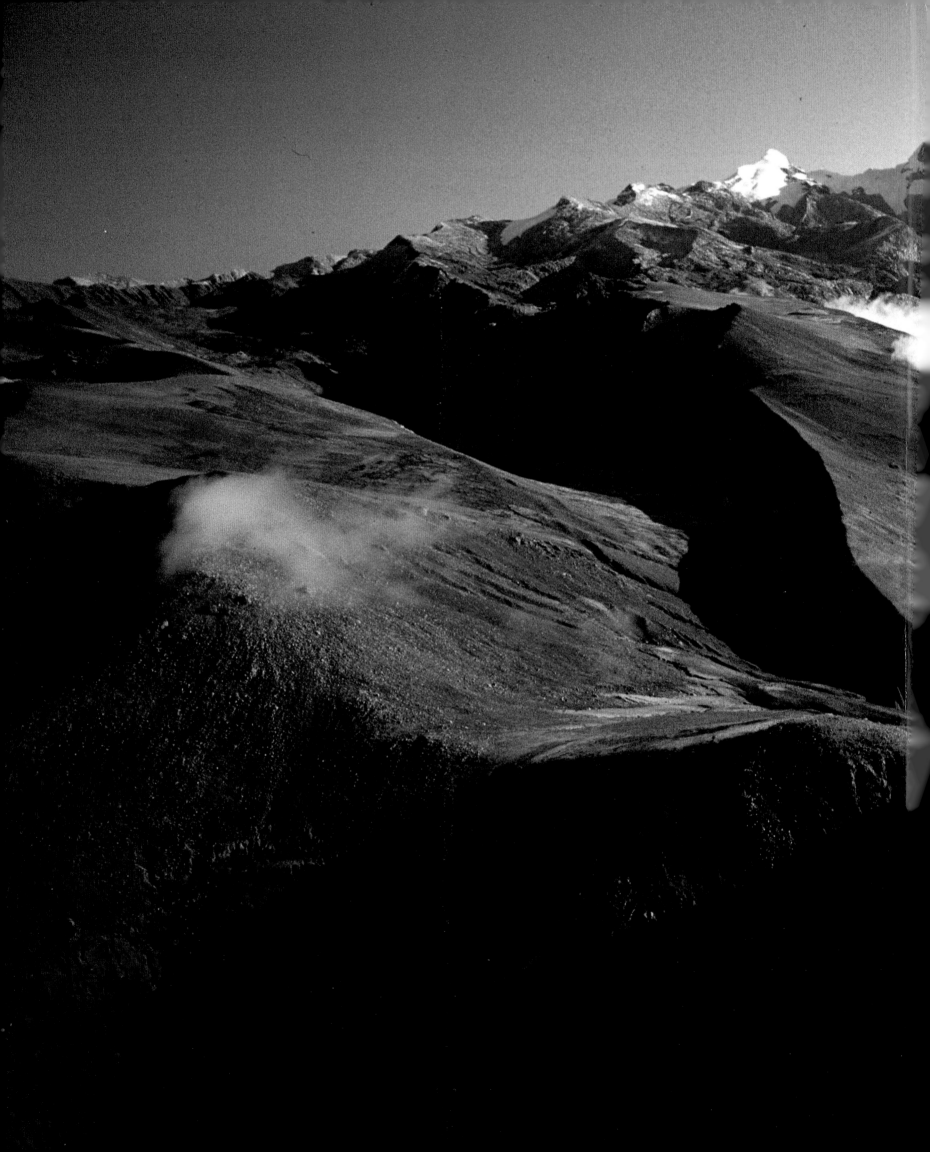

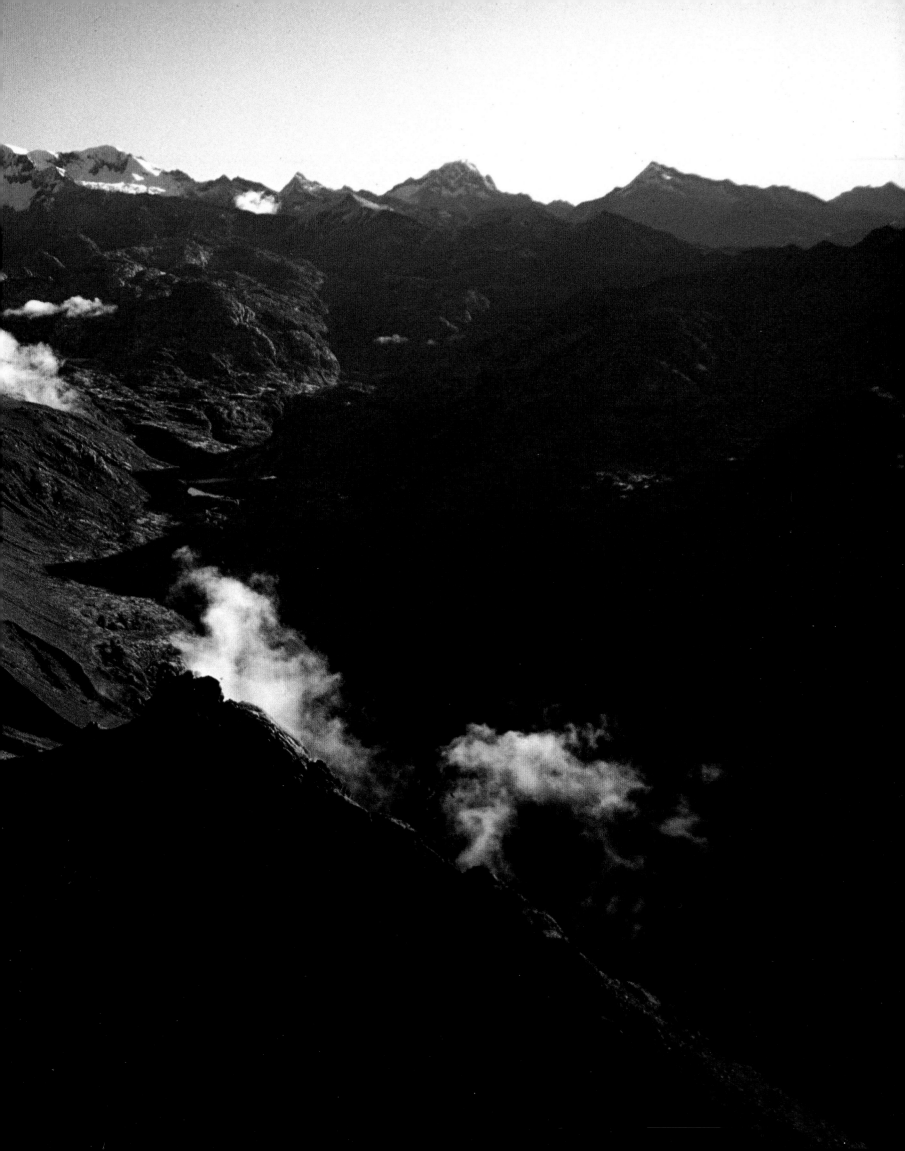

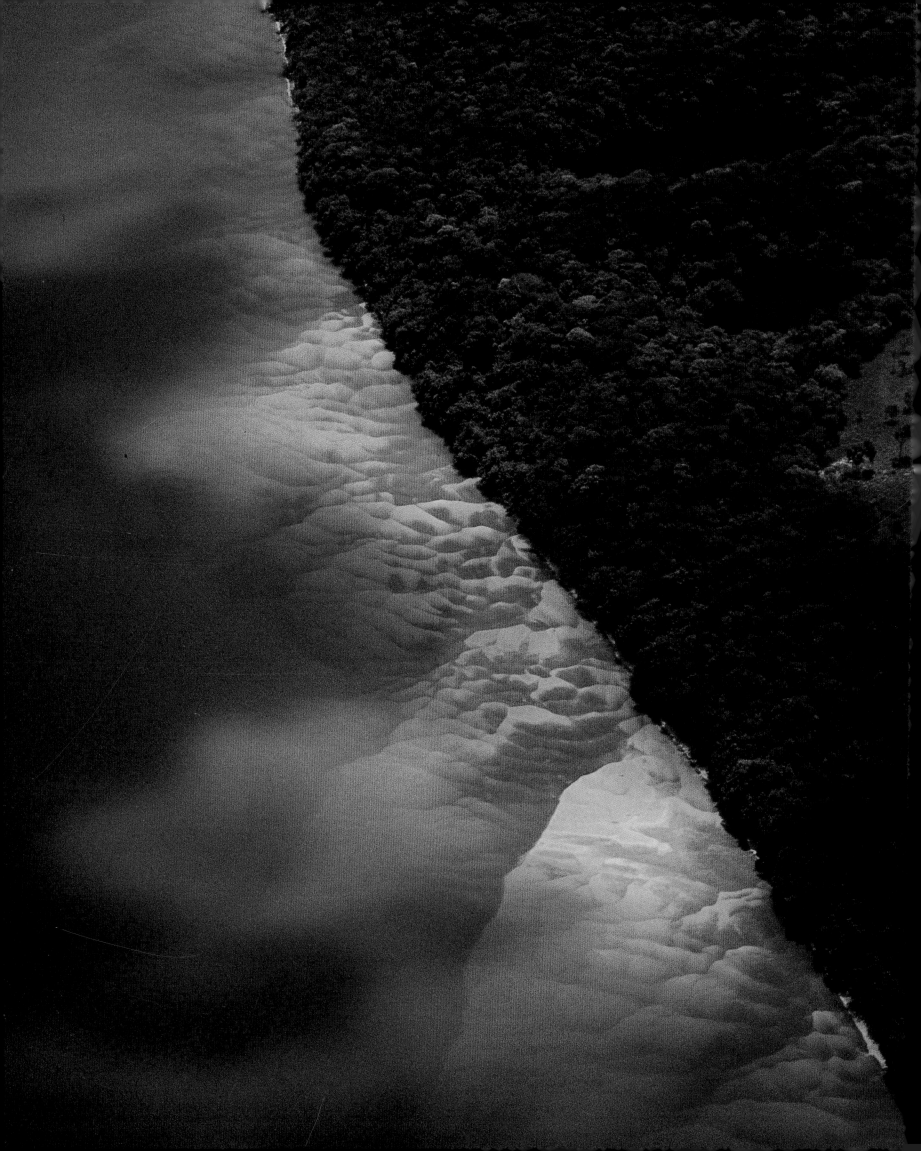

COLOMBIA
from the air

Directed and edited by
BENJAMIN VILLEGAS

❏

Photography
ALDO BRANDO

❏

Texts
GUSTAVO WILCHES-CHAUX

❏

Foreword
PLINIO APULEYO MENDOZA

❏

Villegas
editores

Complementary photography
GUILLERMO CAJIAO Pages: 110, 111, 112a, 112b, 113a, 114, 115
CARLOS CASTAÑO: 28a, 113b, 153a, 175a, 176, 178, 179
HERNAN DIAZ: 48, 63, 132
RUDOLF: 82/83, 94/95
JAIME BORDA: 38/39, 41

English version
ALAN S. TRUEBLOOD

Art and production
PILAR GOMEZ, MERCEDES CEDEÑO,
LORENA PINTO

Bibliographic research
ANDRES DARIO CALLE NOREÑA

© VILLEGAS EDITORES 1993
Avenida 82 No. 11-50, Interior 3
Conmutador 616 1788. Fax 616 0020
Santafé de Bogotá D.C., Colombia

First edition, October 1993

ISBN
958-9138-88-8

The editor wishes to thank
FLOTA MERCANTE GRANCOLOMBIANA,
CADENALCO, TELECOM and
FUNDACION PRO-IMAGEN DE COLOMBIA EN EL EXTERIOR
for sponsoring the first edition of this book.
He also thanks Helicol,
his Pilots Rubén Darío Sandoval and Héctor Anzola Díaz,
and their flight technicians Eduardo Fandiño and Humberto Márquez
for their services on the aerial photography for this book.

CAPTIONS FOR INITIAL PAGES
Jacket. The Sierra Nevada of Santa Marta, Magdalena, at dawn.
Pages 2/3. Snow-covered peaks of the Sierra Nevada of Santa Marta, Magdalena.
Page 4. Bank of the Vichada River where the jungle meets the plain, Vichada.
Page 8. Points of land in the Neguage area of Tairona Nature Preserve, Magdalena.

CONTENTS

FOREWORD
Plinio Apuleyo Mendoza

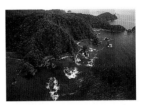

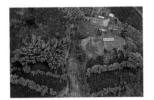

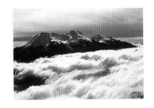

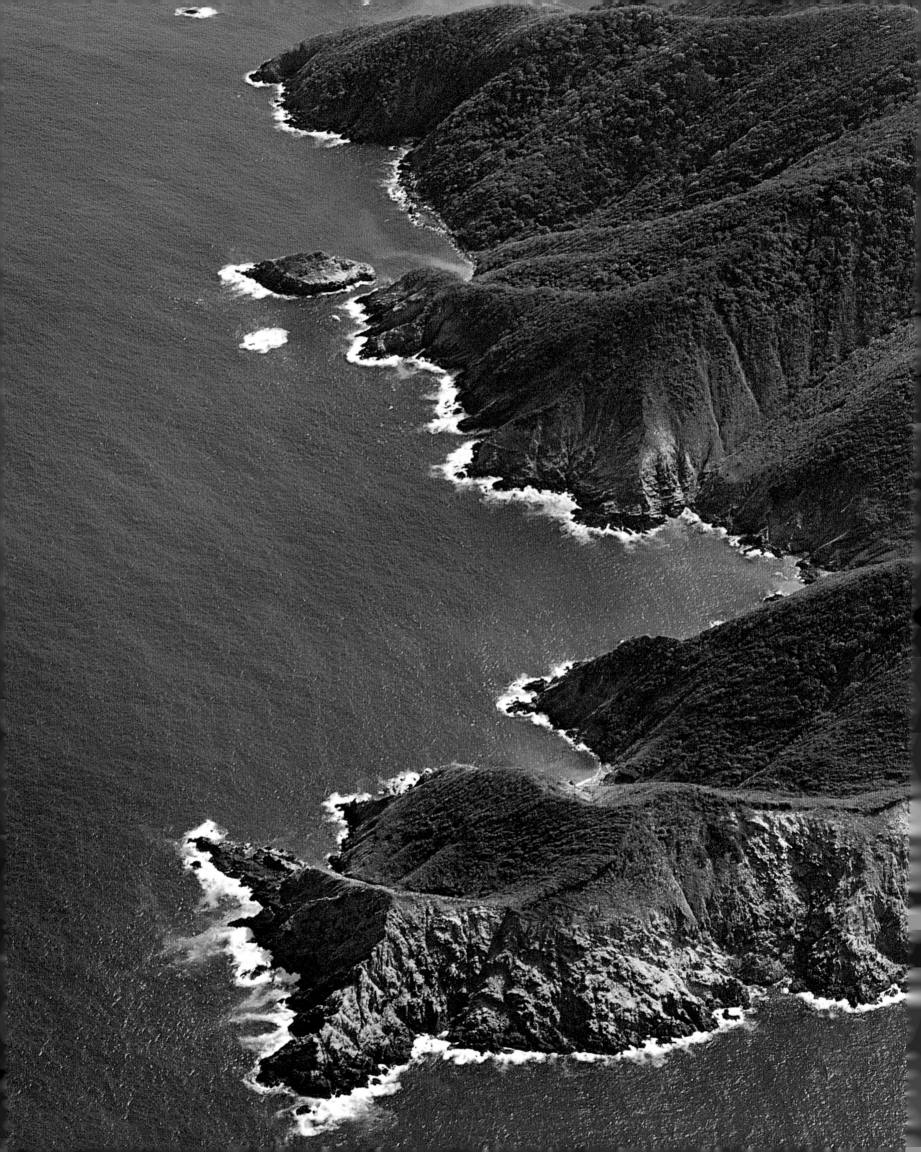

FOREWORD

Plinio Apuleyo Mendoza

Because of its special geographical location, Colombia has been called the "house on the corner" of South America. In this part of the New World it is the only country with one face on the Atlantic and another on the Pacific. But its singularity does not stop here. Colombia, in addition, is a country of synthesis, a crossroads, a favored spot where the regions, landscapes, peoples and cultures of the South American continent converge ❑ Colombia is often spoken of as an Andean country. And indeed it is one. Here the long backbone of the Cordillera of the Andes splits into three branches that together take up somewhat more than half the country's area. They break it up dramatically and cover it with cool green tablelands, hazy mountain tops, lakes asleep in the diaphanous air of the heights and at times with volcanos and snow-capped peaks whose white cupolas glisten in the morning sunlight as a silent rejoinder to the flicker and glare of vegetation shut away within chains of mountains. It is a world of contrasts: all climates, all flowers, fruits and birds find their place on the gradient down from the high freezing tablelands sprinkled with *frailejón* bushes to the sleepy river of yellow water that creeps along in the heat of the lowlands. Daring highways snake their way up the back of the cordillera and the rare towns that one sights across this Andean Colombia seem discarded upon this mountainous geological expanse that is as full of pleats as a ballerina's skirt. Andean as well are the people of these cordilleras, who retain from their ancestors, both indigenous and Castilian, a certain dignified sobriety and traces of melancholy that can be felt in the music of their strings so typical of the high plateaux ❑ As one drops closer to the coast, this Andean country disappears completely, reshaping itself into a Caribbean land. Another landscape, another world, another culture—one as vigorously expressed in the novels of García Márquez as in the canvases of Alejandro Obregón. In the very intense tropical light the hot air fills with salty smells and

Points of land in the Neguage area of Tairona Nature Preserve, Magdalena.

colors grow more vivid. The sea brings together, according to the time of day, the distance and the tones of the sky: emerald green, turquoise blue, sapphire. Sands of La Guajira, palm trees, dusty flocks, quagmires, mangrove swamps, savannahs drained limp by the sun: all reach a boiling point in the noonday glare. The music, for all its local variation, is essentially the same music that reverberates night and day in every Caribbean port. The light-hearted coast-dweller–unrestrained, as lively as an Andalusian, with a hedonistic sense of life which makes a cult of festivity and bursts forth in the riotousness of carnival-time–is Colombia's Southerber. Quite the opposite of the Andean–the slow-moving *cachaco* with his restrictions, his ceremonial, his distances and protocols, and his dramatic sense of death ❏ Colombian, too, is the encompassing Pacific, which with its winds and tides lines the continent's rim from Alaska to the southernmost reaches of Chile. For Colombians this is still a secret world of virgin gulfs and bays, damp jungles, primeval rivers, deafening rains. A trace of Africa is discernible in the lake-dwellings, in the burning heat of the villages, in their dark-skinned inhabitants–a trace that quavers, by the light of candles and over the beat of drums, in songs and dances brought by black slaves to these lands on the Pacific shore ❏ Nor does the many-sidedness of Colombia stop here. In the eastern part of the country vast tropical plains open one, a replica of the Brazilian *sertão* and the Argentine pampas, perhaps too of the Old West of the United States. Moreover, its mythology recalls that of the great steppes, overpowering in their boundless distances. Its life has the same harshness. Broad rivers, herons, pooled water, a gallop of colts, overemphatic dusks and sudden dawns which lift bands of parrots above the palm trees: this is the world in which the plainsman moves, the age-old horseman inured to distances and the rough freedom they give ❏ Colombia, finally, is also an Amazonian country. The jungle that invades vast portions of Brazil or Peru spreads into the South of the country like a huge green carpet. Settlers, missionaries, native villages scarcely leave a trace in this vast vegetable kingdom. Traversed by great rivers, it contains one of the richest treasure troves on the planet in flora and fauna ❏ A surprising and unprecedented look at all this endless variety of landscapes and regions is furnished by this book, originally of Villegas Editores. Here is a bird's eye view of Colombia. Like a voyeur peering, it reveals to the reader from a viewpoint of choice, the almost feminine intimacy of Colombian geography: textures, porousness, swellings, hidden luxuriance. The smouldering skin of its open spaces gives way to abrupt cordilleras, secret valleys, fluvial arteries, blue seaborne escapes. This is an indiscreet visual exploration of the country. One might also see this book as an exhibition of pictorial or plastic art. The palette in this instance shows a great wealth of color. Greens, grays, blues, violets and ochres set up every sort of unexpected interplay. At times the brushstrokes are gentles; at other times, brusque and vigorous. The material, as on canvas of an imaginative expressionist painter, is rich profligate and almost always sensual. Taken together it gives us a splendid portrait of Colombia–one that, without ceasing to be reality celebrates and transcends it, turning it into a fascinating creation in paint. Here landscape becomes pure art ❏

Small holdings in the Tajumbina region near the Doña Juana Volcano, Nariño.

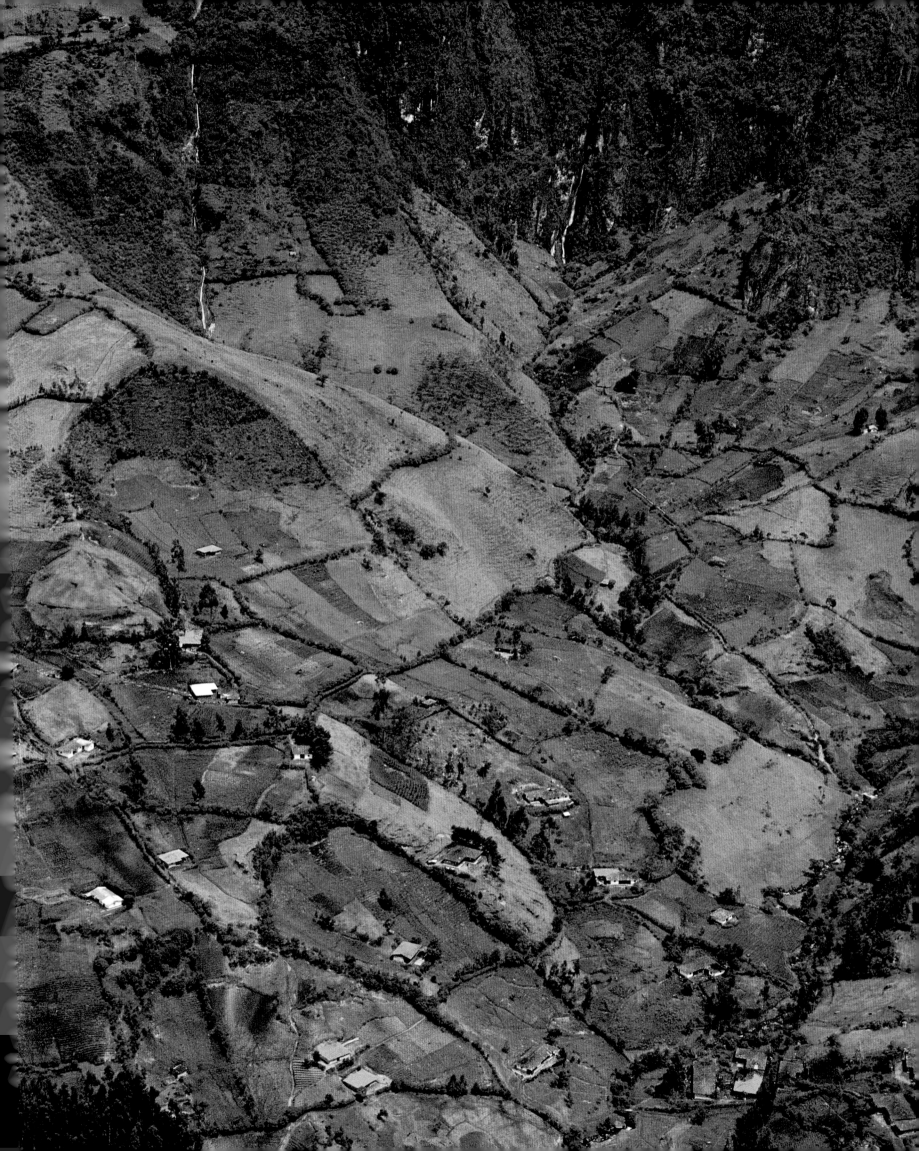

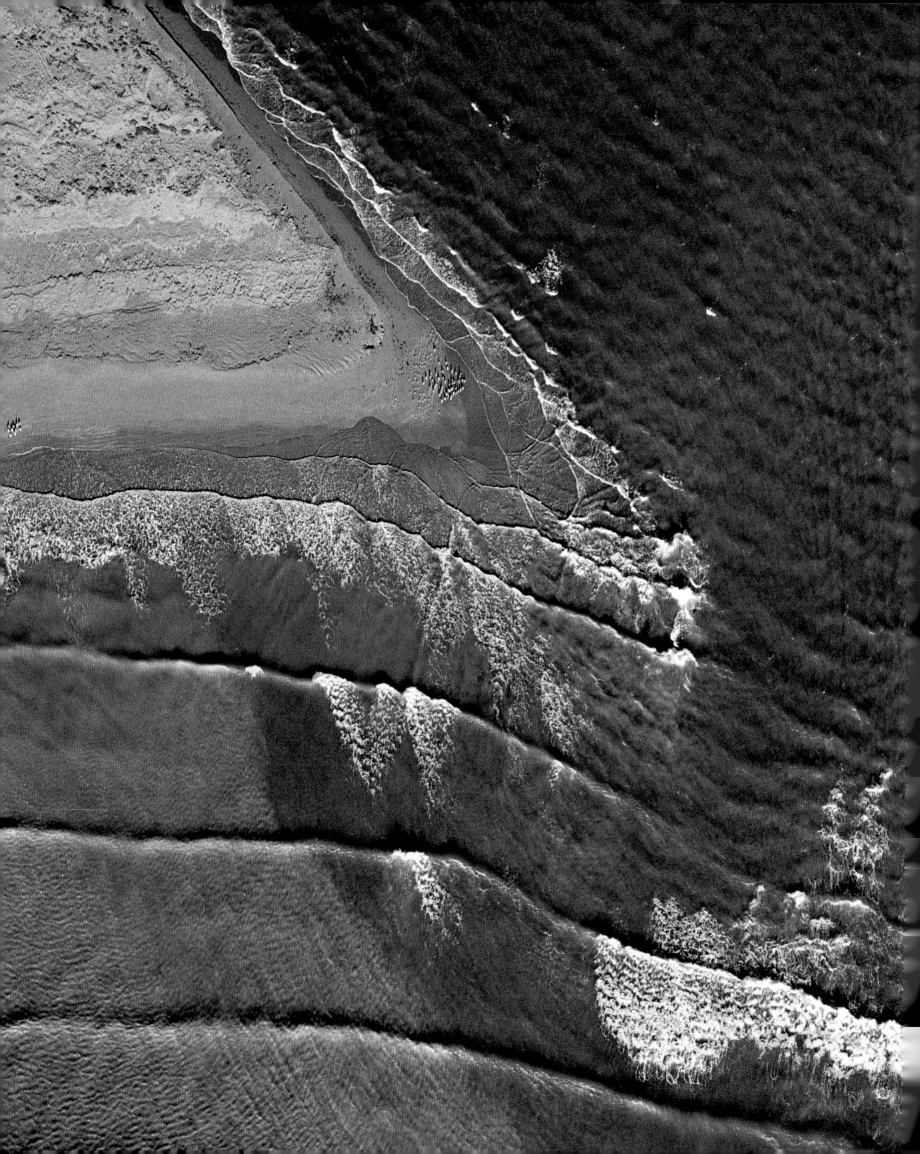

ATLANTIC COAST

I f one follows the steps of the first European conquerors and mapmakers to enter Colombia, at the dawn of the sixteenth century, one finds oneself on a peninsula jutting out into the Caribbean where life has learned to subsist under extreme conditions of wind, sandiness and dunes, high temperatures and aridity: this is La Guajira. Where earth, air and sun contend amidst the gigantic coal mines of El Cerrejón and the Wayuú Indians. Where natural gas issues from the subsoil, the beaches yield salt and cacti produce blooms that might be creatures of another planet or sea monsters. Where mountain ranges with sonorous names–Macuira, Jarara, Simarua, Parash–rumple up a plain flickering with solar radiation ❏ Then, southward, the relief suddenly changes temporarily. The Sierra Nevada de Santa Marta shoots up right from the ocean's edge where the Tairona Park is located today–indeed, from beyond, from the depths of the ocean with their coral reefs. Occupying land in three departments, this triangular pyramid whose peaks come close to 20,000 feet elevation above sea level, is the most massive cordillera in the world in proportion to the area of its base and also the highest mountain on earth with a coastline at its feet. On its abrupt slopes, in the midst of a steamy topical jungle, one finds the remains of the "Lost City" (Buritaca) and other complex pre-Hispanic settlements, whose terraces and stone walkways reveal the expertise in "environmental management" of the Taironas, forebears of the Ikas or Arhuacos, the Koguis, the Kankuamas who inhabit the Sierra Nevada today. Near its base, at sea level, in the Department of Magdalena (in whose capital city, Santa Marta, the oldest such in Colombia, the Liberator Simón Bolívar died) is the Ciénaga Grande. Together with Urabá, Santa Marta is one of the main centers of the banana business. Barranquilla, capital of the Department of Atlántico and the main sea and river port of Colombia, is spreading out of control near Bocas de Ceniza (Mouths of Ash), the present-day mouth of the Magdalena. It is one

Seagulls on a beach in the Auyama area, La Guajira.

of those "new" Colombian cities that came into the twentieth century silently and almost suddenly burst upon the scene and assumed a new leadership with the full force of industrial and commercial capitalism ❑ On the other hand Cartagena, the capital of Bolívar Department, is filled with history. Founded in 1533, during the colonial era it frequently had to withstand the sieges of English and French pirates and corsairs: Sir Francis Drake, the French Baron de Pointis, the English Admiral Vernon. Whence the Castles of San Fernando and Bocachica, of San Sebastián del Pastelillo, of San Felipe de Barajas; whence also the city walls. In 1811 it is the first city to declare itself wholly independent of Spain. In 1816 it was once again the a butt of a siege, this time by the Spanish "Pacifier" Pablo Morillo, who was charged with the task of reestablishing royal authority. Side by side are two Cartagenas: the historic city and the city of skyscrapers bursting with tourists eager for the seashore. And a third: the Colombia of the industrial complex of Mamonal. Not far away, on the Magdalena, is Mompox or Mompós, a riverfortress and city of sixteenth century Spanish holders of *encomiendas* (trusteeships) over Indians, as well as one of the liveliest centers of smuggling in the colonial period. South of Cartagena the oldest dated pottery in the Americas has been found (between 4000 and 3000 B. C.). The archaeologist Reichel Dolmatoff states: "It appears that the native societies of the Atlantic coast of Colombia were the ones that originally acted as focal points for what three centuries later would become the centers of the great classic cultures of the Americas" in Mexico, Guatemala, Bolivia and Perú ❑ On the Sucre coast, facing the Gulf of Morrosquillo, sits Tolú, which gives its name to TNT or trinitrotoluene. In all, ten departments of Colombia include area on the Caribbean plain. In addition to those already mentioned: Córdoba and Cesar, producers, respectively, of cattle and cotton. And Antioquia and Chocó, which look out onto the Gulf of Urabá. In the Mompós depression, an "island delta" inundated for close to nine months of the year by waters of the Magdalena, Cauca and San Jorge Rivers; and also on the banks of the River Sinú, there are remains of networks of dikes, terraces and channels put to use in an ecologically exemplary way by the Zenú Indians between the first and the tenth centuries of the Christian era to render fertile and cultivate land subject to flooding. The inhabitants of the Caribbean plain are collectively known as "costeños" (coast people) even though their particular traits vary from region to region and many of them live well away from the sea. Only literary magic realism has managed to take the measure of this startling mixture of rhythms and races which occupies the 51,500 square miles of plains and quagmires and overflowing rivers and bays and coral reefs that Colombia identifies as the Atlantic coast. In the Caribbean also lies Colombia's most important island territory, the archipelago of San Andrés and Providencia, a collection of coral and volcanic islands, originally colonized in 1629 by English Puritans and traders, that passed into Spanish hands in 1700 and, with independence, became an inseparable part of the "biodiverse" Colombian identity ❑

Dawn on the north slope of the Sierra Nevada de Santa Marta, Magdalena.

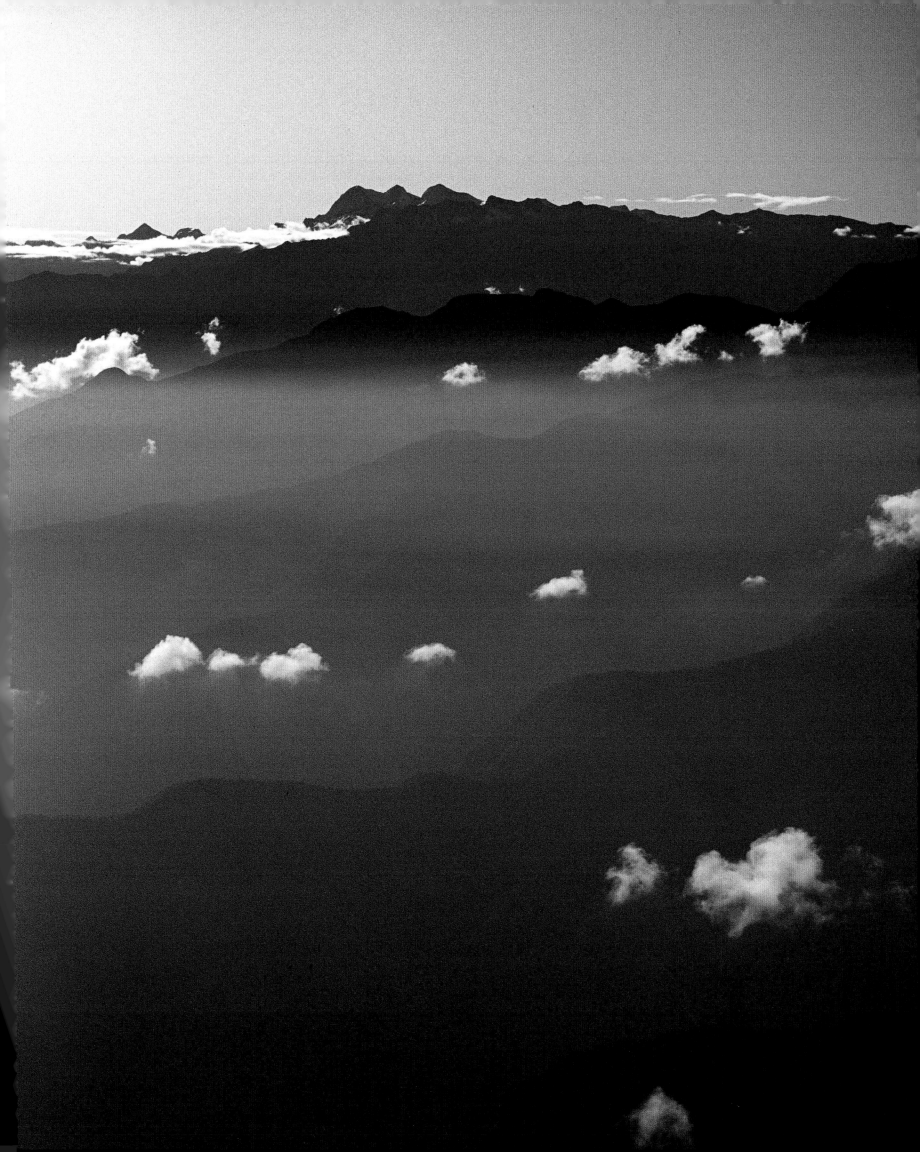

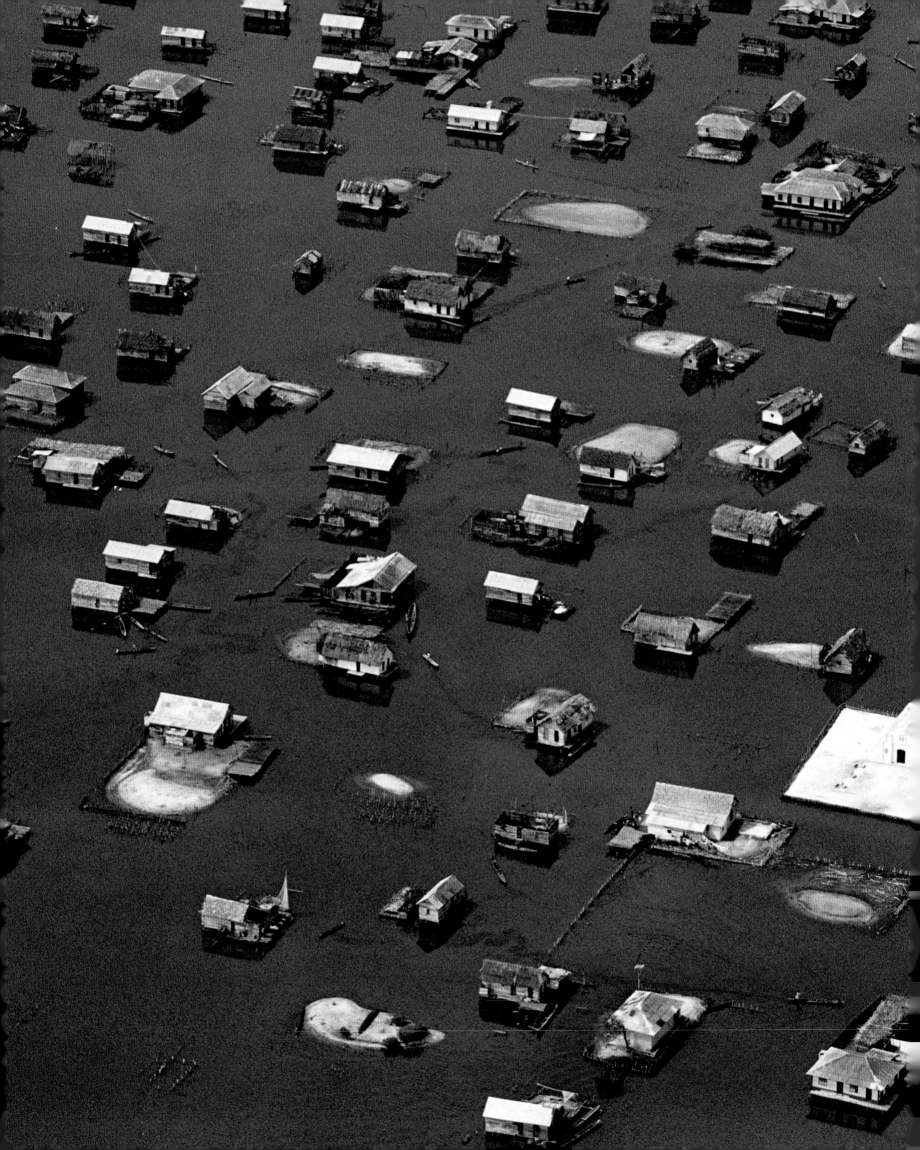

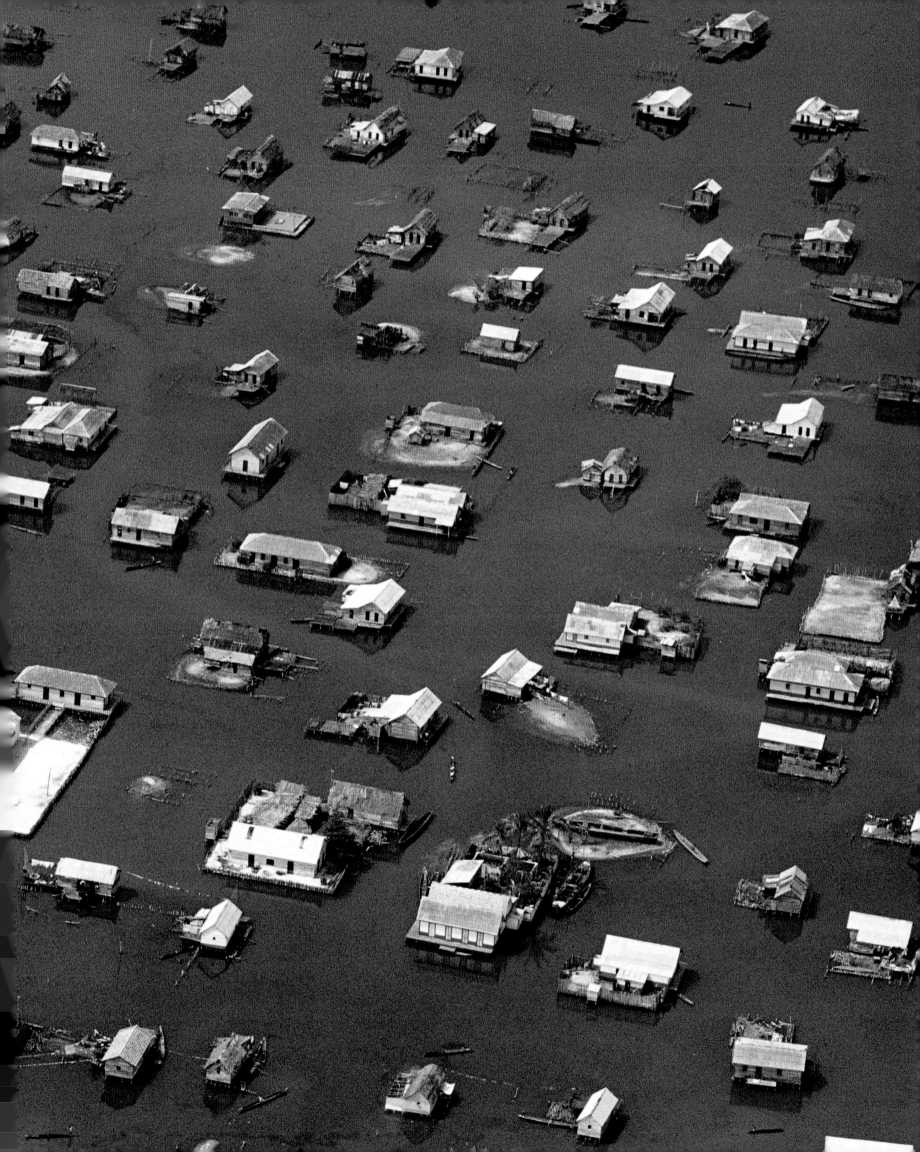

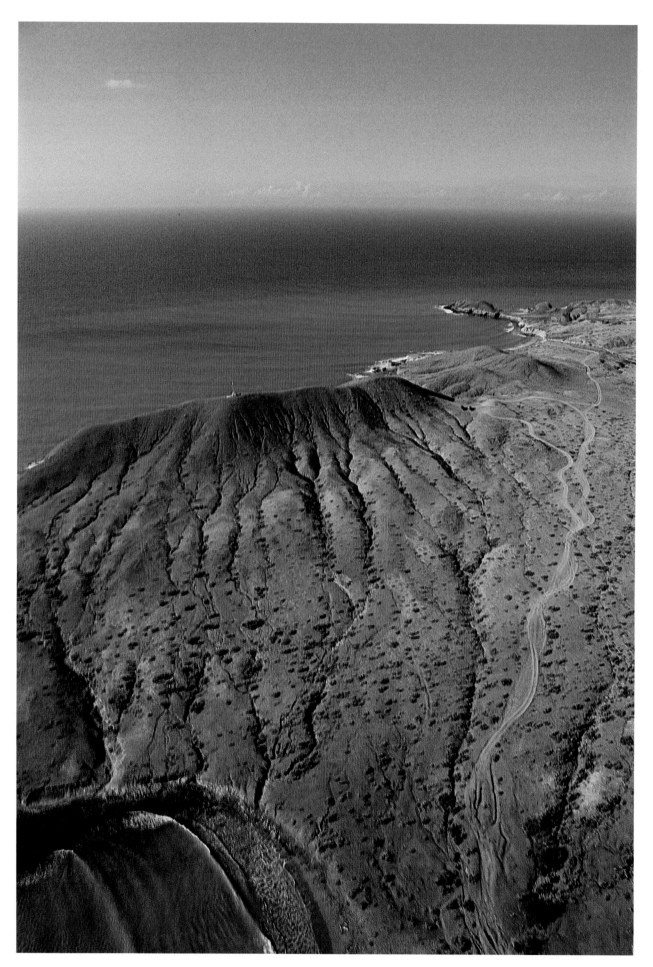

Area around the ancient lighthouse at Cape de la Vela, La Guàjira.

⟳ New Venice, village of lake-dwellers, Great Quagmire of Santa Marta, Magdalena.

Jarara Ridge at the center of La Guajira peninsula.

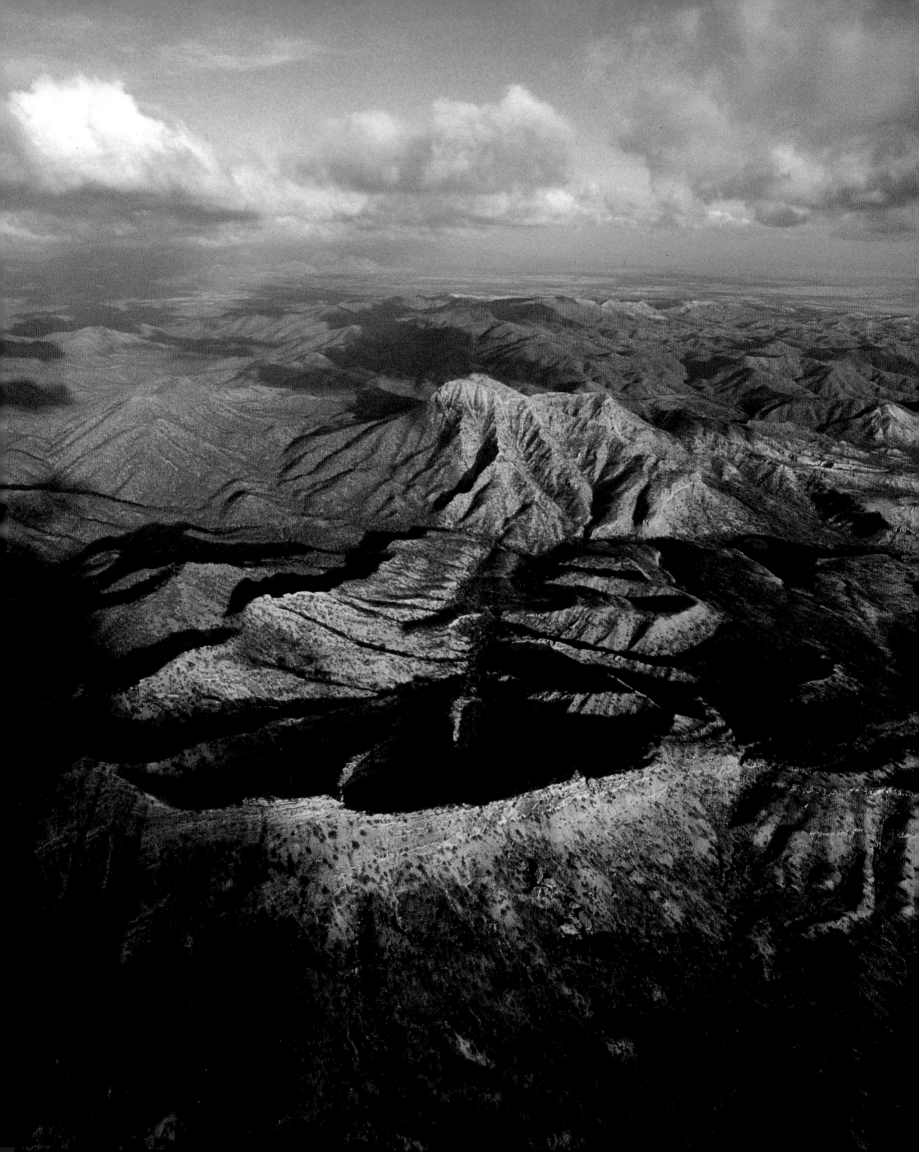

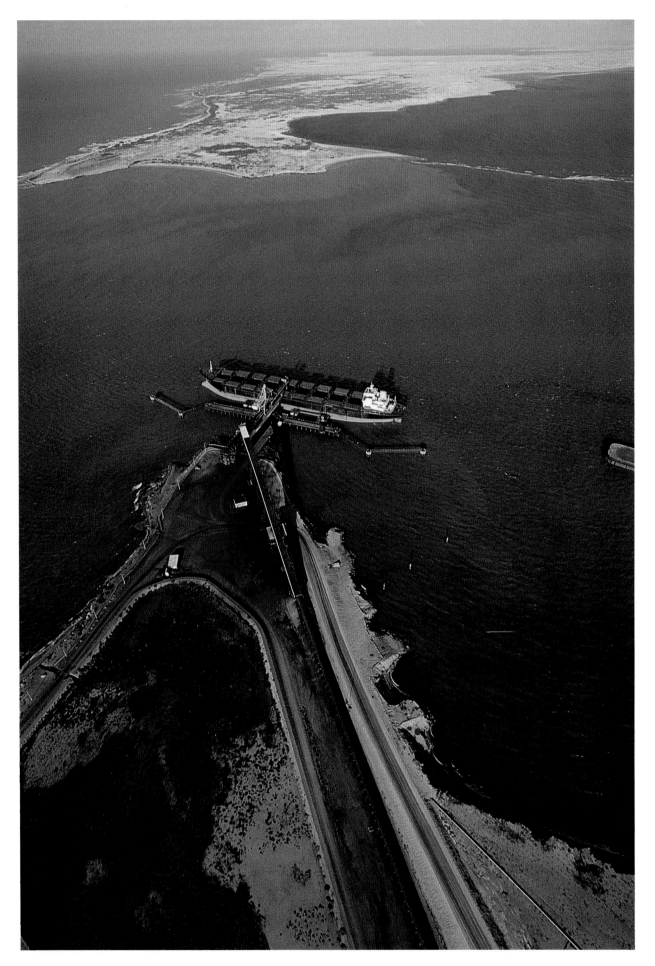

Loading coal at Puerto Bolívar, La Guajira.

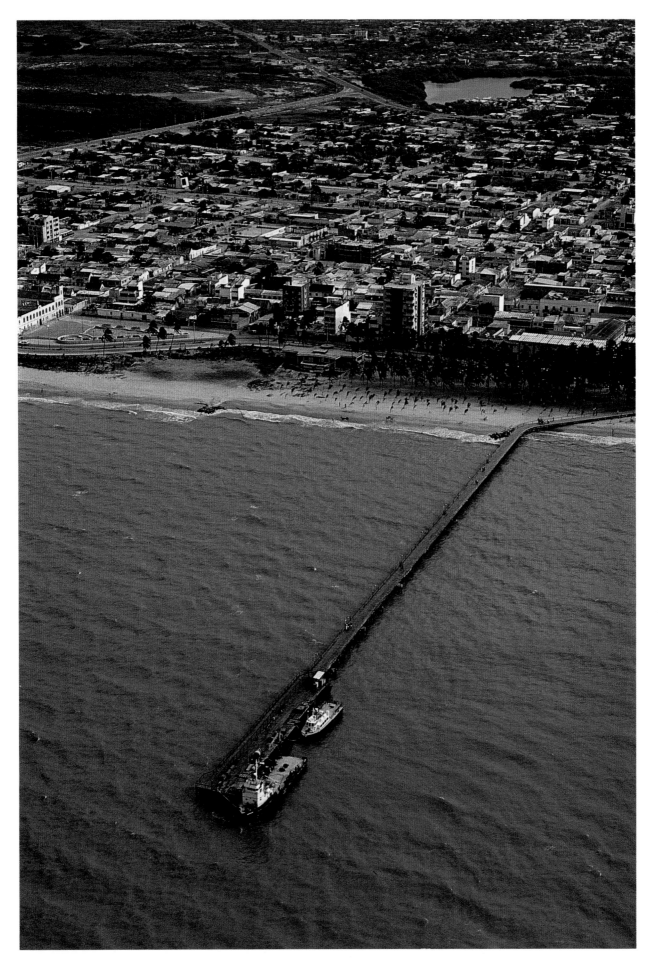

Wharf opposite the tourist zone of Riohacha, capital of La Guajira.

Salt-collecting basins at Manaure, La Guajira. ⇨

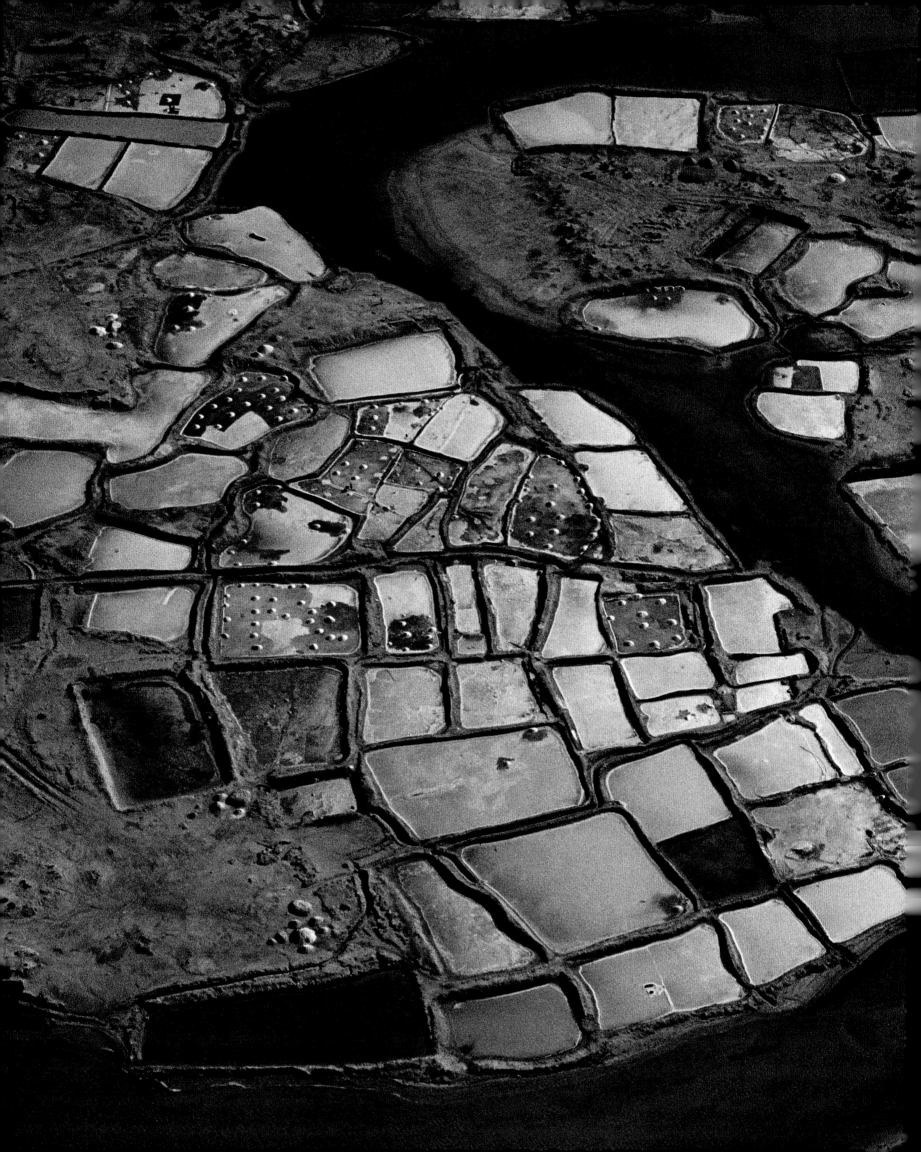

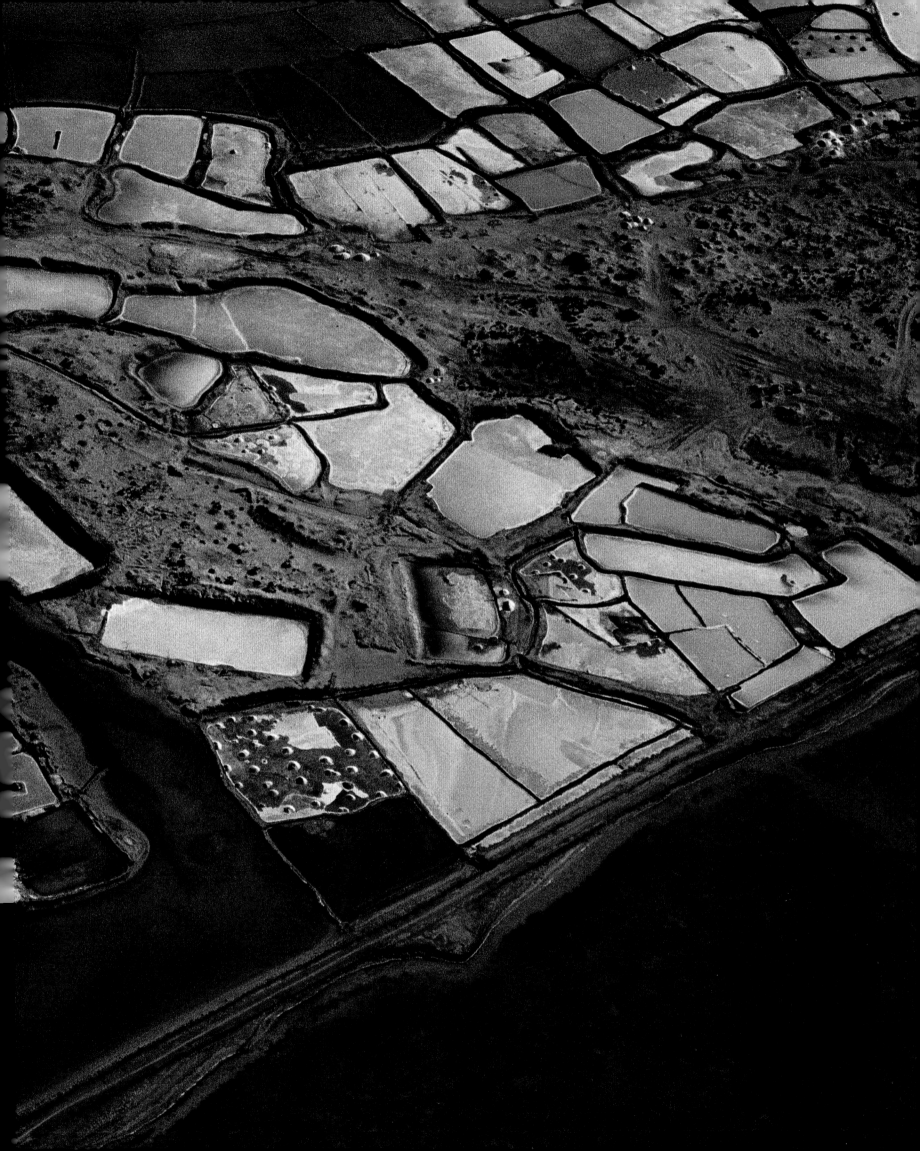

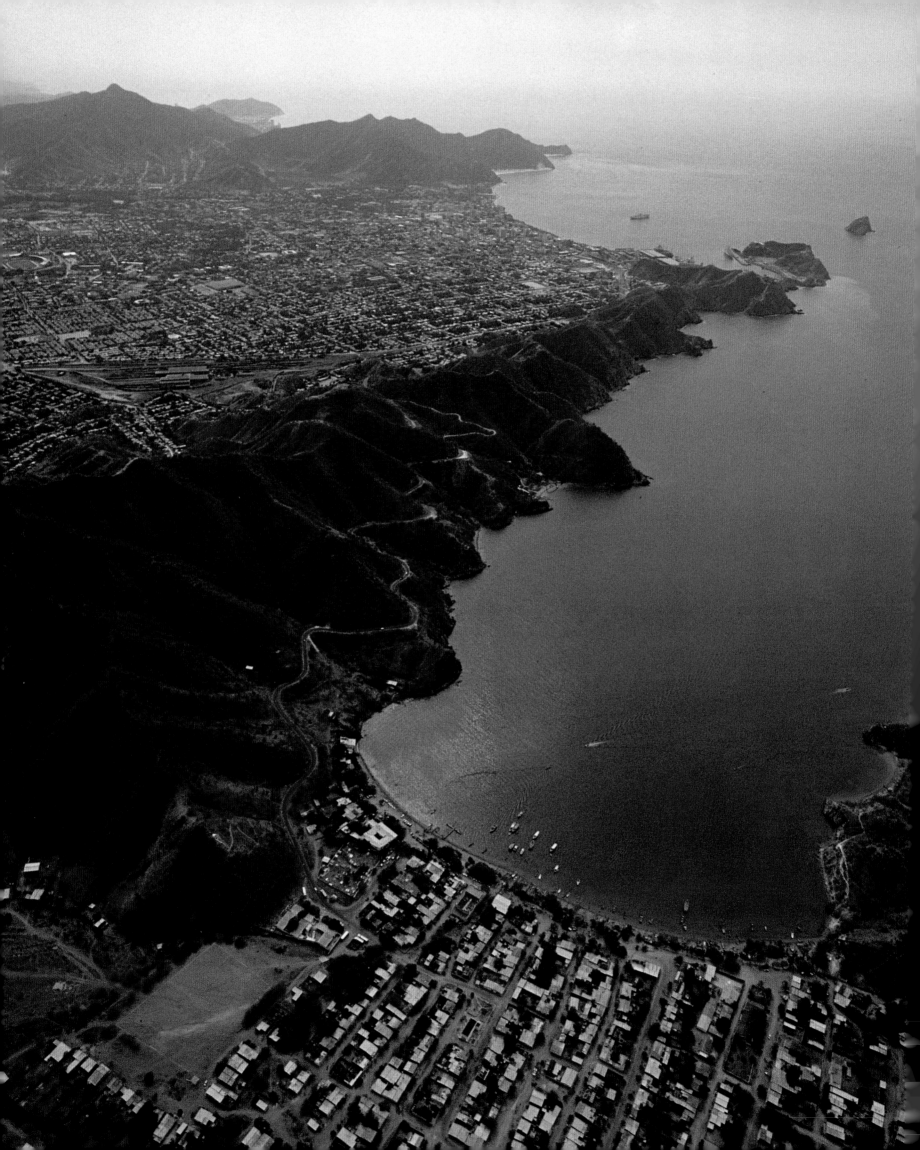

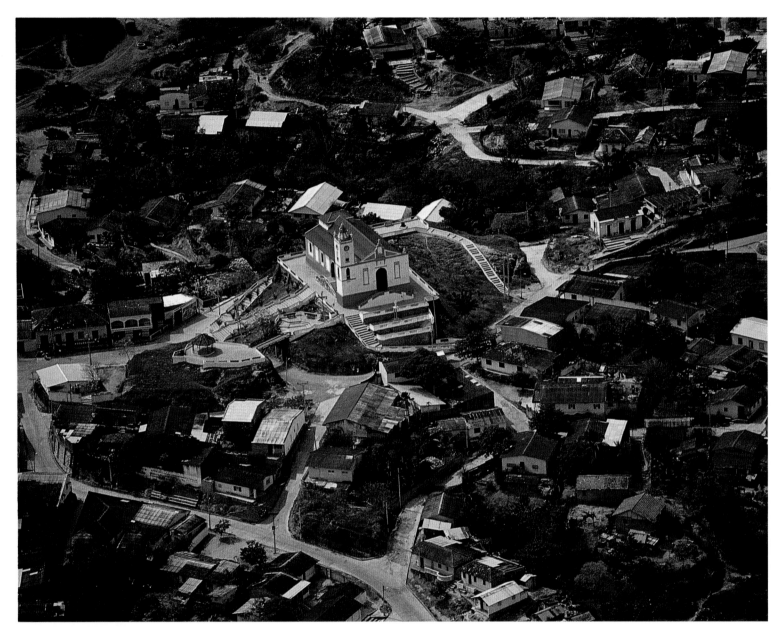

Town of Usiacurí north of Sabanalarga, Atlántico.

Sunshine reflected as a rainbow in the Great Quagmire of Santa Marta, Magdalena.

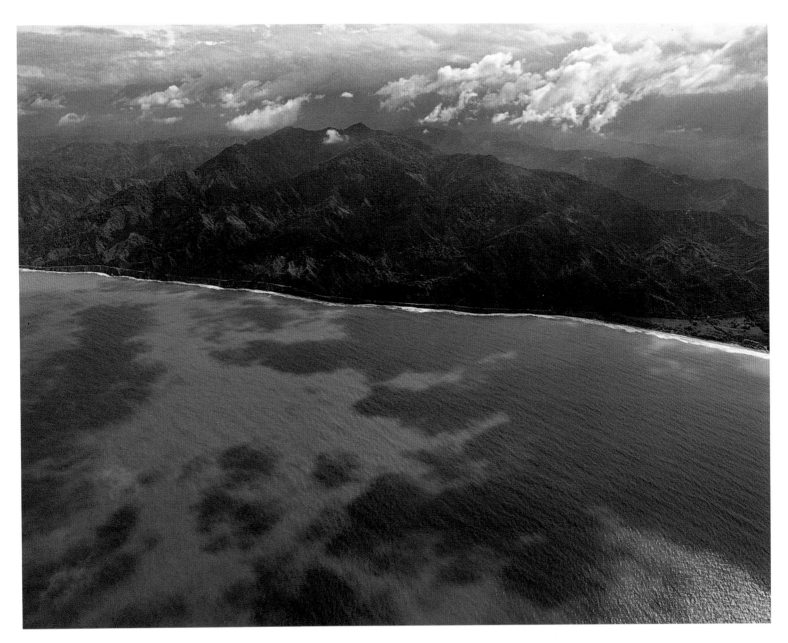

Coastal zone of Buritaca in the Tairona Nature Preserve Magdalena.

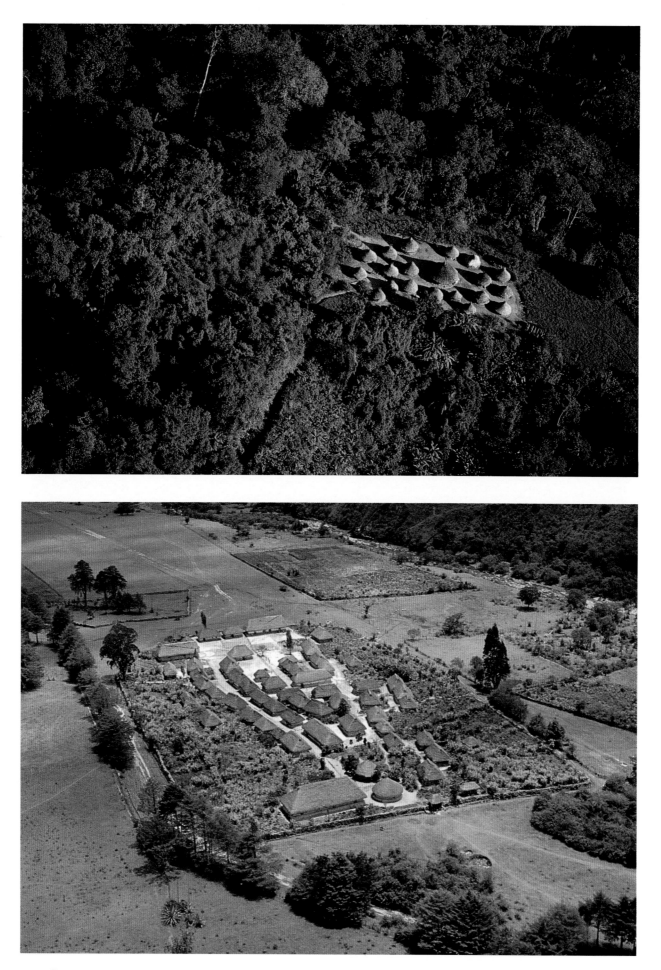

Kogi village on the south slope of the Sierra Nevada of Santa Marta, Magdalena.

Arhuaco town of Nabusímake in the Sierra Nevada of Santa Marta, Cesar.

Tairona pre-Columbian terraces of the Lost City in the Sierra Nevada of Santa Marta, Magdalena.

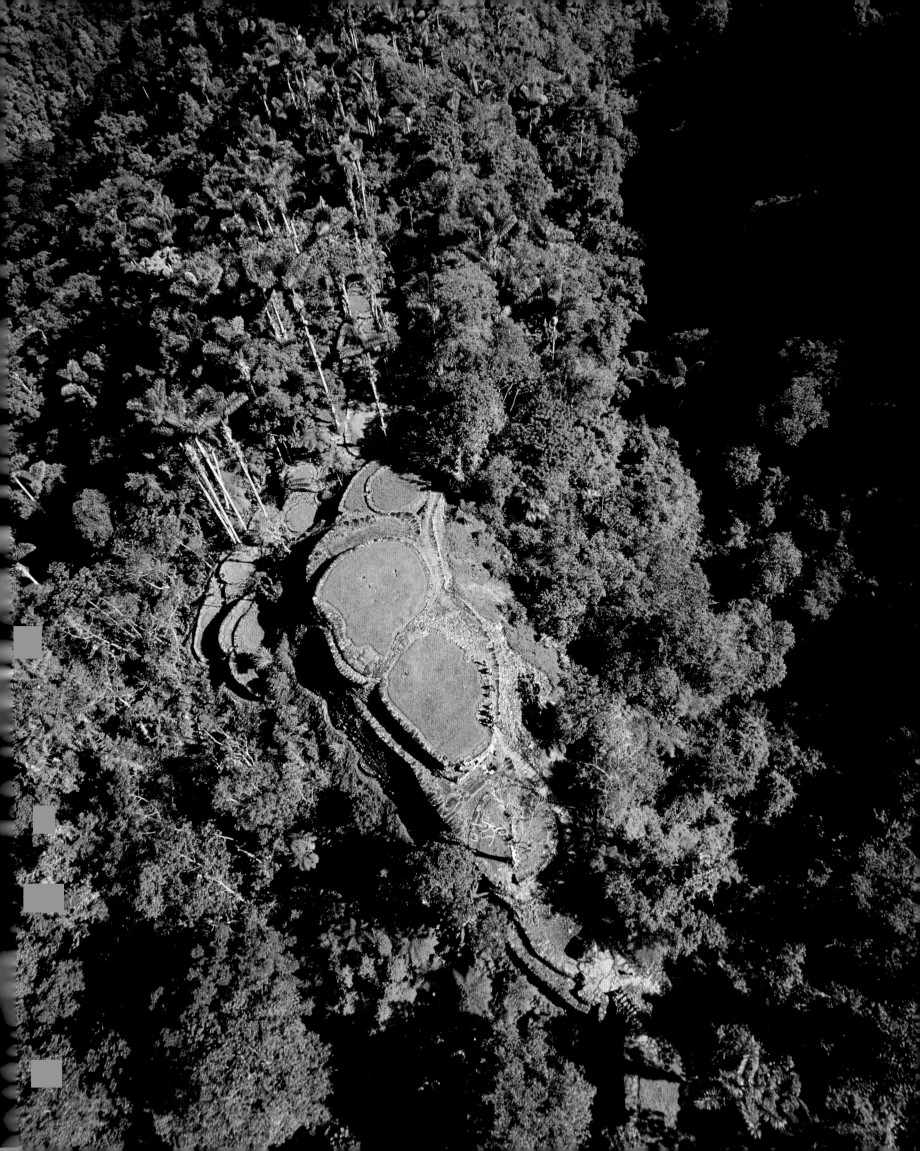

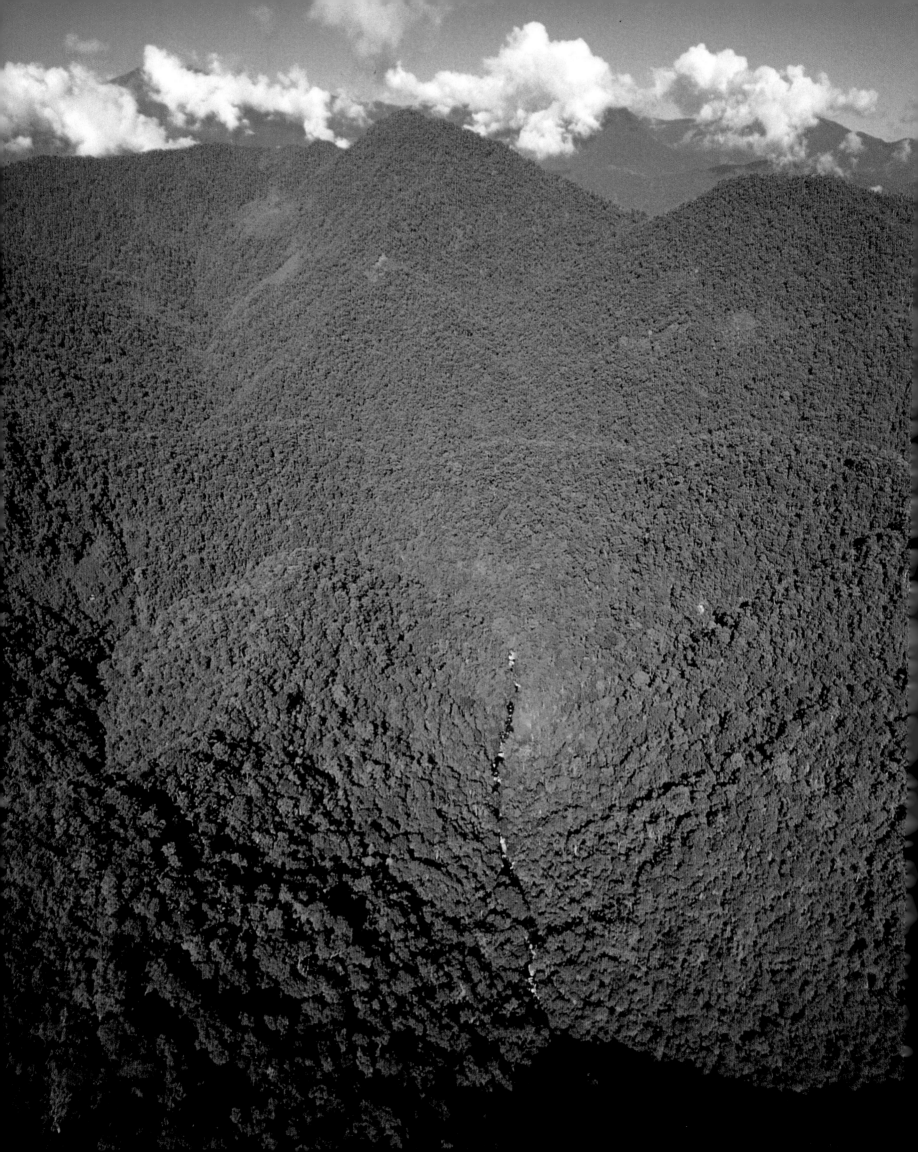

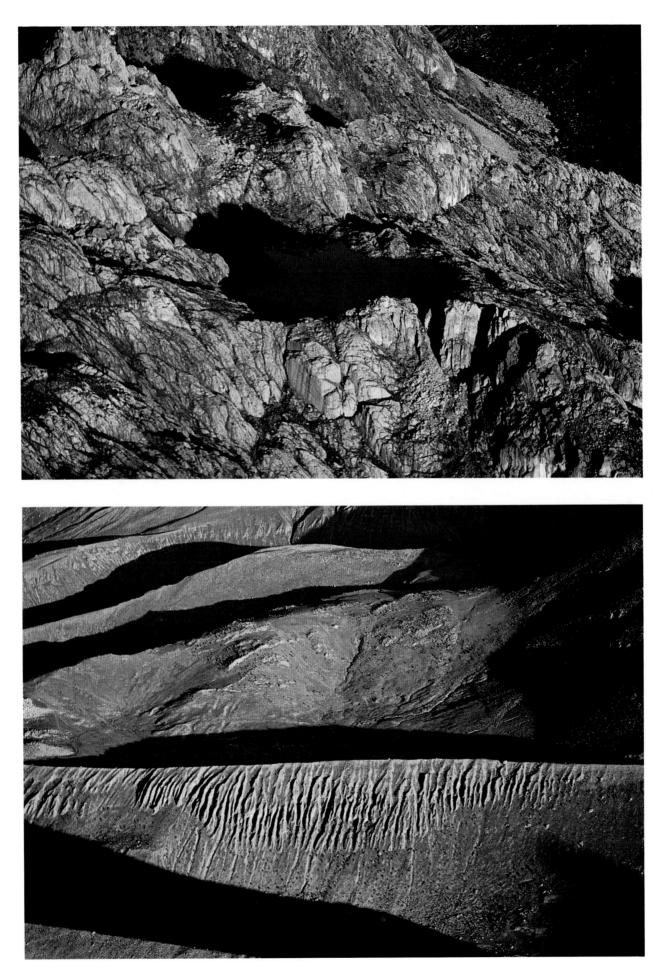

Virgin forest on the north slope of the Sierra Nevada of Santa Marta, Magdalena.

Glacial lake at over 13,600 feet in the Sierra Nevada of Santa Marta, Magdalena.

Folds of rock, southwest slope of the Sierra Nevada of Santa Marta, Magdalena.

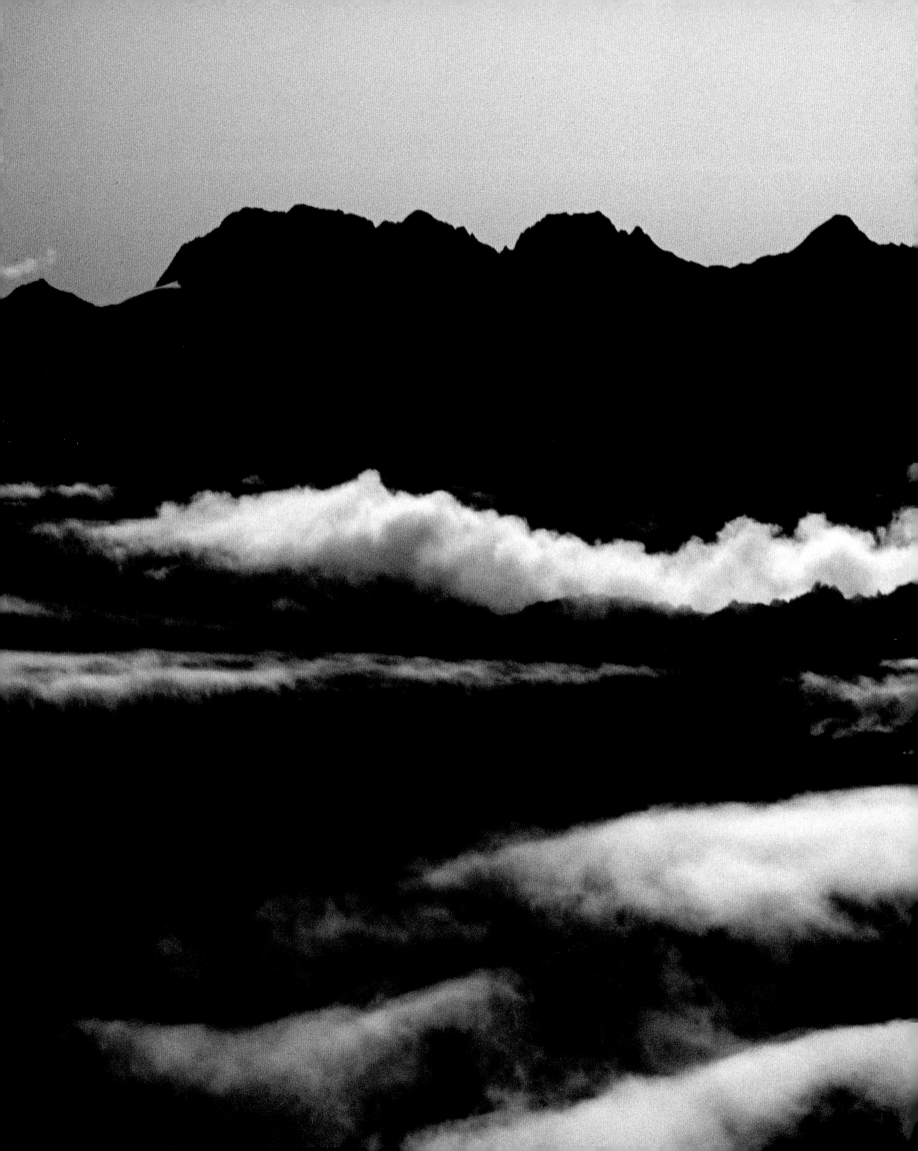

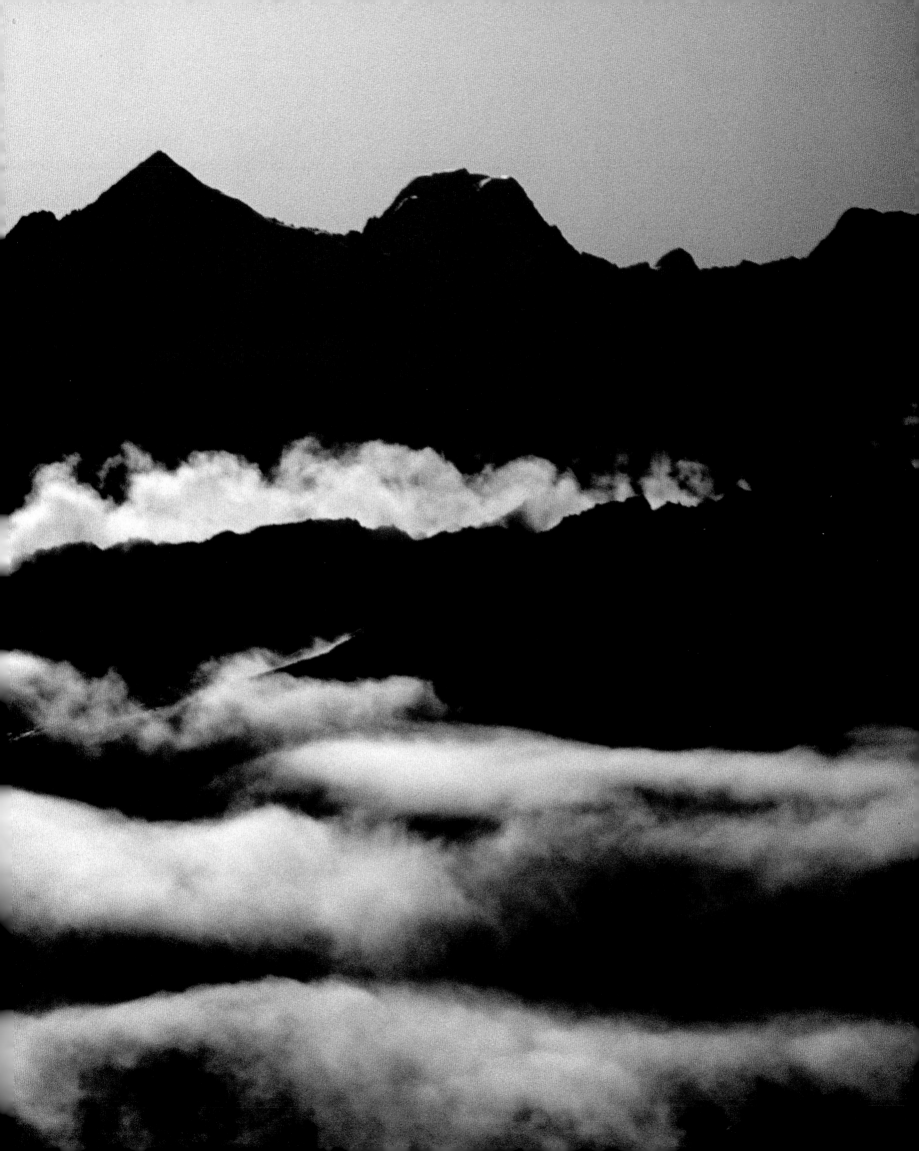

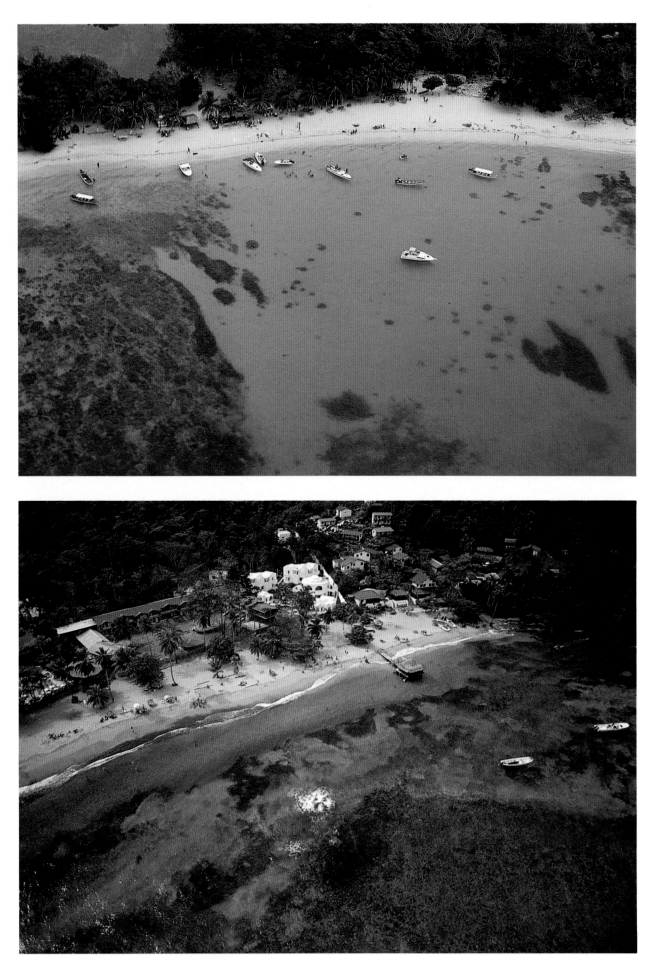

Beach at Point Barú across from the Rosary Islands, Bolívar.

Hotel zone of Capurganá on the gulf of Urabá, Chocó.

↻ Highest peaks in Colombia, Sierra Nevada of Santa Marta, Magdalena.

Beaches of El Rodadero at the height of the tourist season, Santa Marta, Magdalena.

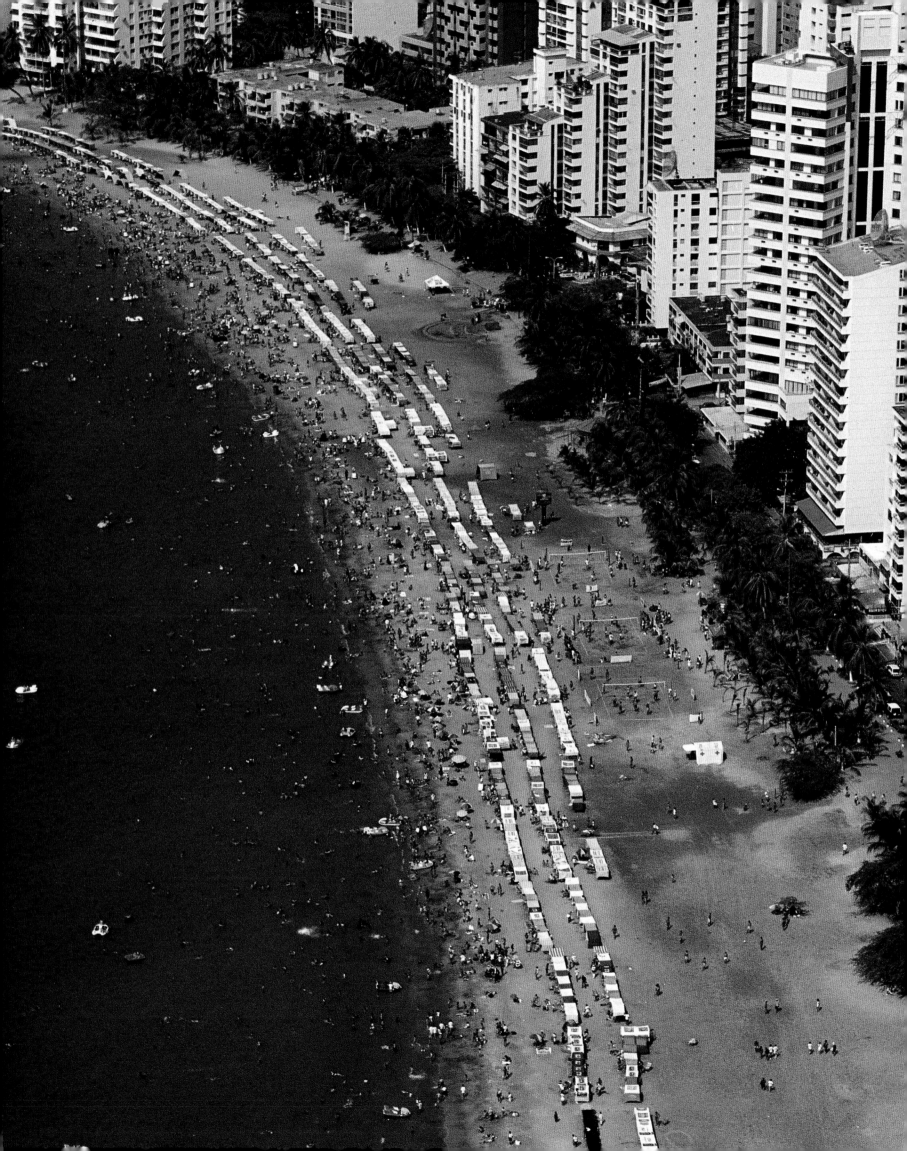

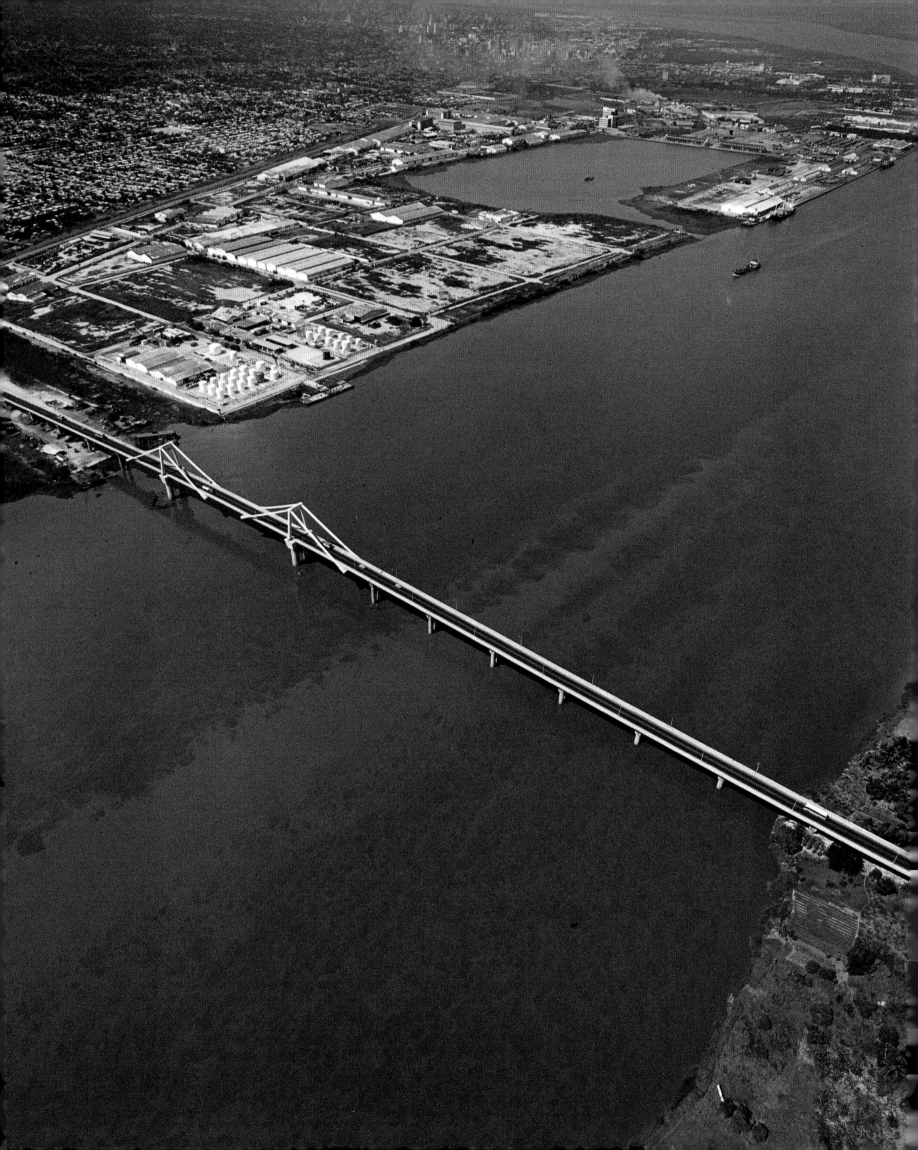

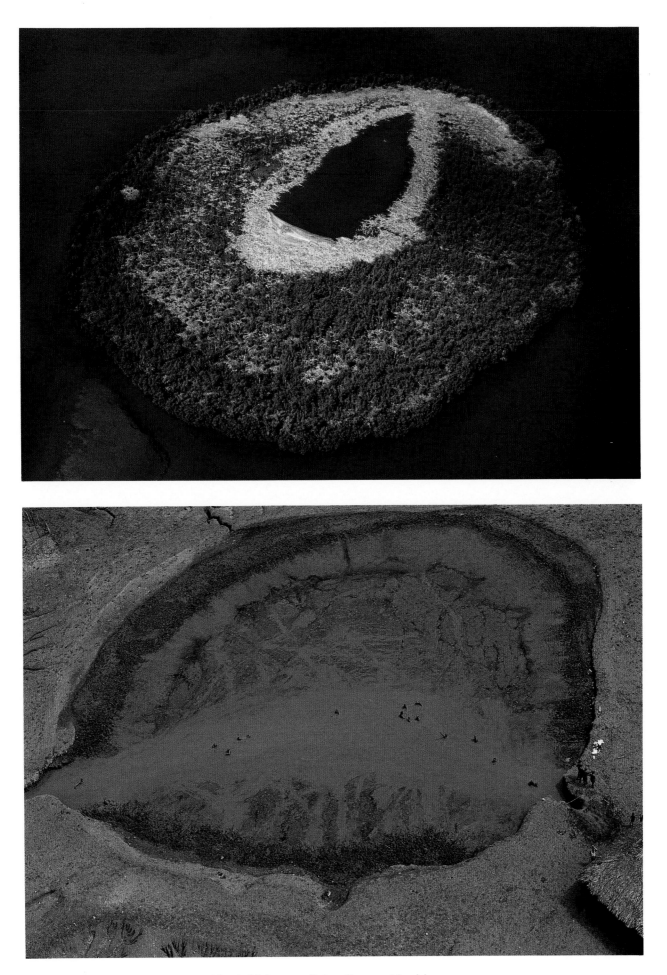

Inner lagoon of the mangrove swamp, Island of Salamanca Nature Preserve, Magdalena.

Bathers in the crater of the mud volcano of Arboletes, Antioquia.

Pumarejo Bridge over the Magdalena River with the city of Barranquilla in the background, Atlántico.

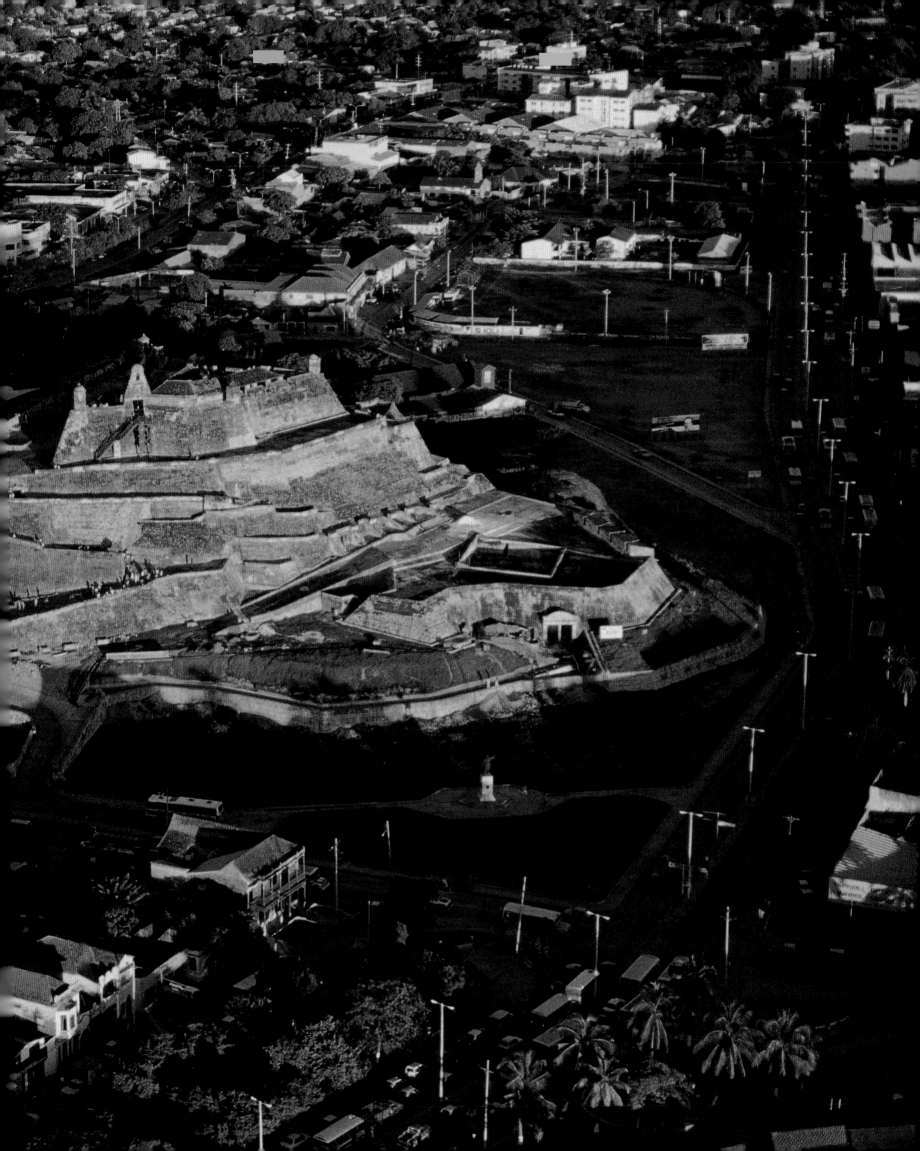

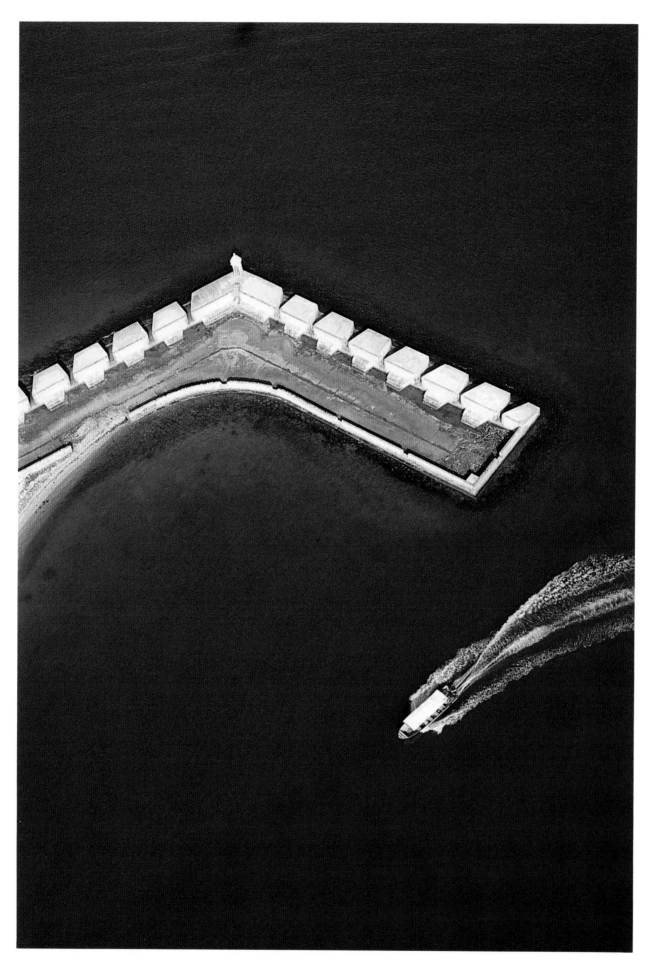

Fort of San Fernando de Bocachica on the Bay of Cartagena, Bolívar.

◁ Fort of San Felipe de Barajas in Cartagena de Indias, Bolívar.

Evening at Castillogrande and El Laguito in Cartagena, Bolívar.

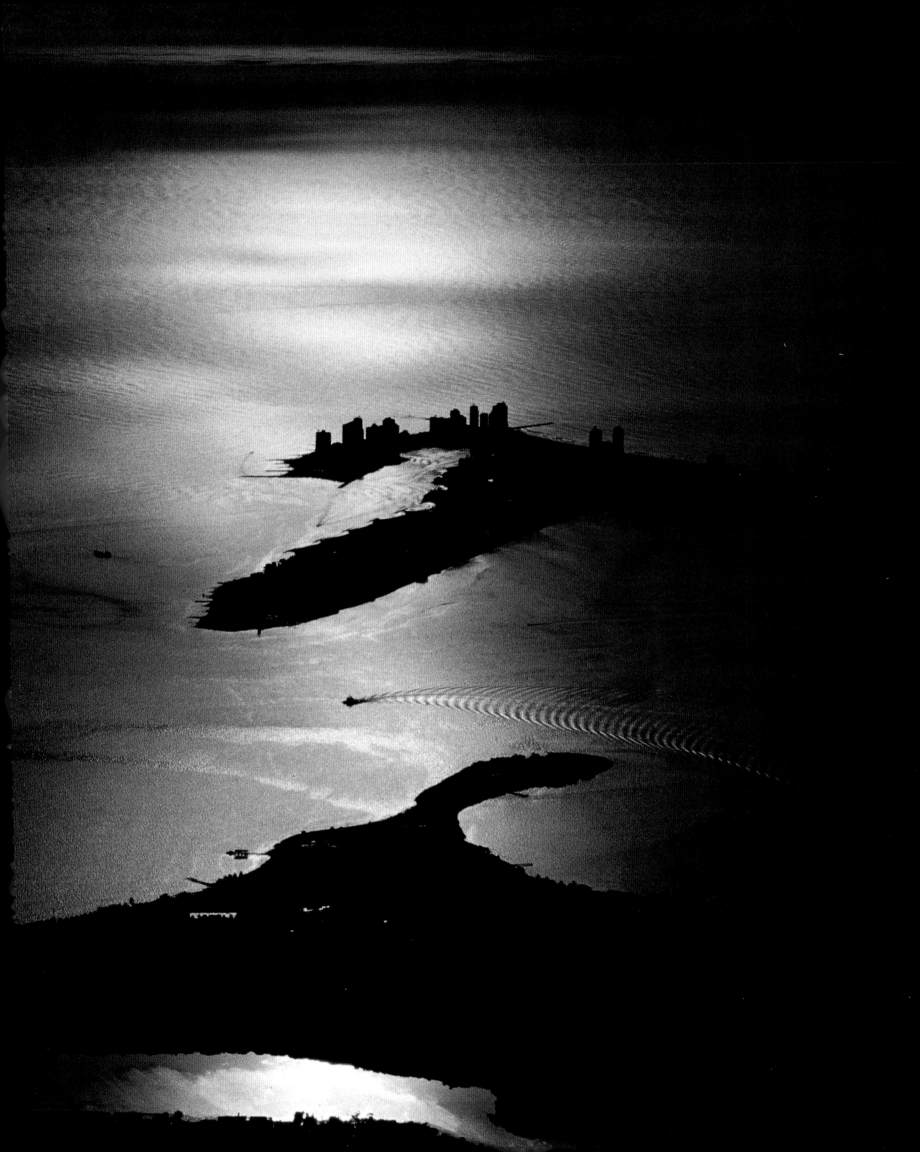

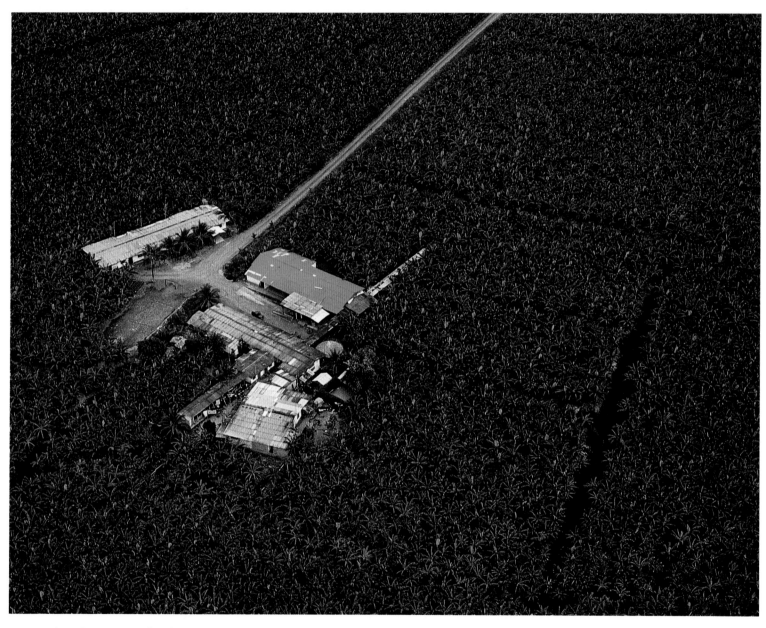

Banana plantation at Apartado, Chocó.

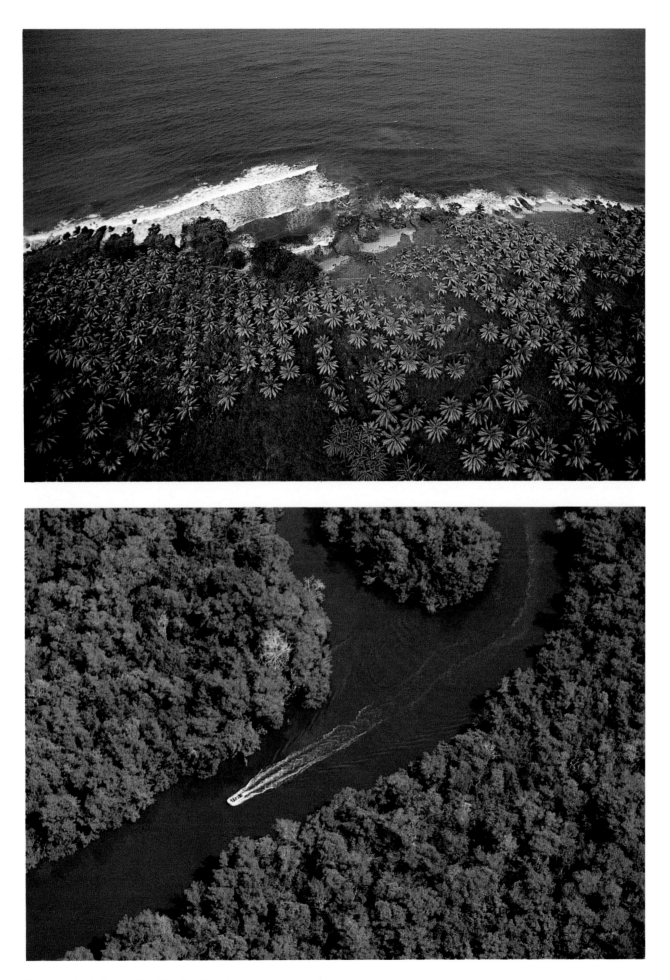

Coconut plantation on the Atlantic, Chocó.

Mangrove swamps of the Quagmire of Cispatá, Córdoba.

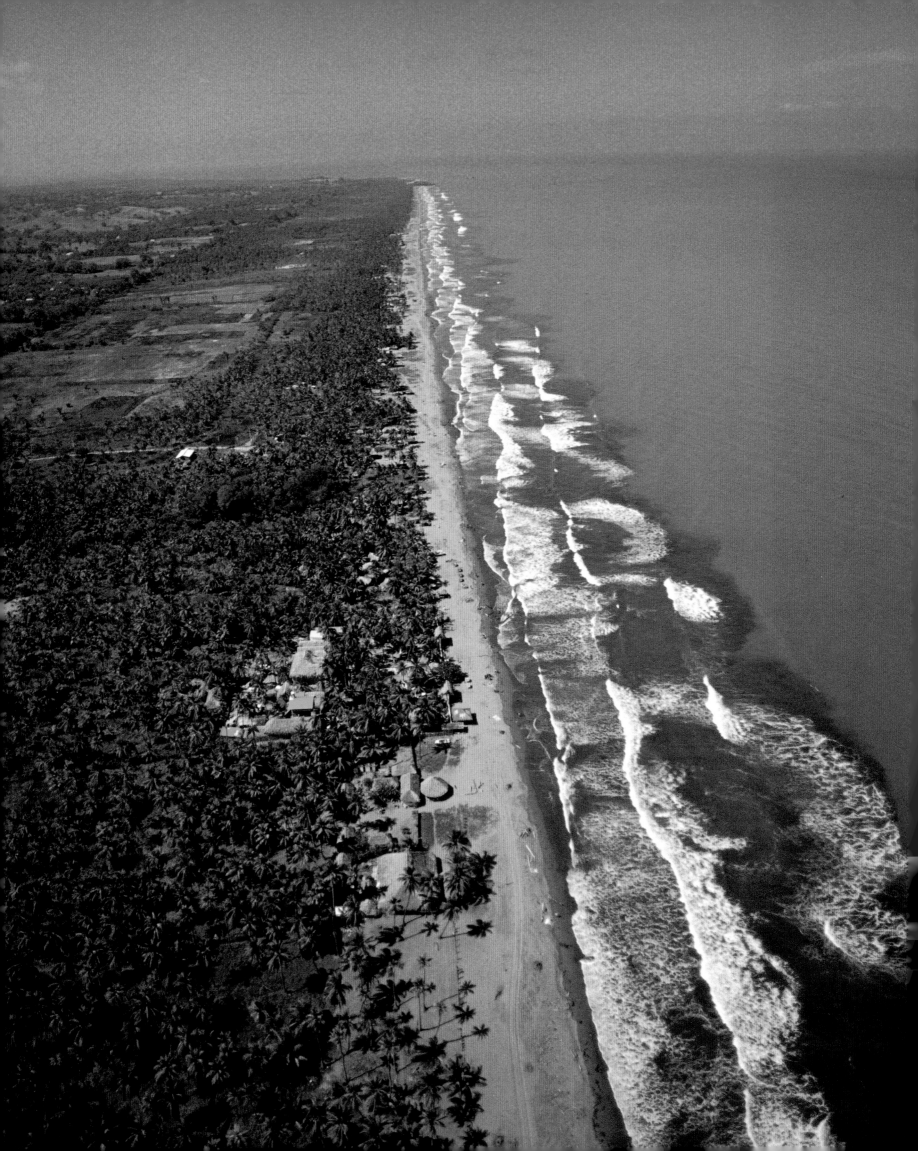

Coral and vacation houses on the coral islands of San Bernardo, Córdoba.

Beach of San Bernardo del Viento near the mouth of the Sinú River, Córdoba.

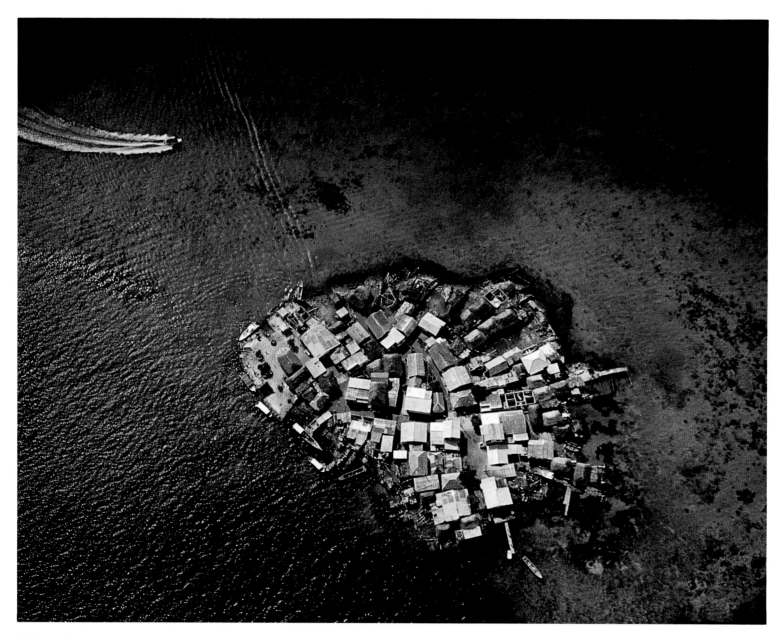

El Islote in the San Bernardo Islands, Córdoba.

Swimmers at the Cayo Cangrejo reef, Providencia.

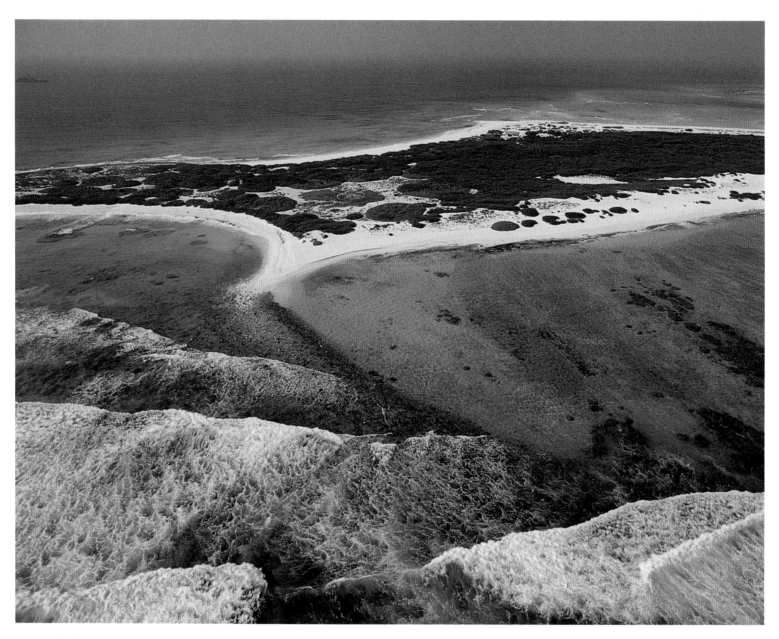

Serrana Shoal northeast of Providencia Island.

Albuquerque Key off southern San Andrés Island.

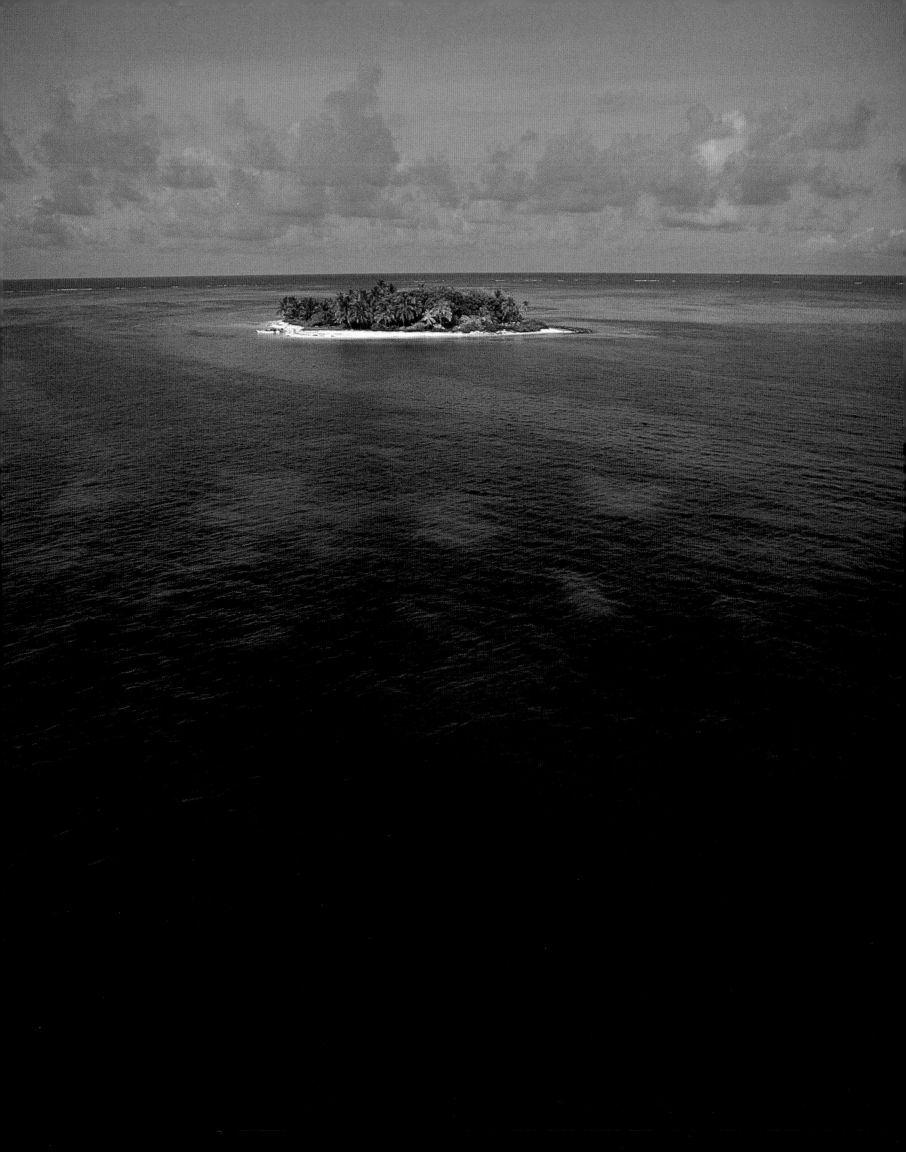

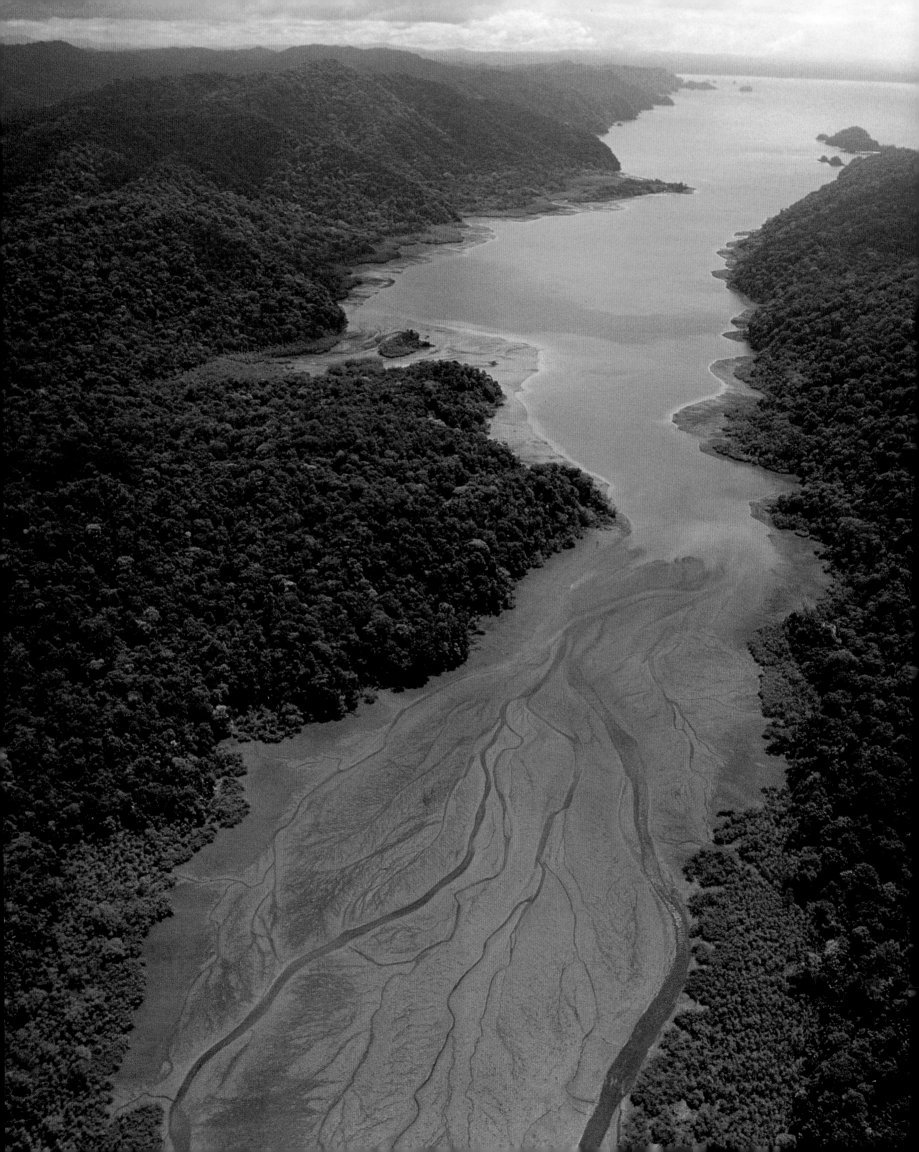

PACIFIC COAST

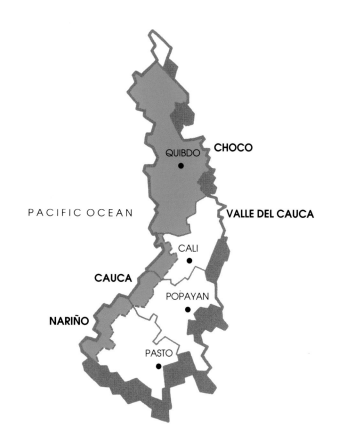

W hen the ocean "discovered" for Europeans by Vasco Núñez de Balboa in 1513 was christened the "Pacific," no one realized that the same name would be borne, in its turn, by this Colombian coast, surely one of the wildest, if not the wildest, in the Americas. It is a coast marked by every kind of disproportion and excess. It is one of the rainiest regions on earth and boasts perhaps the most humid spot on the globe. In many places annual precipitation exceeds 400 inches, which means that yearly rainfall would fill a cylindrical container 33 inches high. Today we know that the so-called "Biogeographic Province of the Chocó," which includes coastal areas of the Departments of the Chocó, Valle, Cauca, Nariño and part of Córdoba, Antioquia and Risaralda, constitutes one of the ecosystems of greatest biodiversity–diversity, that is, of species per unit of area–in the world. According to the botanist Alwin Gentry, the Pacific jungle is one of the world's richest in species of vegetation; in some places up to 265 different species have been identified in a single quarter acre The same scientist declares that on this coast one finds possibly the greatest specific endemism of the whole continent–that is, the greatest number of species that live only there and nowhere else on earth. There, too, is the Atrato River, which flows into the Gulf of Urabá on the Caribbean and boasts headwaters rich in platinum and gold. This river holds the greatest volume of water in proportion to depth to be found anywhere in the world and is South America's second in volume of flow, in some places reaching depths of as much as 375 feet. There, too, are found: the San Juan River, the heaviest in flow of any South American tributary of the Pacific; forests containing the highest proportion of palm trees in the world; the richest mangrove swamps of the western world; the plants with the largest leaves... And, esthetically speaking, the most beautiful coves and bays: Humboldt, Cupica, Bahía Solano, Utría, Málaga ❏ Not many miles

Utría Bay at low tide, Chocó.

to the west of this coast, the Pacific sea-bottom plunges down from South America into a trench nearly ten thousand feet deep, the result of the phenomenon known as continental drift, according to which continents are actually afloat on the molten undersurface of the earth. Hence it is not surprising that this sea bottom or the adjacent land are fairly often violently shaken. In 1906, at Tumaco, near the Colombian-Ecuadorian border, occurred one of the greatest earthquakes ever recorded ❏ On can distinguish two main sectors of the Pacific Coast. The northern lies between the Panamanian border (where the Tule-Kun a and the Emberá-Katío Indians live) and Cape Corrientes, in the Department of Chocó, where the Baudó mountain ridge forms a precipitate stretch of coast along which the differential in depth between high and low tide may be as great as 33 feet. Then there is the southern sector, between Cape Corrientes and the Ecuadorian frontier, comprising the Department of Valle, off whose coast emerges the islet of Malpelo, and the Department of Cauca, in whose territorial waters are Gorgona and Gorgonilla Islands and the sea route of the humpbacked whale. Here the so-called "Pacific Shelf" drops off less and less steeply and widens increasingly. Here, too, there is a greater and greater proliferation of bays, gulfs, creeks and channels formed by the mouths of the short, plump rivers which come down from the Western Cordillera, often carrying gold. Along this section of the coast the principal means of communication, after the sea and the rivers, are the creeks, a web o watercourses deep in the jungle and mangrove swamps, which interconnect all points. Their currents and depths change every six hours with the tides or "thrusts" of the sea ❏ Quibdó, capital of the Department of Chocó, a city founded in 1690, can be reached by navigating the Atrato upstream from the Gulf of Urabá, or by air. In the early days of aviation in Colombia–and the heyday of the mining companies–the only way was to fly in a Catalina seaplane. The Atrato River is a sort of umbilical cord connecting the Pacific region with the Atlantic coast. Small coastwise vessels regularly ply the route between Quibdó and Cartagena ❏ The Pacific coast's largest city is Buenaventura in the Department of Valle. It is not only the main port on this coast for fishing and trade, but the one that handles the heaviest volumes of freight of the whole Pacific coast of South America. Unlike Quibdó, it is connected with the interior of the country by a train line and by a highway upon which a high percentage of Colombian imports and exports is dependent. Buenaventura is followed in rank and population by Tumaco, in the Department of Nariño. Then come Istmina, at the headwaters of the San Juan in Chocó, Guapi in Cauca, El Charco (The Pool) in Nariño. At Bahía Málaga, one of the places in the Pacific region where the proliferation of biodiversity, both on land and in the sea, reaches a maximum, the Colombian Navy has just built its main Pacific base. Plans to convert the bay (another stopping-place for humpbacked whales) into an oil port are causing alarm ❏ Five hundred years before the Christian era a pottery-making culture flourished in the mangrove swamps of the Pacific coast. Colonial chroniclers speak of whole populations of tree-dwellers and farmers as victims of genocide by Spanish conquerors. Today nearly a million people inhabit the Biogeographic Province of the Chocó, ninety per cent of them of African origin, five per cent of mixed race and a final five of Kima, Emberá-Katío and Waunana Indians apportioned into nearly sixty reserves. The blacks were first brought to the Pacific coast region by the Spaniards to work as slaves in the gold mines. Others, the "mavericks," came to seek refuge after rebelling against their masters. Three centuries later, throughout Colombia– and especially along this coast–communities of blacks are struggling to establish their ethnicity on a pattern of development that respects their cultural identity and is able to guarantee the biodiversity of their ecosystems ❏

Bed of the Atrato River in the Darién zone, Chocó.

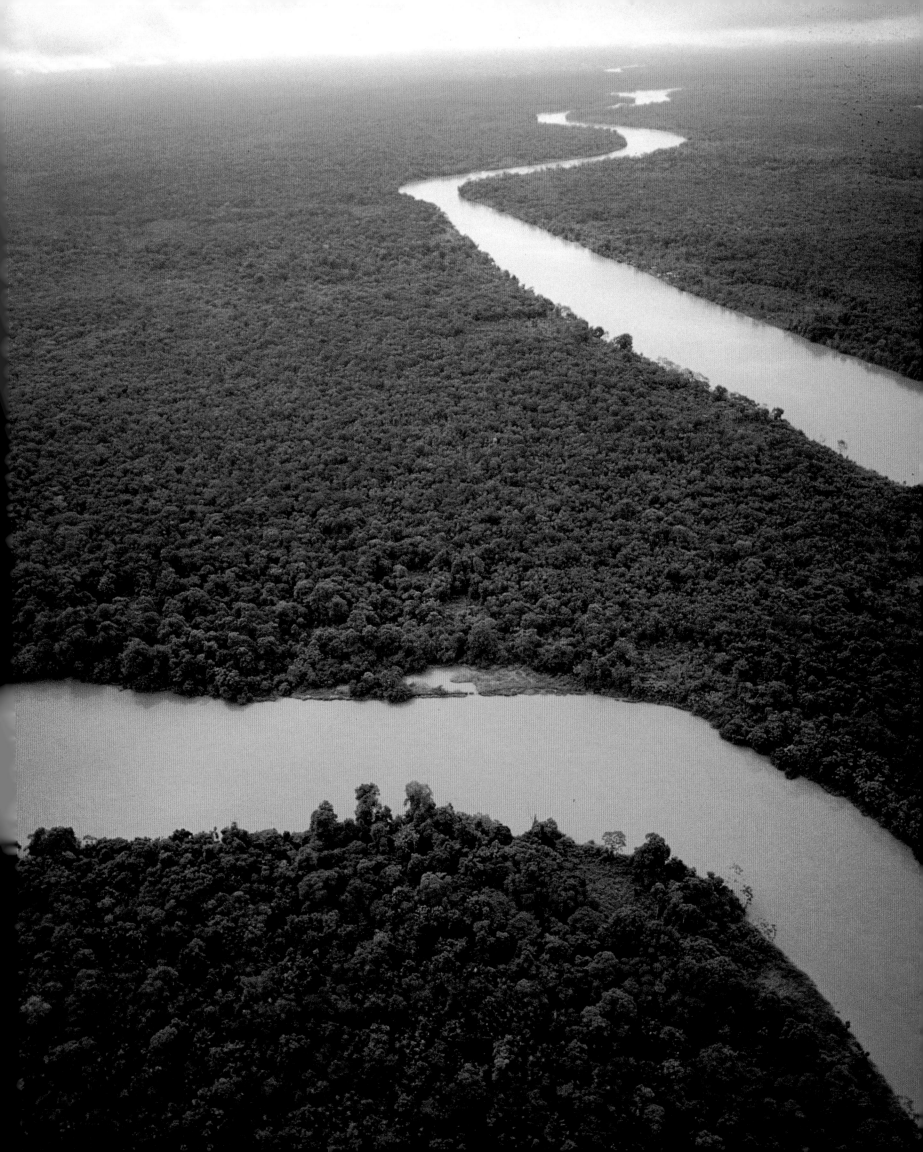

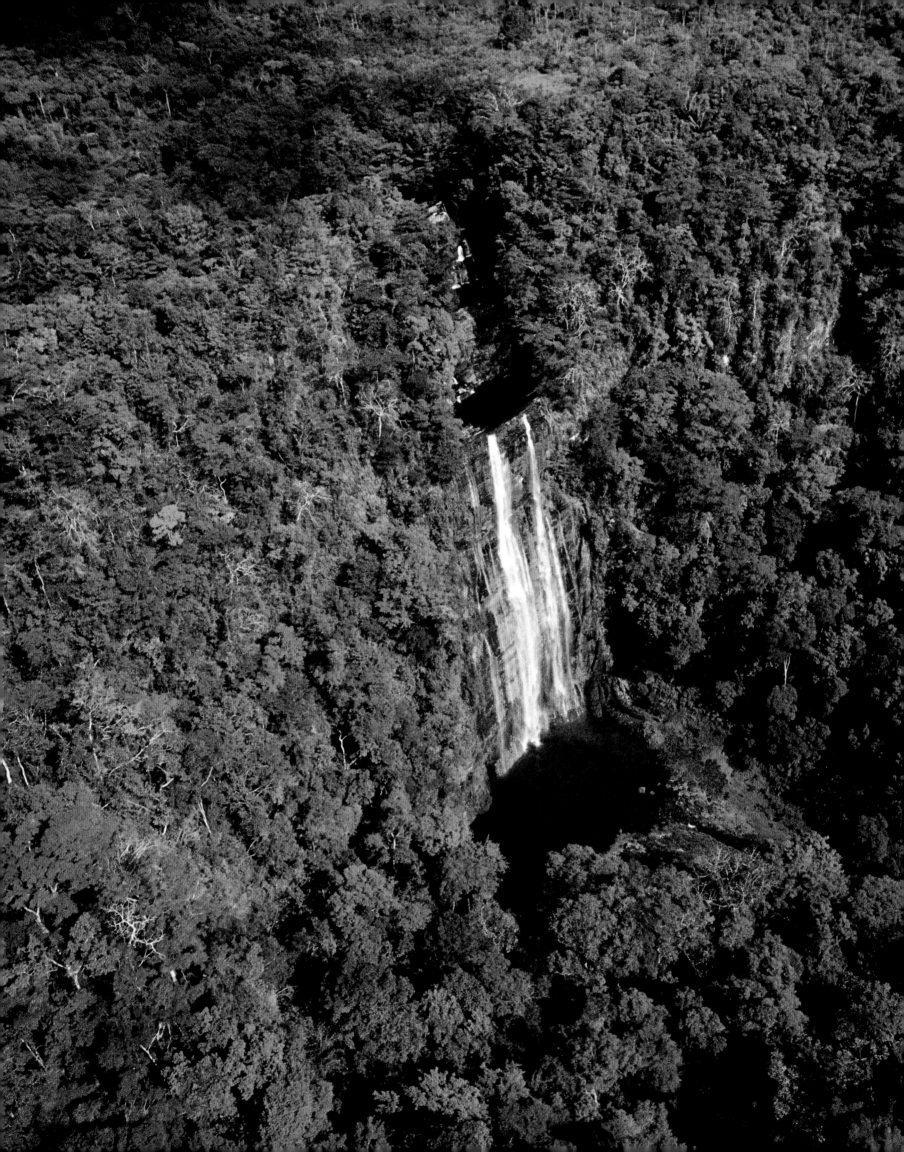

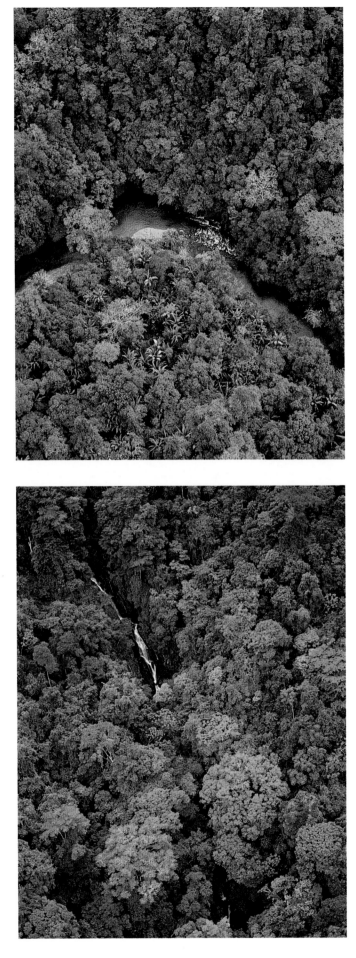

Los Saltos Range north of the Gulf of Cupica, Chocó.

Headwaters of the Peye River in Los Catíos Nature Preserve Chocó.

Tilupo Cascade in the Los Catíos Nature Preserve, Chocó. 55

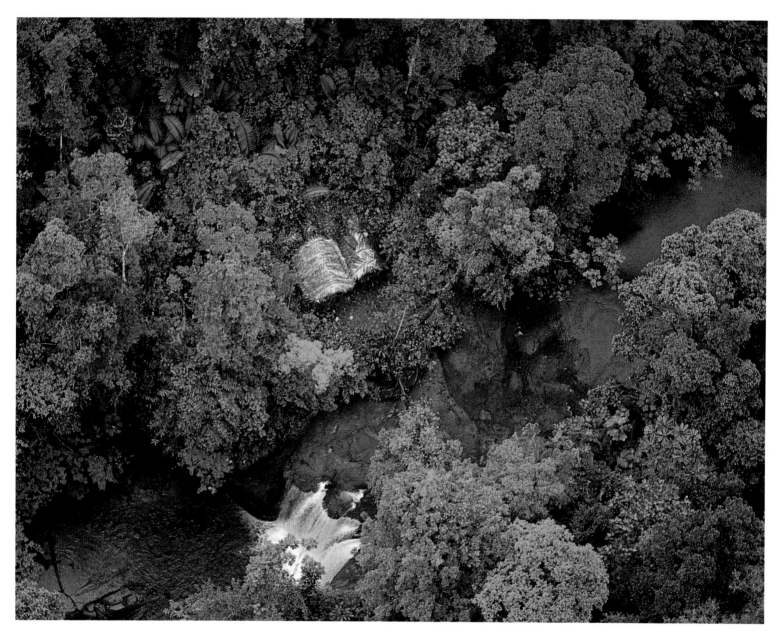

Native dwelling facing the falls of the Zabaletas River, Valle del Cauca.

Natural palm grove in the Darién region, Chocó.

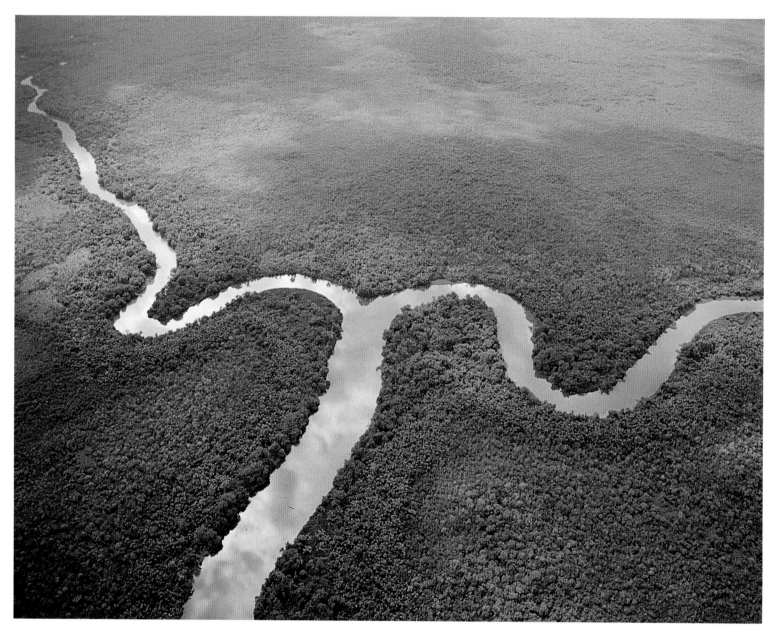

Brazo León north of the quagmire of Tumaradó, Chocó.

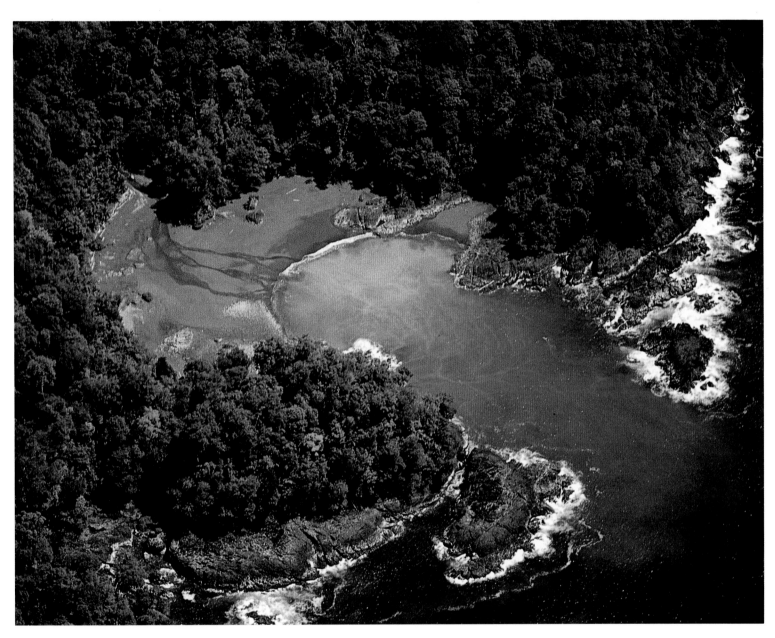

Beach in the Cabito area of Utría Bay Nature Preserve, Chocó.

Marzo Point north of Octavia Bay, Chocó. ↻

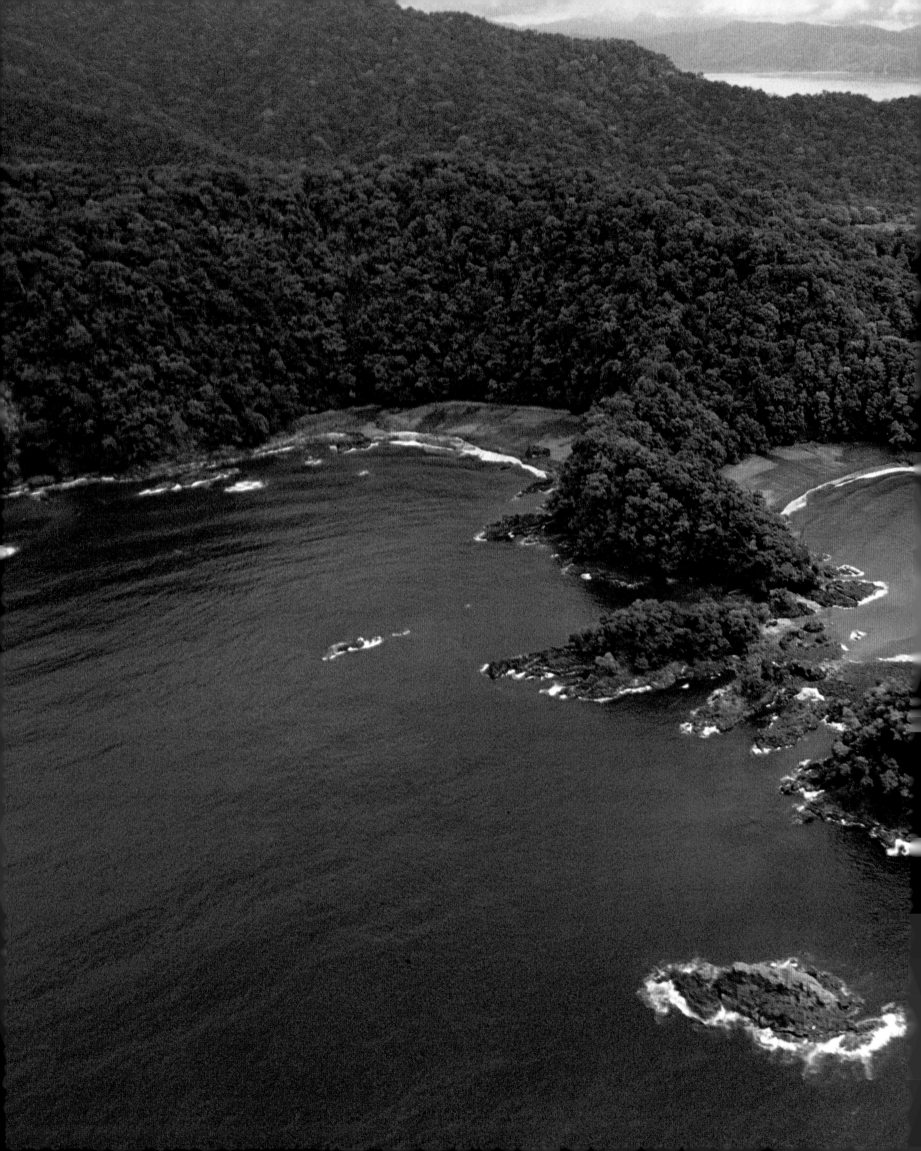

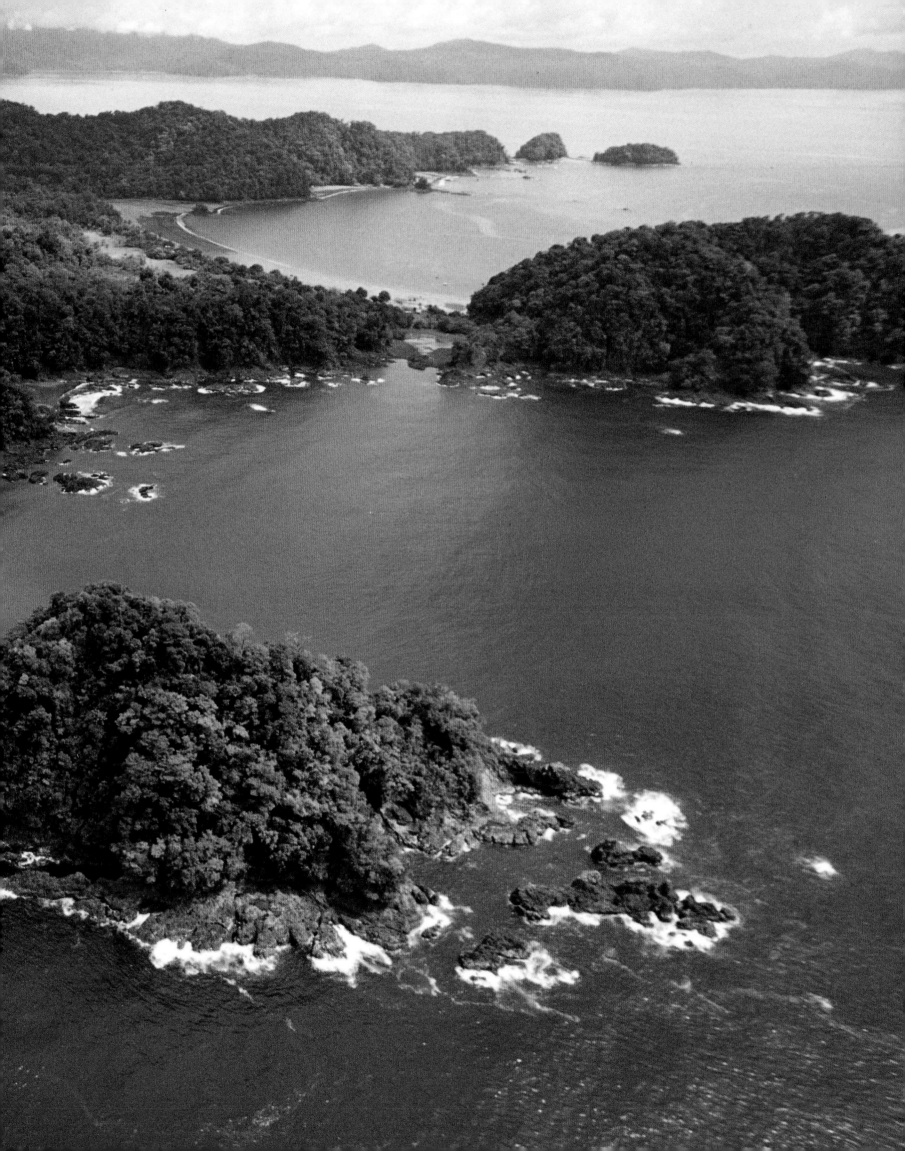

Pelicans and cormorants on an island of sand at the mouth of the Salahonda, Nariño.

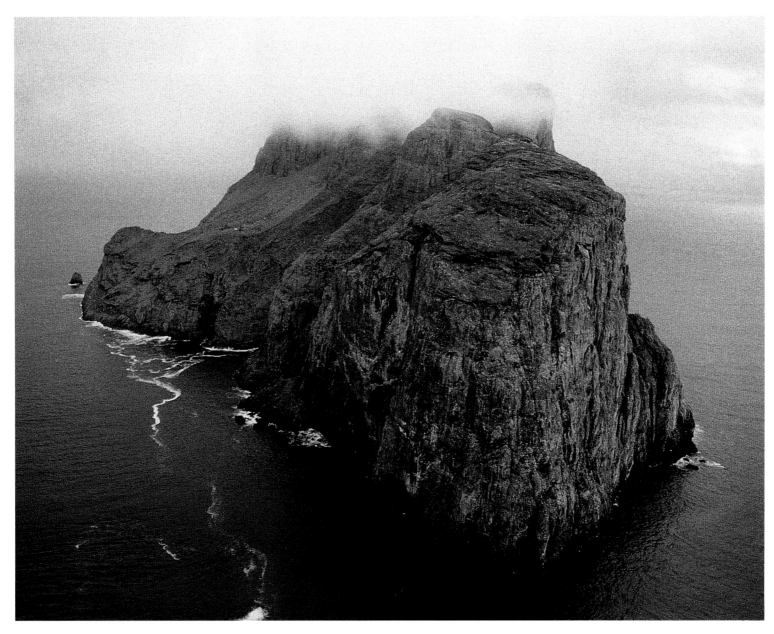

Ocean island of Malpelo at the westernmost limit of Colombia.

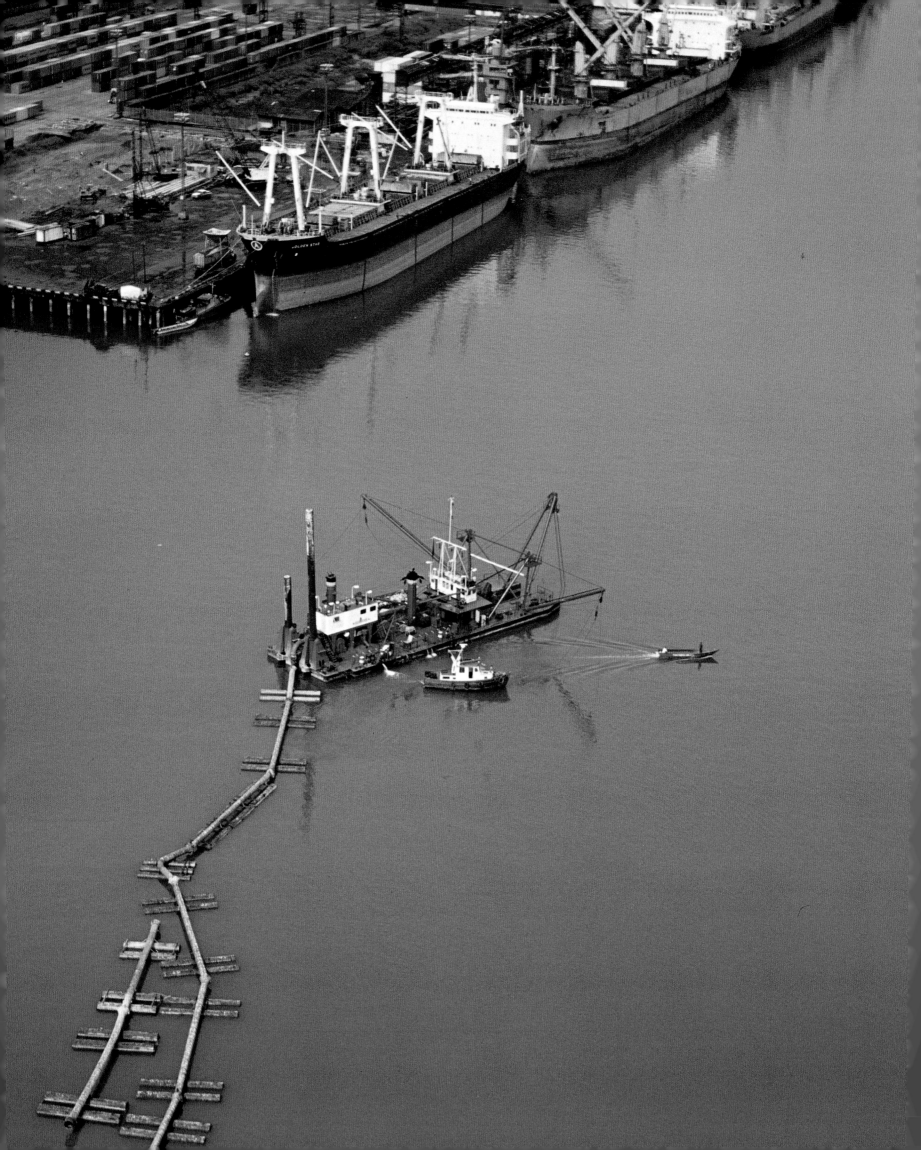

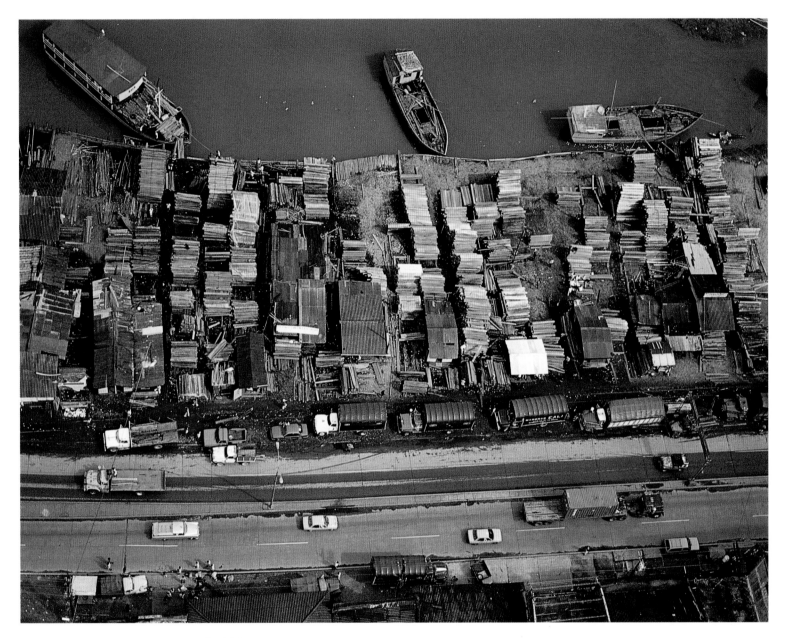

Distributing wood at Buenaventura, Valle del Cauca.

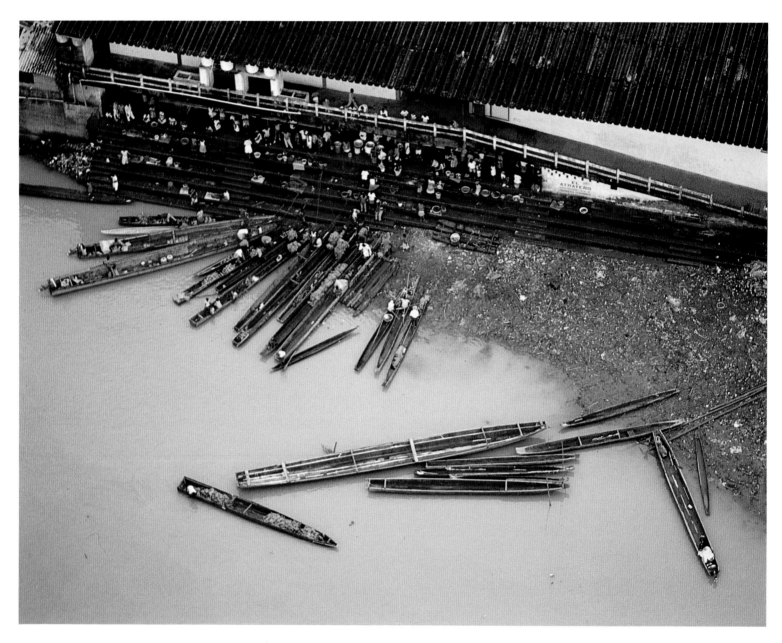

Market on the bank of the Atrato River, Quibdó, Chocó.

Town and beach of Bahía Solano, Chocó.

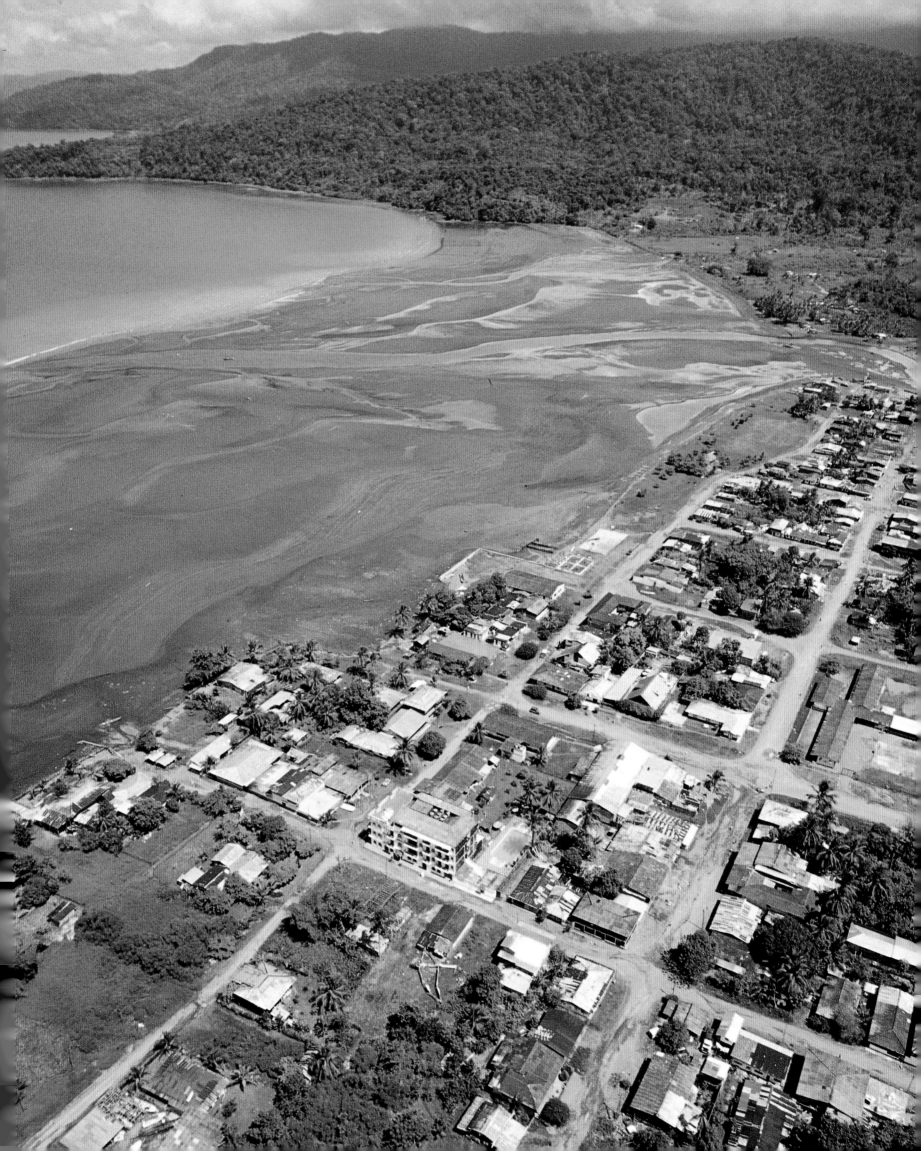

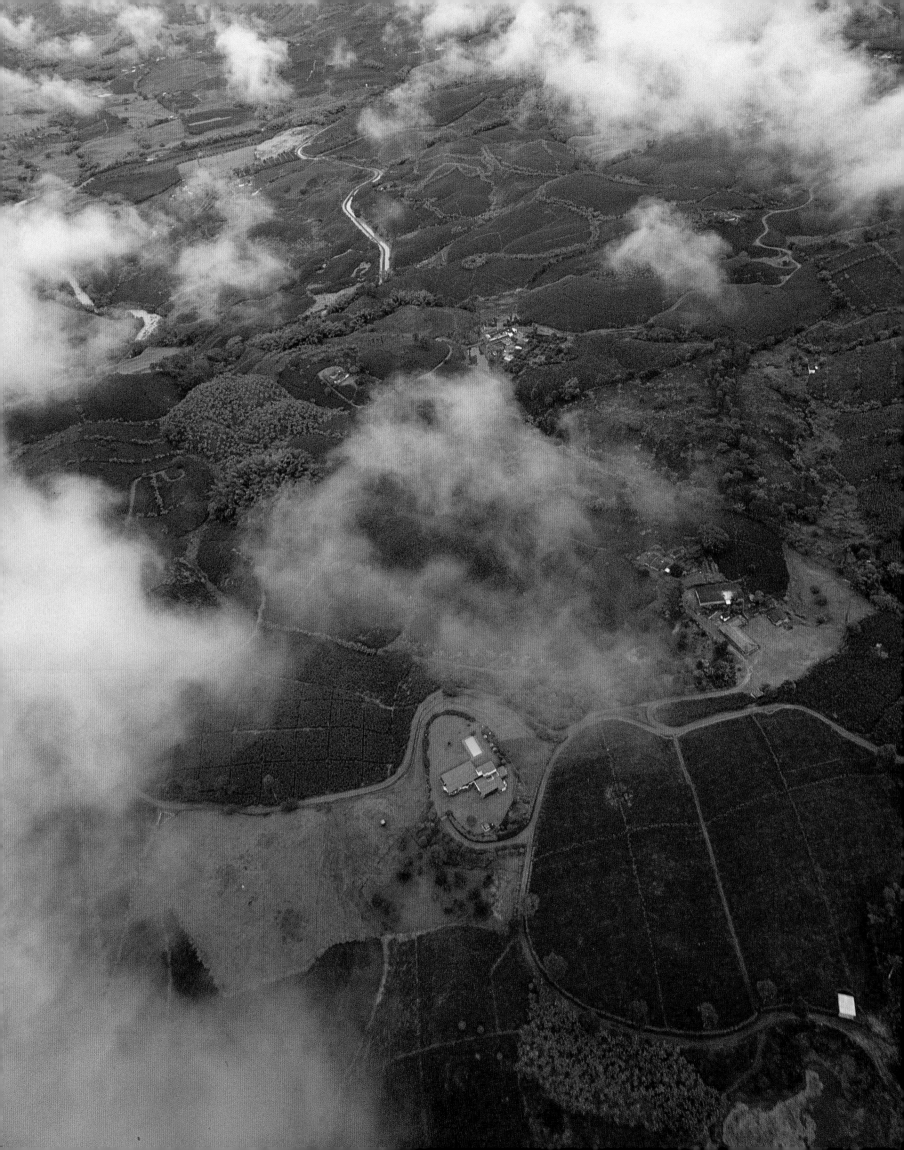

COFFEE-PRODUCING ZONE

ANTIOQUIA

MEDELLIN

CALDAS

MANIZALES

RISARALDA

PEREIRA

QUINDIO

ARMENIA IBAGUE

TOLIMA

O ne human group without which the present face of Colombia would defy ex-planation is the *paisas*. Two examples will suffice to describe the spirit behind what has become known as the "*paisa* rhythm." It is said that in Mexico City, in Garibaldi Square, one would be hard-pressed to find a *mariachi* ensemble without at least one or two *paisas*. And that in Egypt you will find a *paisa* who rents camels to tourists in the very shadow of the Pyramids... *Paisa* culture has its roots in the Department of Antioquia, covers the Departments of Caldas, Quindio and Risaralda, exerts its influence on Tolima, and reaches as far as Sevilla and Cartago, in the north of Valle Department ❑ In the sixteenth and seventeenth centuries the economy of Antioquia was bound up with the exploitation of gold. (Platinum was thrown away because no one could see any use for it or any way of putting it into alloys.) Zaragoza, Cáceres, Buriticá, Arma, Marmato, Remedios were extremely rich mining towns. In 1616 San Lorenzo de Aburrá is founded, subsequently to be called Villa de Aná, then Villa de la Candelaria de Medellín. Or simply Medellín. Deca-dence ensues in the eighteenth century with the exhaustion of the mining industry. In the nineteenth, on the other hand, after Colombian independence and the civil wars of the ear-liest days of the republic, the "mule drivers" appear. With long trains of heavily laden mules, the Antiochians go forth to conquer the cordilleras. They set up the Antiochian Railroad. The century's end finds them "clearing out jungle," sowing pasturage, founding cities and towns, opening up roads, laying out coffee plantations. In the socio-economic history of Co-lombia the phenomenon is known as "the Antiochian colonizing." In 1849, on the razor's edge of a hilltop, at a crossroads, Manizales is founded; in 1863, Pereira; in 1889, Armenia. These are the most important cities of the so-called "Old Caldas," a region divided up today among three departments–Caldas, Quindío and Risaralda. We are in the land of the

Coffee-growing zone of Chinchiná in the rainy season, Caldas.

Quimbaya Indians, contrivers of what some archaeologists have called "the most famous treasure of all pre-Hispanic craftwork in gold." ❏ The geography of Antioquia does not run to perpetual snows. Frontino Peak (in the Western Cordillera), the highest point in Antioquia, rises to over 13,000 feet. Out from the "Knot" of Paramillo, which reaches 12,800, extend the ridges of Abibe, San Jerónimo and Ayapel, the last gasps of the Cordillera of the Andes on the Caribbean plain. In contrast, Old Caldas and Tolima are a region of snow fields and volcanos: Nevado del Ruiz (Ruiz Snow-peak), 17,700 feet; the Snow-peak of Tolima, 17,300 (Tolima–or Dulima–means "land of snows."); that of Santa Isabel, 16,250. And on downwards: Quindío, the Nevado del Cisne (Snow-peak of the Swan), the Paramillo de Santa Rosa, the Machín Volcano, Cerrobravo (Savage Mountain)... The area is known as the Nature Preserve of the Snow-peaks ❏ On their slopes, made fertile over the centuries by "chimneys" that bring nutrients up from the bowels of the earth, is the land that produces fifty per cent of the Colombian coffee crop. The mountains themselves see to its irrigation. Among their glaciers and high tablelands, amid the mists and wax-palm trees of their forests, and in their *guadua*-palm groves arise the rivers that bathe both slopes of the Central Cordillera: the western, eminently coffee-producing, and the eastern, which drops away in the Department of Tolima into the broad Magdalena Valley, planted in cotton and rice, its soils enriched by periodic thaws and mud-flows. There, in 1985, a partial thaw of the Nevado del Ruiz came down 16,500 feet of mountainside in the Lagunilla river valley to carry away the then thriving town of Armero and its 20,000 inhabitants ❏ A couple of decades ago the coffee-producing zone felt the effects of a major change. Coffee bushes that had been set out under fruit trees, shade trees and banana plants, were replaced by "clean-growing," un-shaded plantings of coffee supposedly more profitable in the market but in fact incapable of protecting the waters, the animal life, the soil, the health of the ecosystems, and, in a word, the whole rural economy ❏ Even though in the Departments of Tolima, Caldas and Antioquia there are cities founded in the sixteenth century, the most typical mark of the cities of this region is their "youthfulness." Sixteenth century cities are Ibagué (the capital of Tolima), Anserma, Ambalema and Santa Fe de Antioquia. There are other historic towns like Mariquita, seat of the Botanical Expedition of the learned José Celestino Mutis at the end of the eighteenth century; and Rionegro, near Medellín, where in 1863 the Federal Constitution was proclaimed that created the United States of Colombia. But the characteristic tone is set by Medellín, with its skyscrapers, factories, floriculture industry–and its tango halls. All these cities keep redefining their identity, rebuilding, displaying themselves proudly as they grow, develop, and consolidate their strength in manufacturing, commerce and finance. The wood (*guadua*-palm) and the tin-plate characteristic of coffee-producing architectural style give way to buildings constructed of the newest materials. All of this carries the paradoxical imprint of *paisa* culture: at the same time machista and matriarchal; materialistic and sensual, yet religious; tradition-bound yet adventurous; puritanical yet ambitious; bold but conservative; unbuttoned but respectful; reverent yet merciless ❏

Colonial town of Santa Fe de Antioquia, Antioquia.

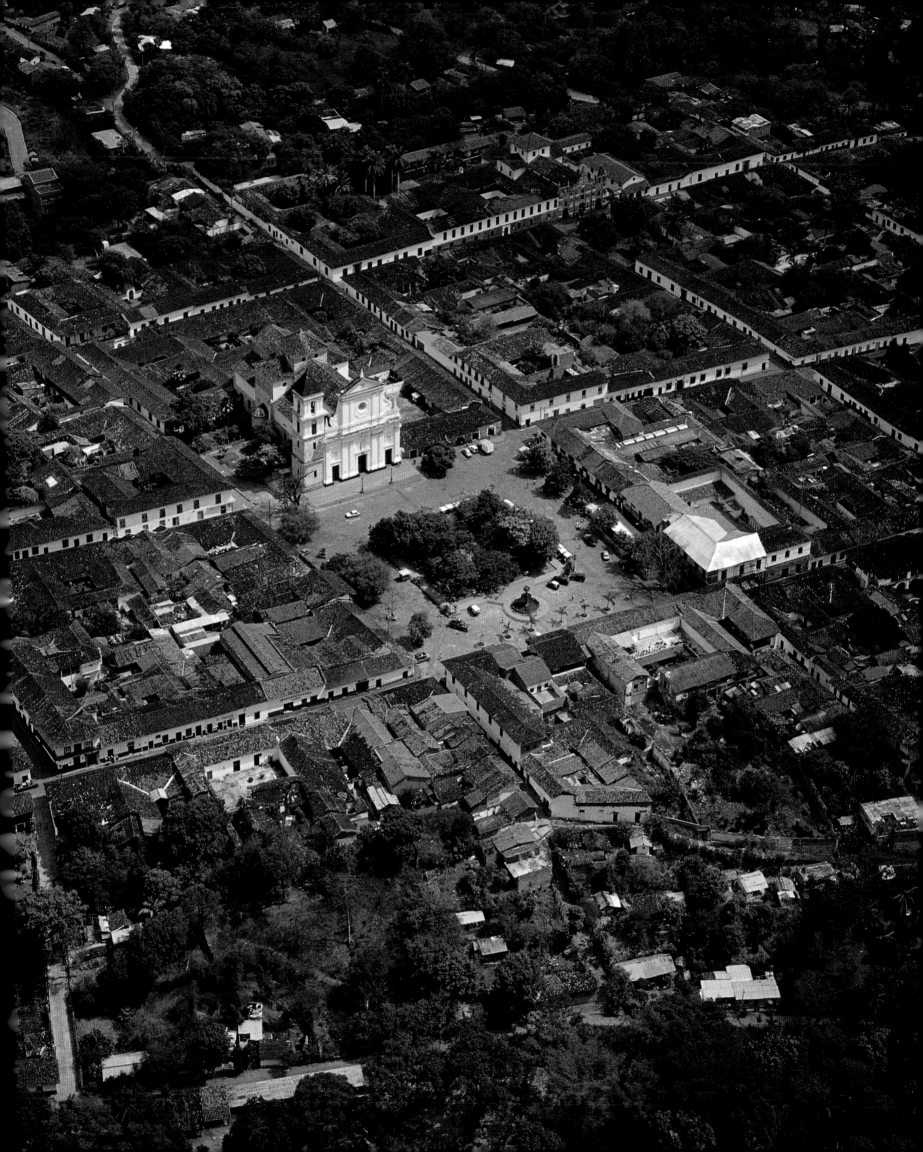

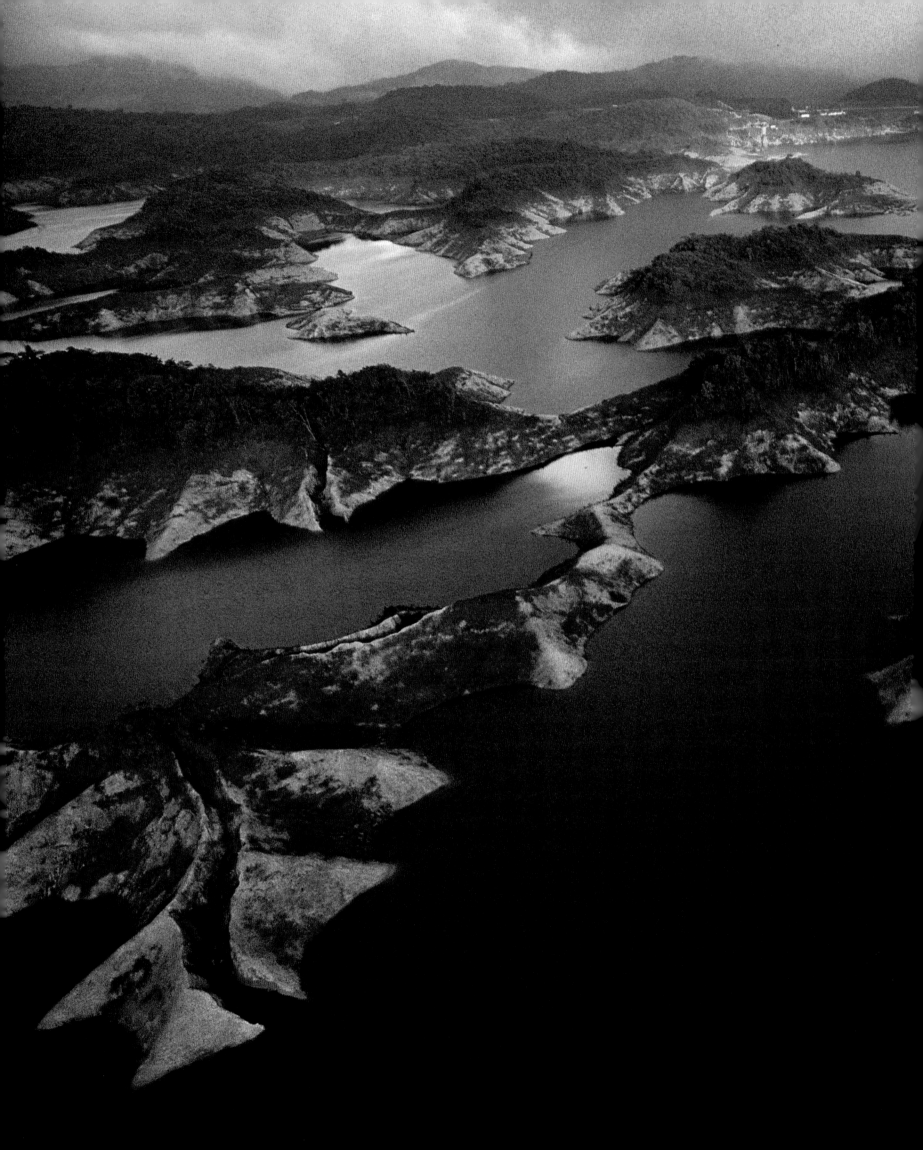

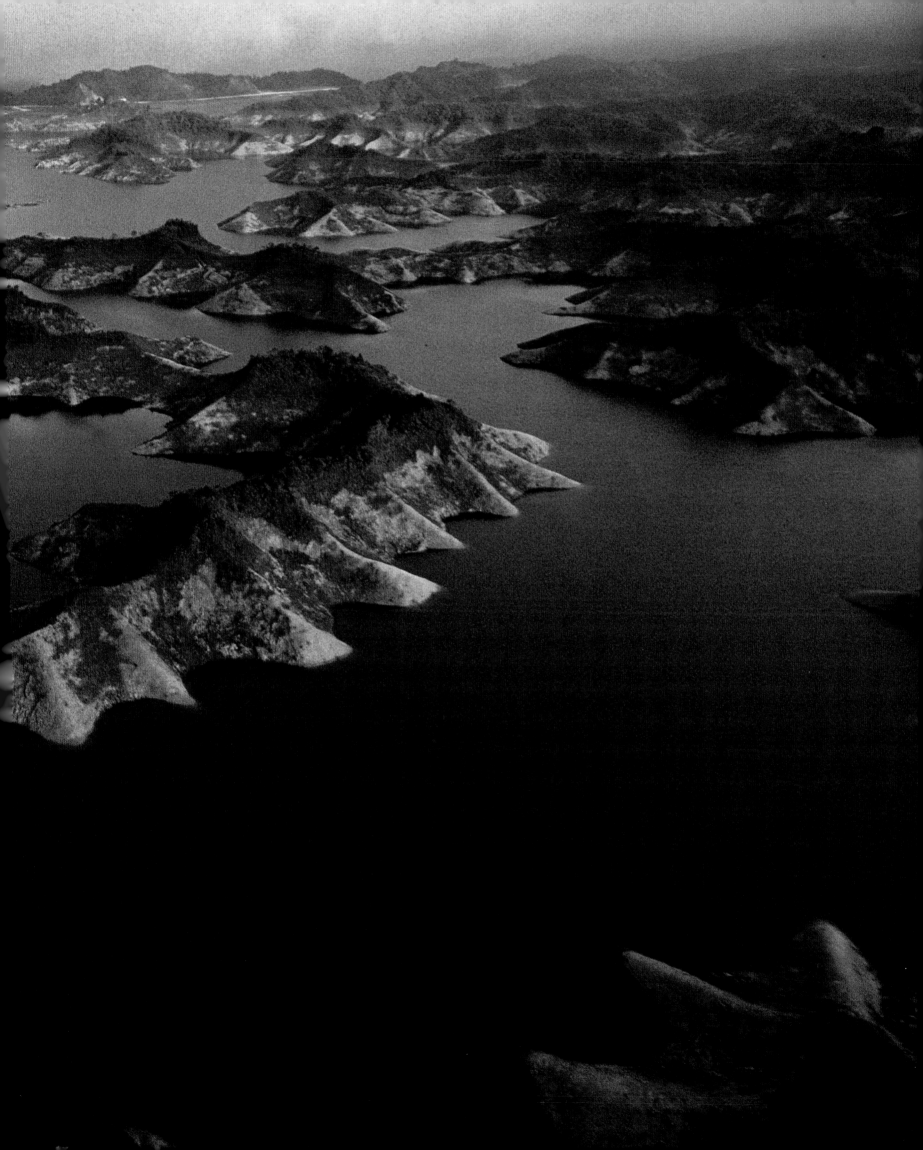

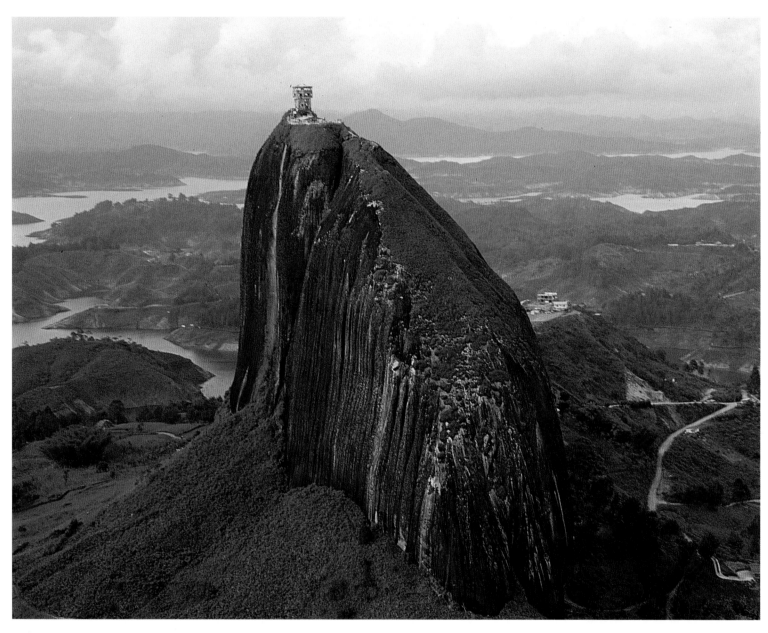

El Peñol Rock, tourist attraction at the edge of Guatapé Reservoir, Antioquia.

↺ Guatapé Dam east of Medellín, Antioquia.

Remnants of virgin forest, Marmato region, Caldas.

Stream bed covered over by forest and stands of bamboo trees in the coffee-growing zone of Manizales.

City center of Medellín, capital of Antioquia. ↻

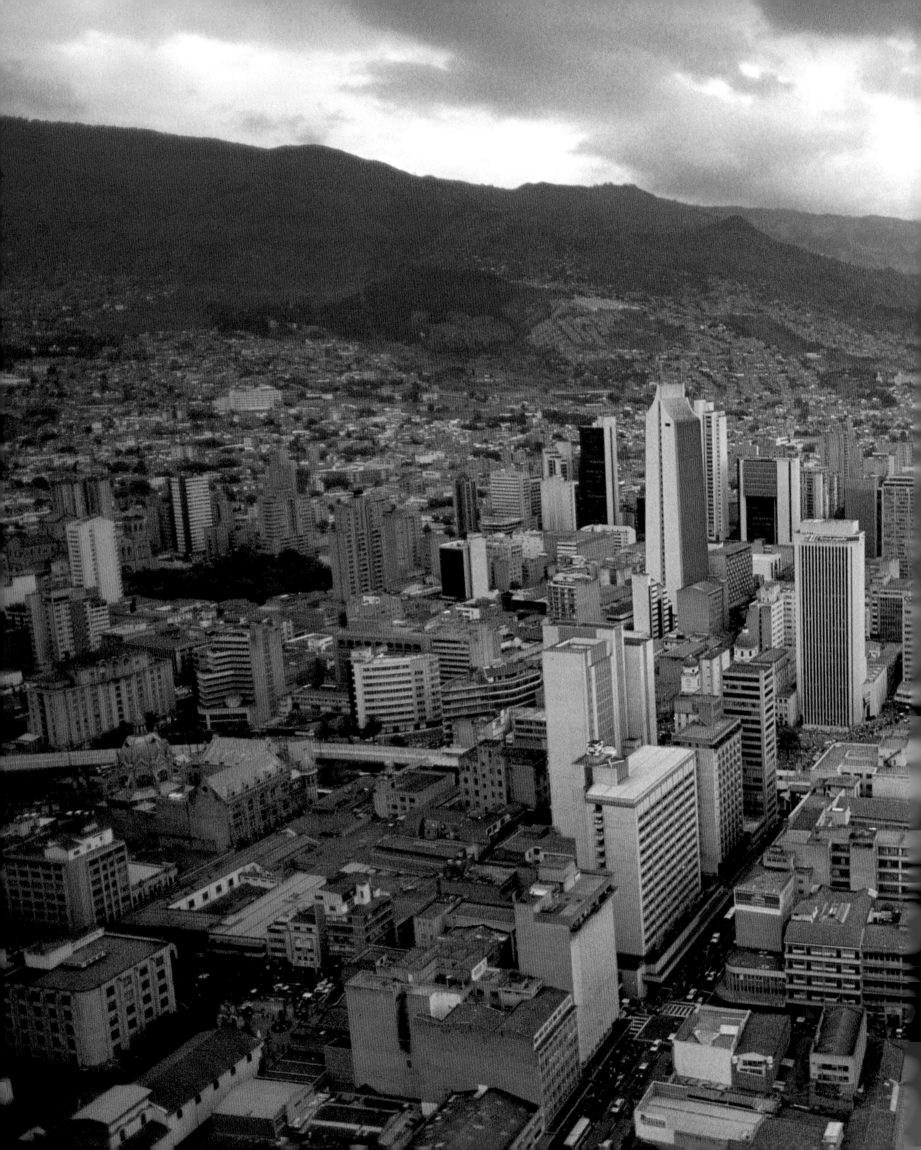

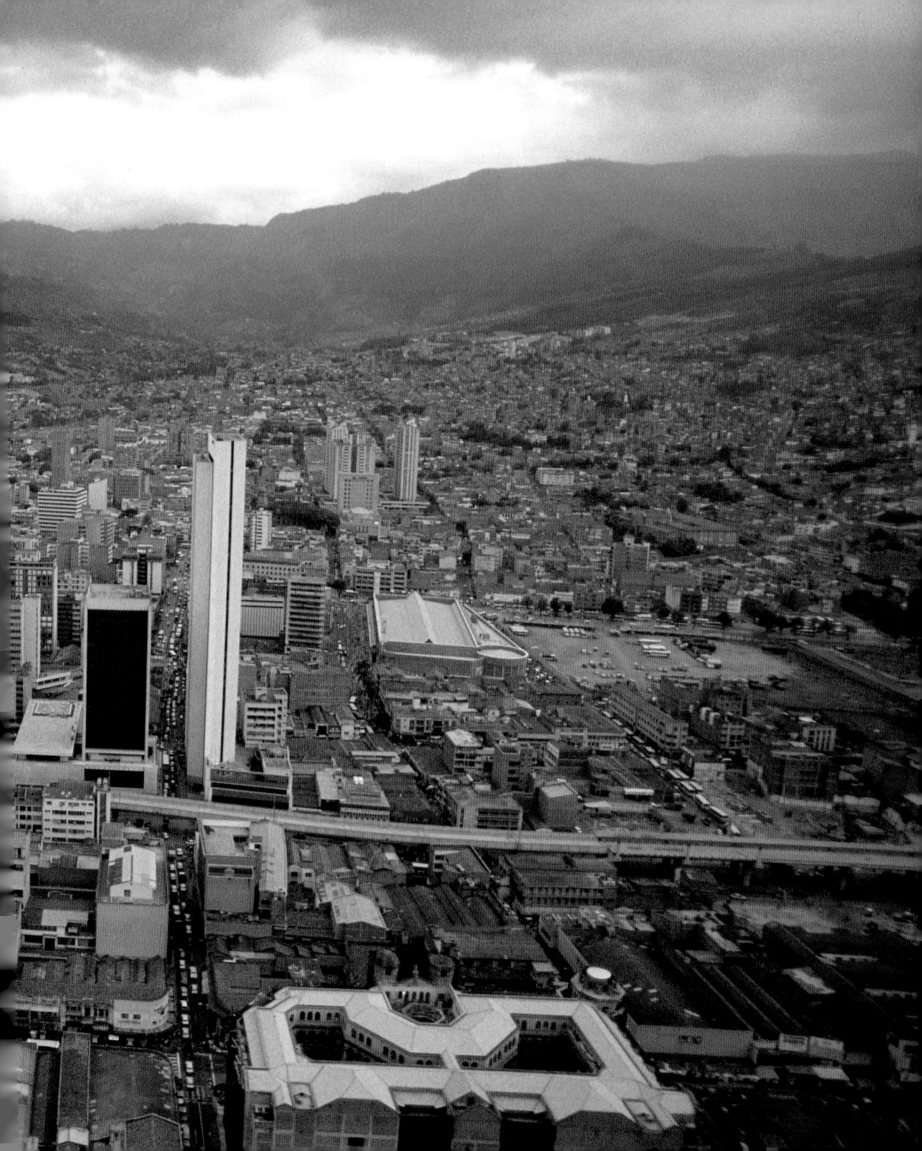

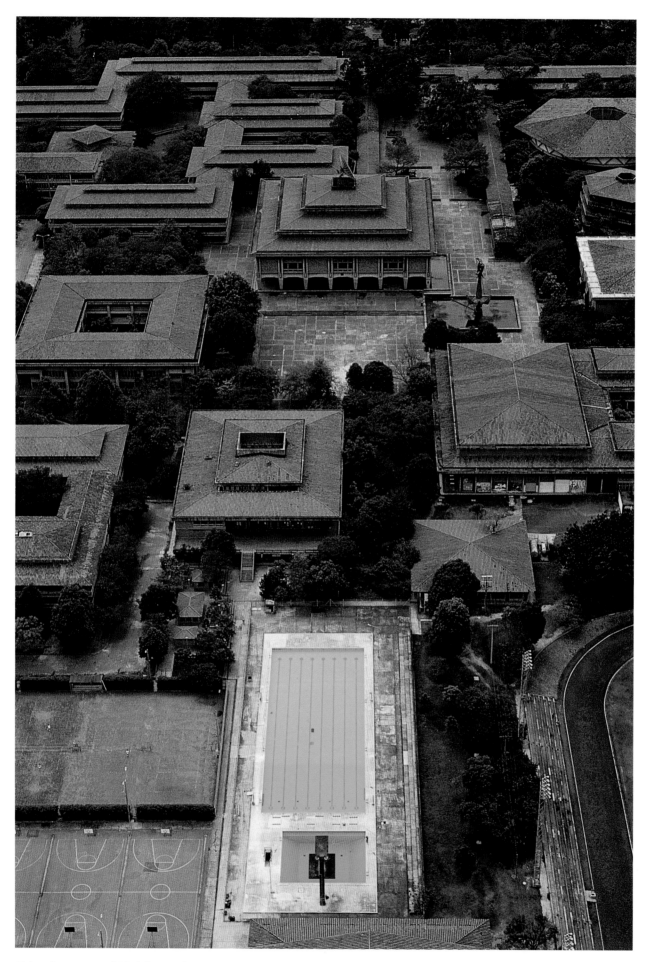

University campus of Medellín, Antioquia.

José María Córdova airport at Rionegro, Antioquia.

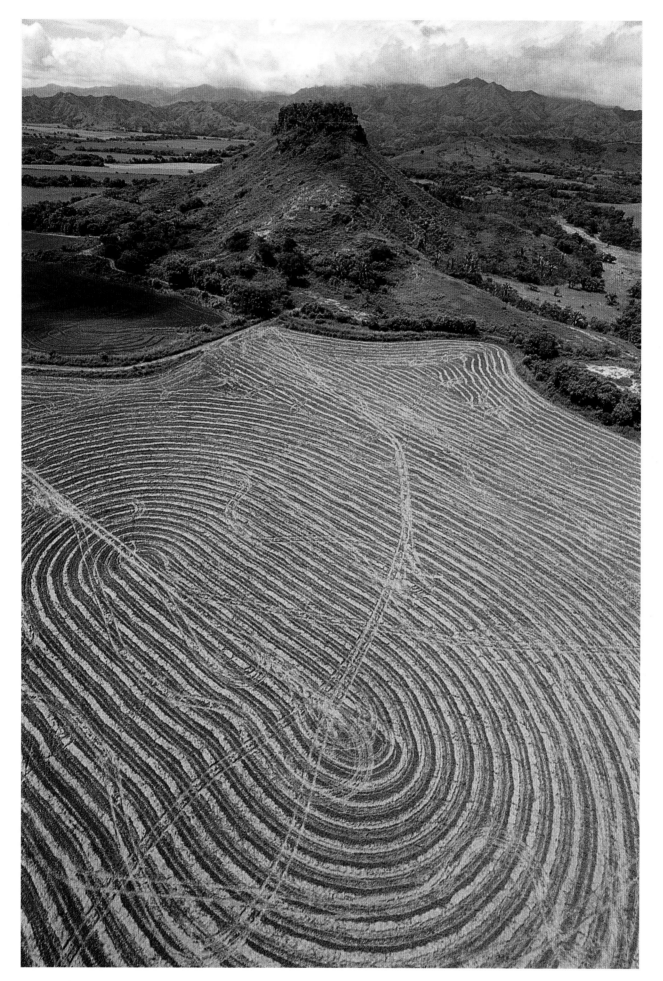

Land enriched and plowed for crops in Tolima.

Tolima, Santa Isabel and Ruiz snow peaks with the city of Ibagué, capital of Tolima. ⇨

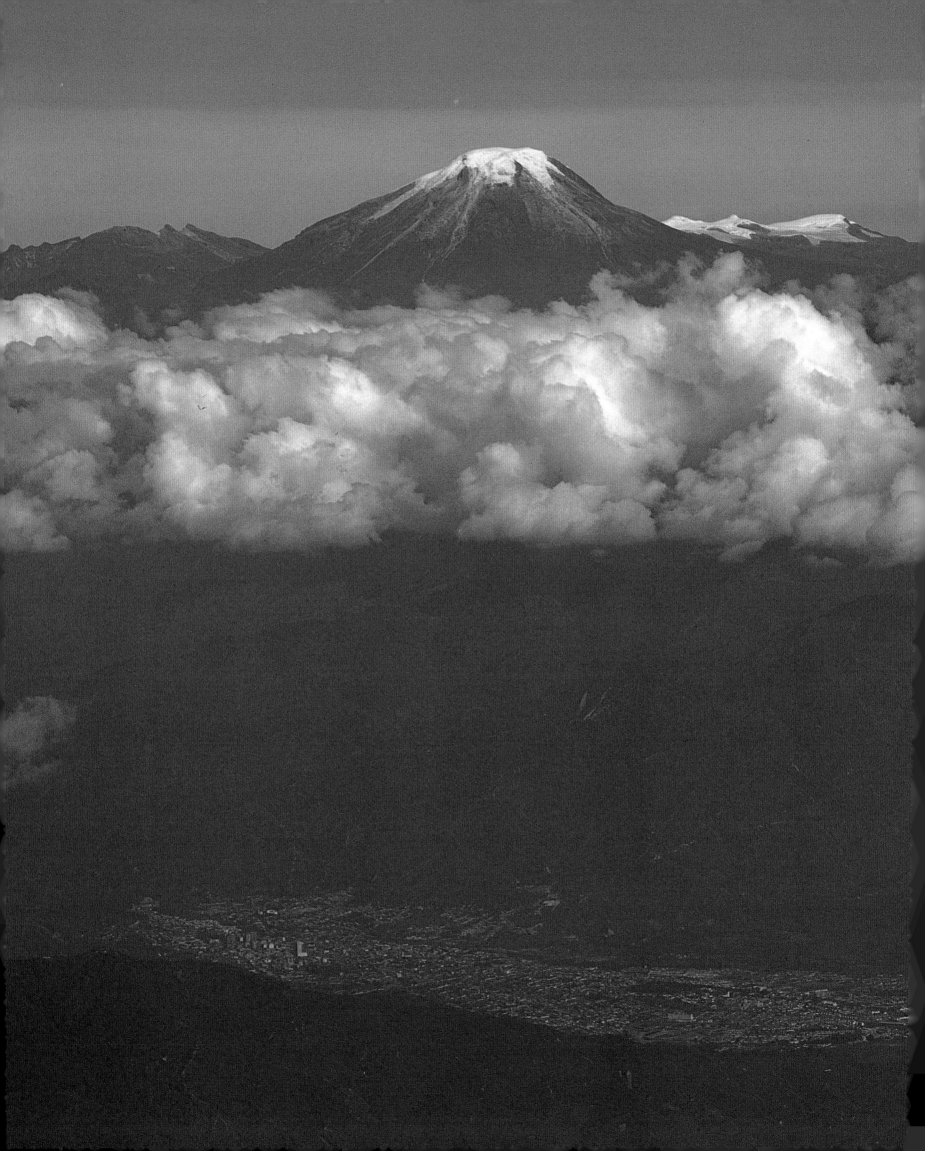

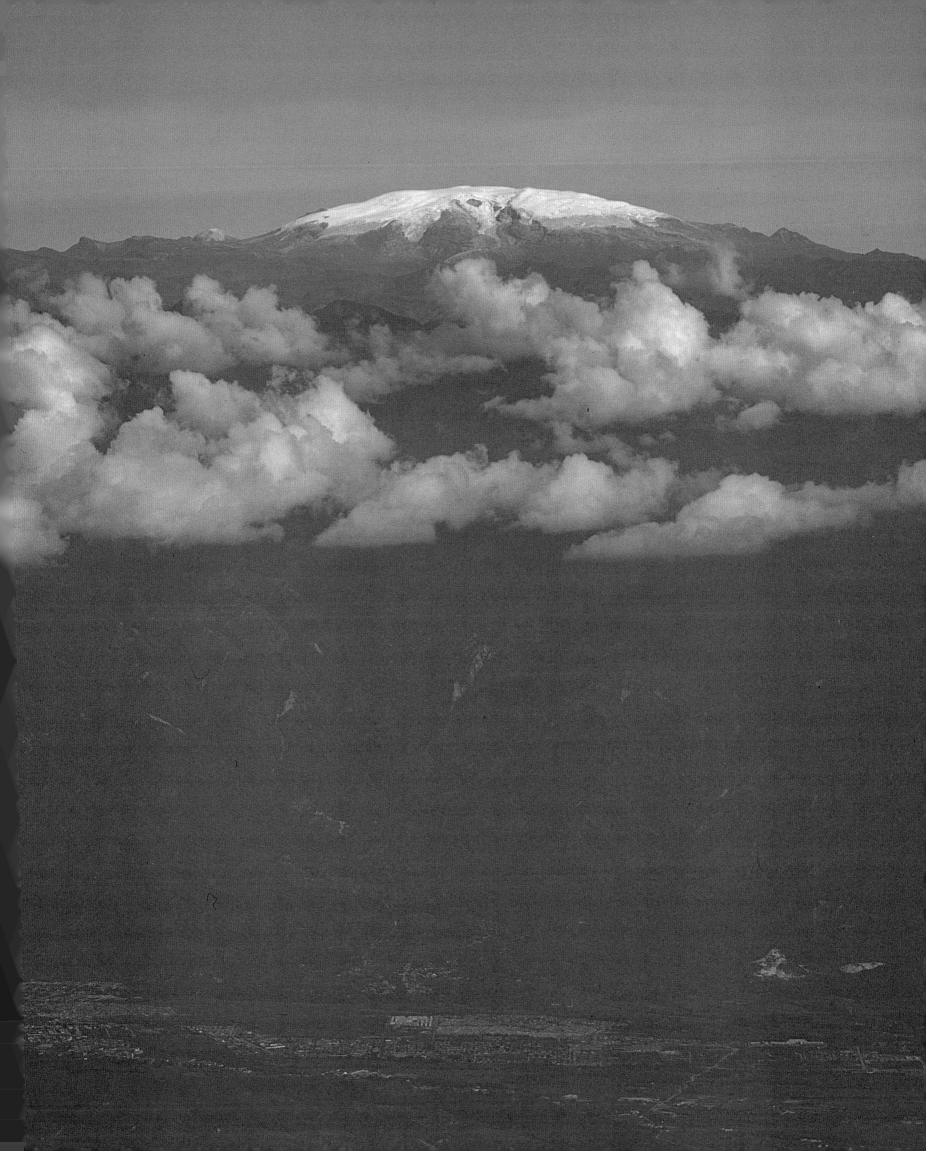

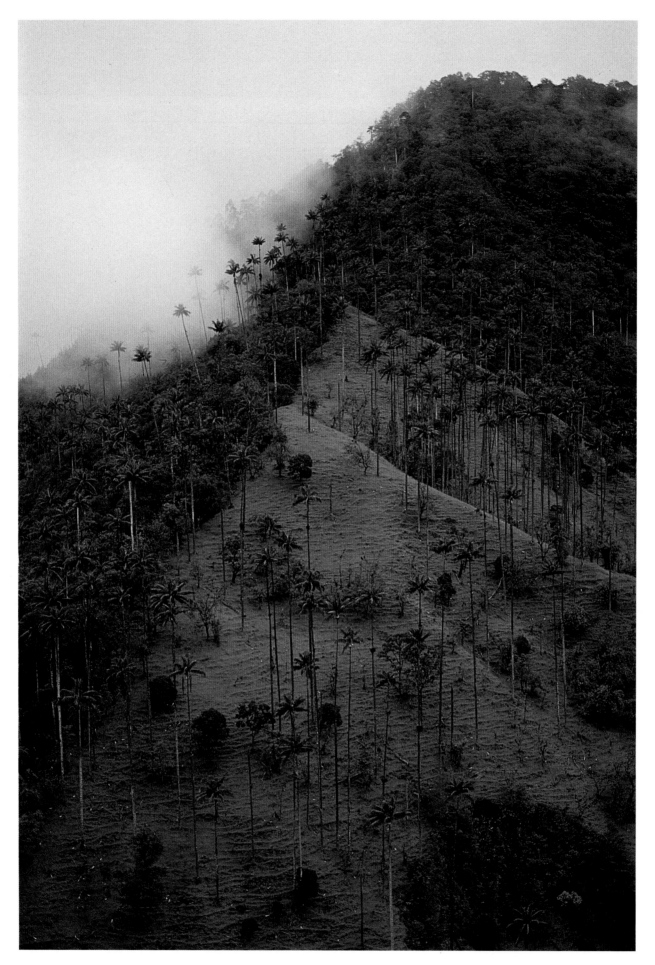

Wax-palms, national tree of Colombia, in Cocora Valley, Quindío.

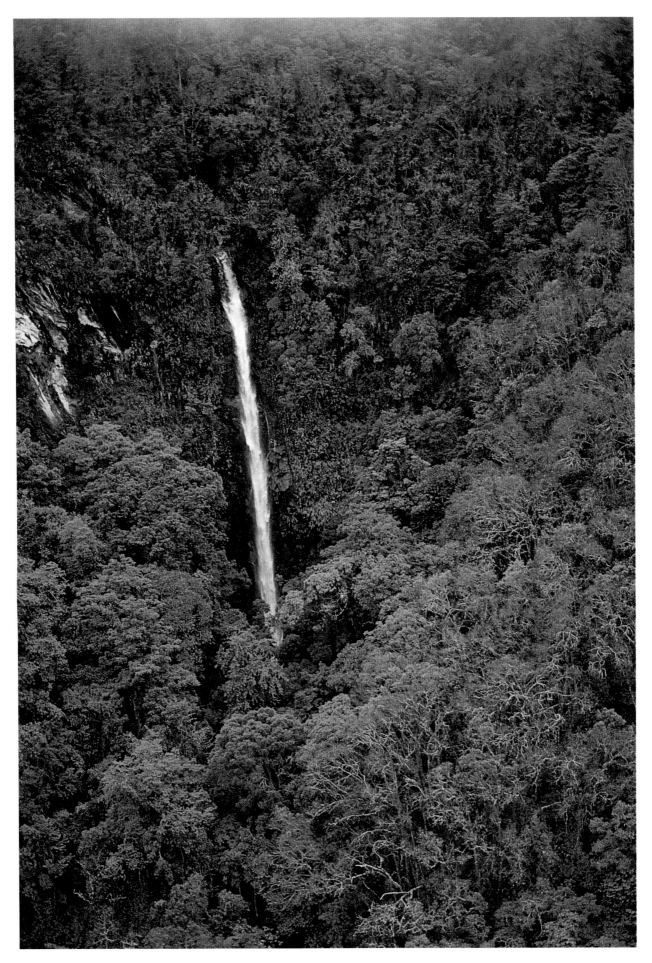

Andean forest north of Cocora Valley, Quindío.

Coffee-growing at Santa Rosa de Cabal, Risaralda.

Rural road between coffee and banana plantations north of Armenia, Quindío.

Cauca River in the zone of Pereira, Risaralda. ↻

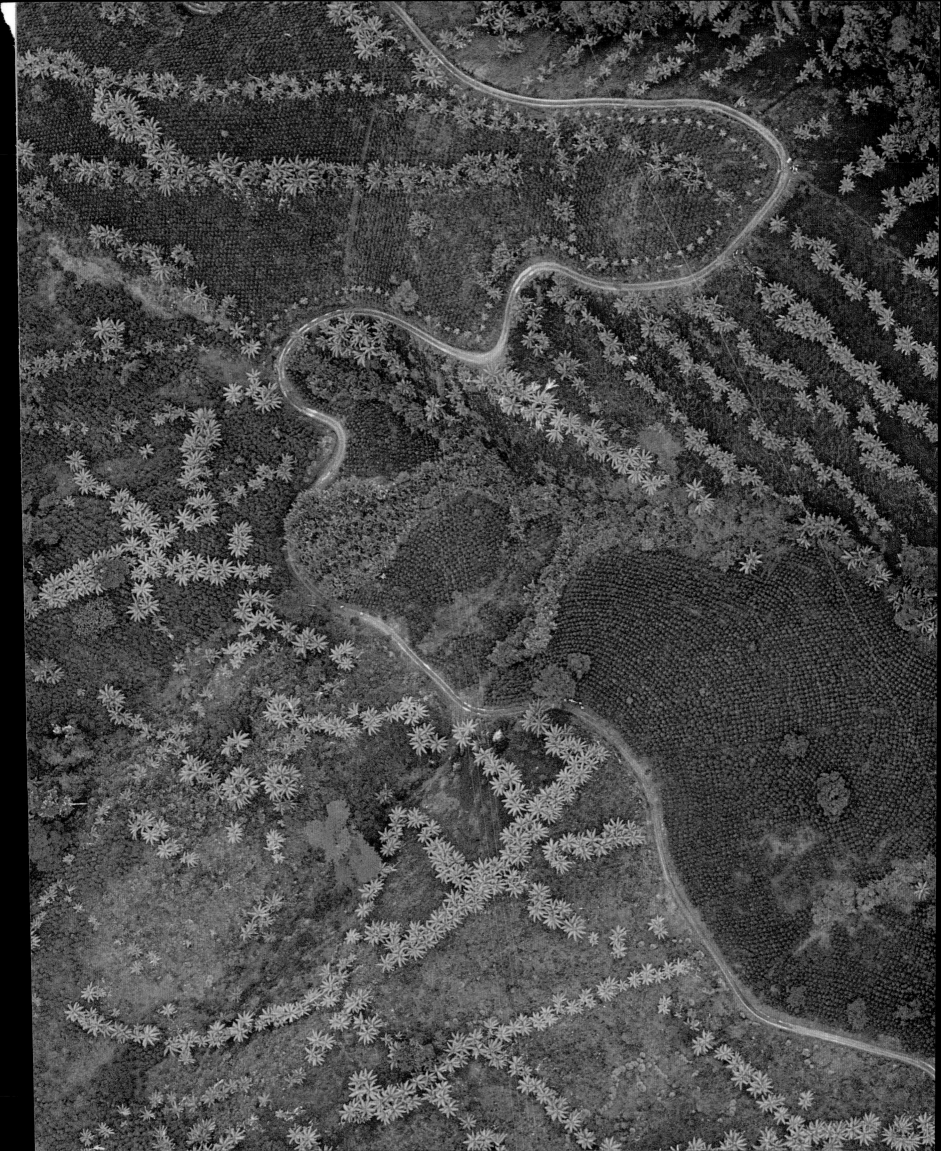

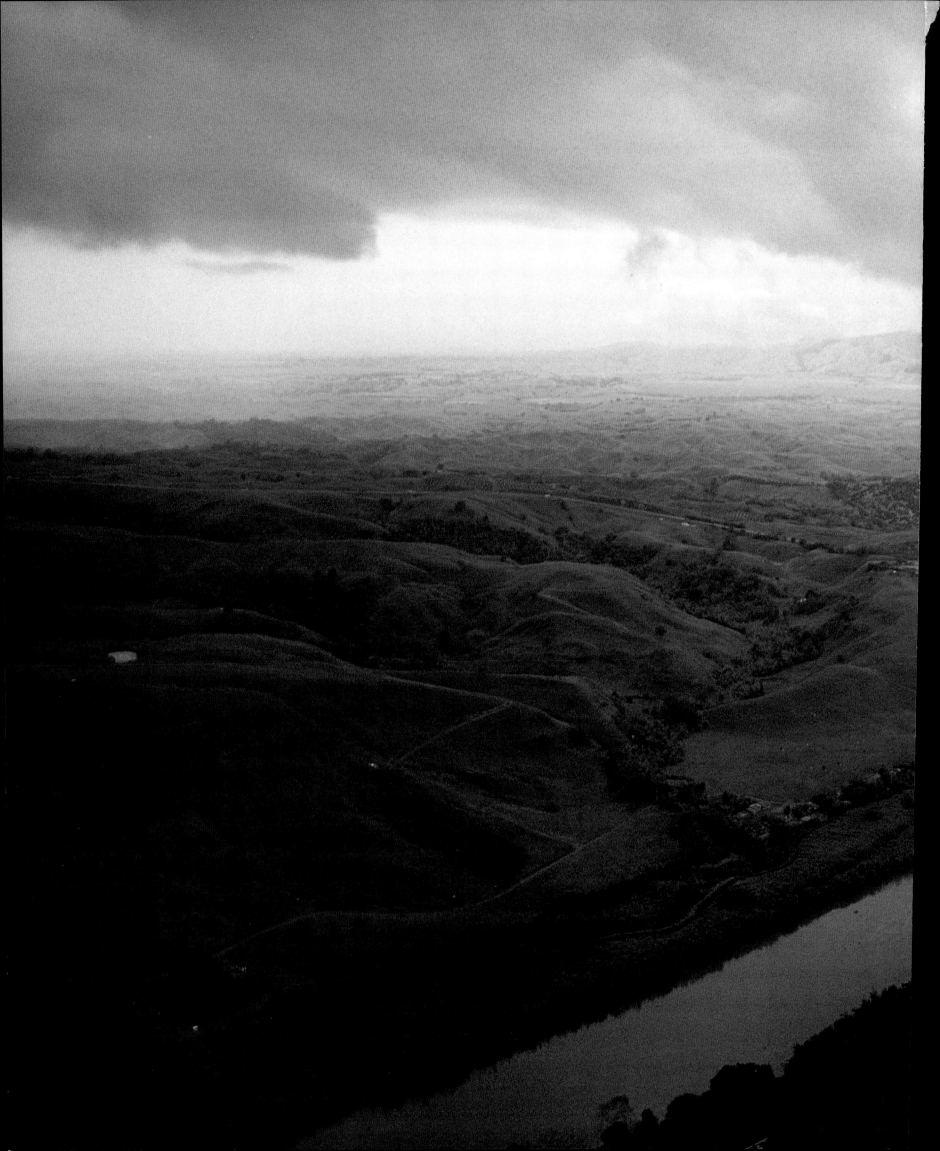

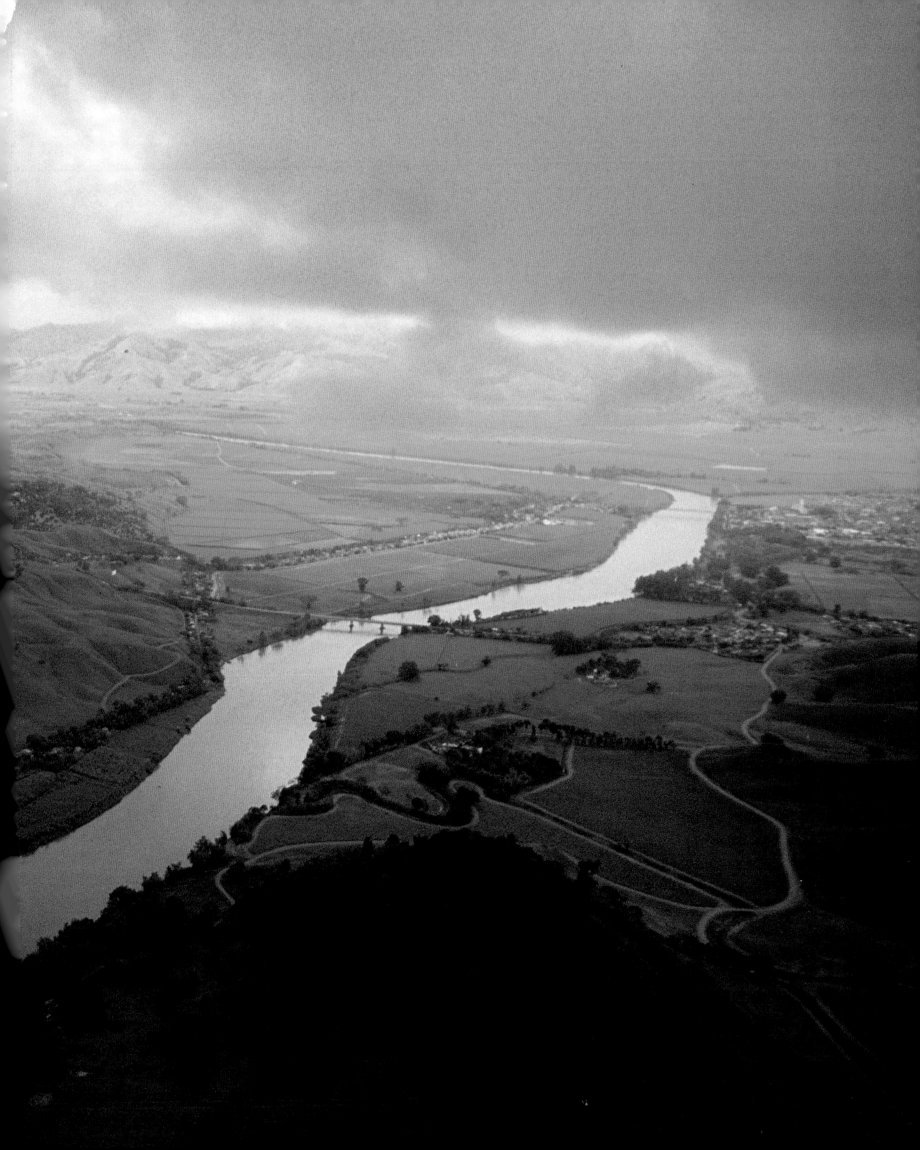

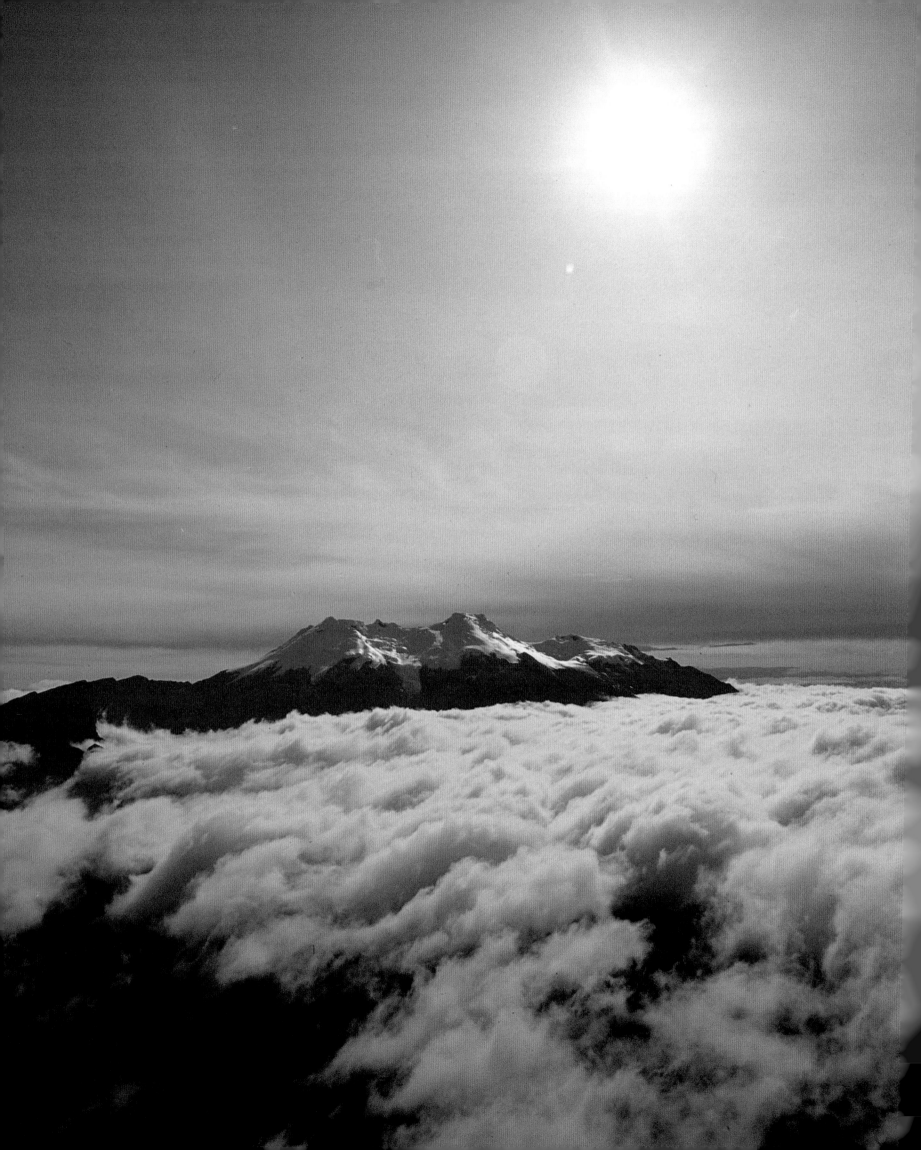

SOUTHERN ANDES

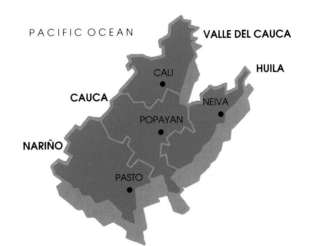

PACIFIC OCEAN

VALLE DEL CAUCA

HUILA

CALI

CAUCA

NEIVA

POPAYAN

NARIÑO

PASTO

After reaching heights of nearly 23,000 feet above sea level at Mt. Aconcagua, on the Chilean-Argentine border, and of nearly 20,000 in Peru and Ecuador, the Cordillera of the Andes enters Colombian territory as a compact rope. Almost immediately, at the Pastos "Nudo" (Knot), this range splits in two, forming, on the one hand, the Western Cordillera, and to the east, a branch which, further on, in the Colombian Massif, splits again into two ranges: the Central and the Eastern Cordilleras. Subsequently, each of these mountain chains, which together make up the Andean region of Colombia, splits again in two or three, like an orographic delta which descends and "empties" into the plain of the Caribbean and into the Lower Guajira, in the proximity of the Atlantic ❑ The Pastos Knot is in the Department of Nariño on the Colombian-Ecuadorian border. It is an agglomeration of volcanos–relatively small ones (between 14,000 and somewhat over 15,500 feet high) in comparison to the snow-covered volcanos of the Far South and of Ecuador. They are Chiles, Cumbal, Azufral and Galeras. The last is an active volcano in part "urbanized" by the city of Pasto–founded in 1536 by Lorenzo de Aldana in the fertile Atriz valley–which has been creeping up its slopes toward the vicinity of the crater ❑ Nariño is a department of fruitful and frigid plains, such as the Sabanas of Guachucal and Ipiales. One might claim them to be, in biblical terms, lands flowing with milk and honey. But this is a region as well of deep and bone-dry canyons, such as those of Juanambú and Guáitera. And of unbelievable feats of engineering like the highway suspended on an iron and concrete shelf at La Nariz del Diablo (The Devil's Nose) over a chasm on the road between Pasto and Tumaco. Nine thousand feet up, in Nariño, is located the greatest natural body of water in Colombia: Lake Guamés or La Cocha, which attains a depth of over two hundred feet and is some 37 miles long. Even the highway leading to this lake must drop into the Sibundoy

Dawn on the Huila Snow-peak, the best protected in Colombia.

Valley where the Kamsá, Inga and Kofán Indians live, and into Mocoa, capital of the Department of Putumayo, in the Amazon basin. In remote geological ages, the Doña Juana Volcano scattered precious stones over the Nariño-Cauca border region. A barren area is advancing dangerously upon the Patía valley. Fossils disclose that forty million years ago it was occupied by a sea ❑ Paradoxically, high in the Cordillera, not very far away, is located the "Fountainhead" (Ojo de Agua) of Colombia: the Colombian Massif, inhabited by peasants of mixed race and Yanacona Indians. There, at nearly 10,000 feet, rise the Cauca, Magdalena, Patía, Caquetá, Guachicono and Putumayo Rivers. Only twenty-five of the secretive lakes of the Massif have been christened. This is a region of high plateaux, of broad-leaved *frailejón* bushes, of beds of succulent mosses or *Sphagnaceae* ❑ The Cauca River descends from Mt. Cubilete (Flatiron Mountain), 10,750 feet high, to about 3,300 feet above sea level, where it forms a valley some nine to twelve miles wide and about 124 miles long between the Central and Western Cordilleras, in territories of the two departments that bear its name: Cauca and Valle del Cauca, the latter often shortened to Valle (Valley). Through a relatively short gorge the Magdalena River drops from the 11,000-feet elevation of the Lake of the Magdalena where it originates, to 1,300 feet at the Betania Dam, which holds it back before it goes through Neiva, the capital of Huila, a department of soils and subsoils propitious to rice and petroleum. There begins the valley that separates the Central Cordillera from the Eastern—the valley of the Magdalena. The Patía River empties into the Pacific after slashing its way through the Western Cordillera at Hoz de Minamá (Minamá Gorge) very close to the Pastos Knot. The Caquetá runs southward and flows into the Amazon in Brazil, with the name of Japurá ❑ North of the Massif, in the central Cordillera, rises a chain of volcanos: Sotará, Puracé, the Coconucos Range and, at the point where Cauca, Tolima and Huila Departments meet, the snow-covered Huila Volcano (18,860 feet), the highest peak in the Colombian Andes. When the Spaniards reached what are now the Huila and Cauca Departments, they encountered the Pijao, the Timaná, the Yalcón, the Páez and the Guanaca Indians—warlike tribes, some of whose descendents still view present-day whites and mestizos as the conquerors of four hundred years ago. In the archaeological preserve of San Agustín in Huila, the most important center of pre-Columbian statuary in this part of South America, datings have been made ranging from 550 B. C. to A. D. 1180. At Tierradentro (Cauca) hypogees—underground burial chambers cut into the volcanic rock—have been dated from the seventh to the ninth centuries. When the Europeans arrived, there was no sign of the builders ❑ In this region, close together, are found two contrasting cities: Popayán, capital of Cauca, situated in the Pubenza valley with the Puracé volcano on the east and Mt. Munchique on the west; and Cali, capital of Valle, both of them founded by Sebastián de Belalcázar. In a period not too far back in history, half of Colombia was governed from Popayán. Still to be seen today are the great houses, the churches, the enormous cloisters which successively have been convents, barracks, universities... Cali, the most important center of the regional economy, with its million and a half inhabitants, is a coastal town that, through some aberration of geography, has its sea two hours away. Straight out of the completely level plain on which Cali lies, a plain planted in sugar cane and other large-scale crops for several surrounding miles, rise absolutely vertically, or so it seems to the eye, the Farallones, "headlands" over 14,000 feet high. Valle is a department of cities: Palmira, Buga (near which the Calima culture flourished), Tuluá, Buenaventura on the Pacific coast, and Cartago in the transitional zone toward Old Caldas. On the barren plain of Las Hermosas rise the waters that freshen the Tolima-Valle border area ❑

Crops in the Magdalena Valley on the banks of the Betania reservoir, Huila.

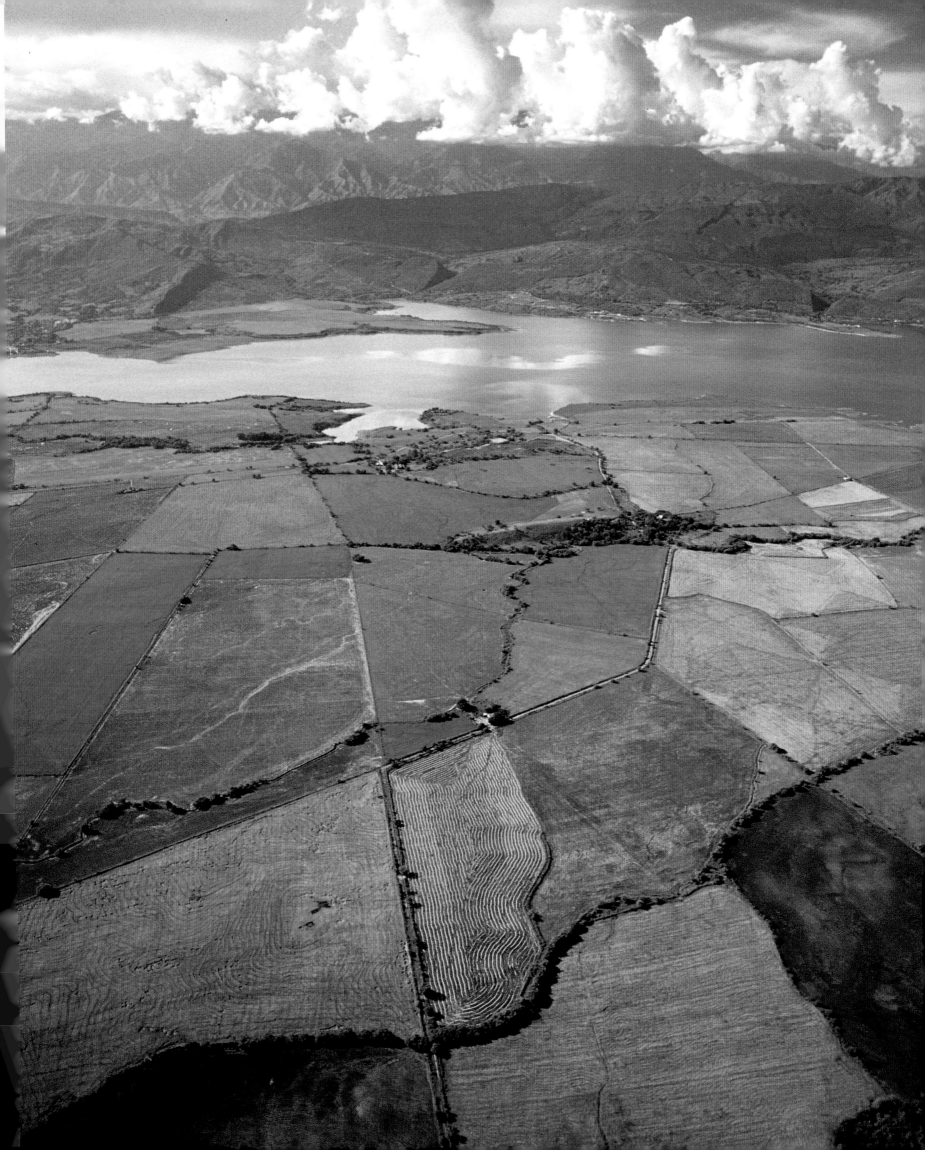

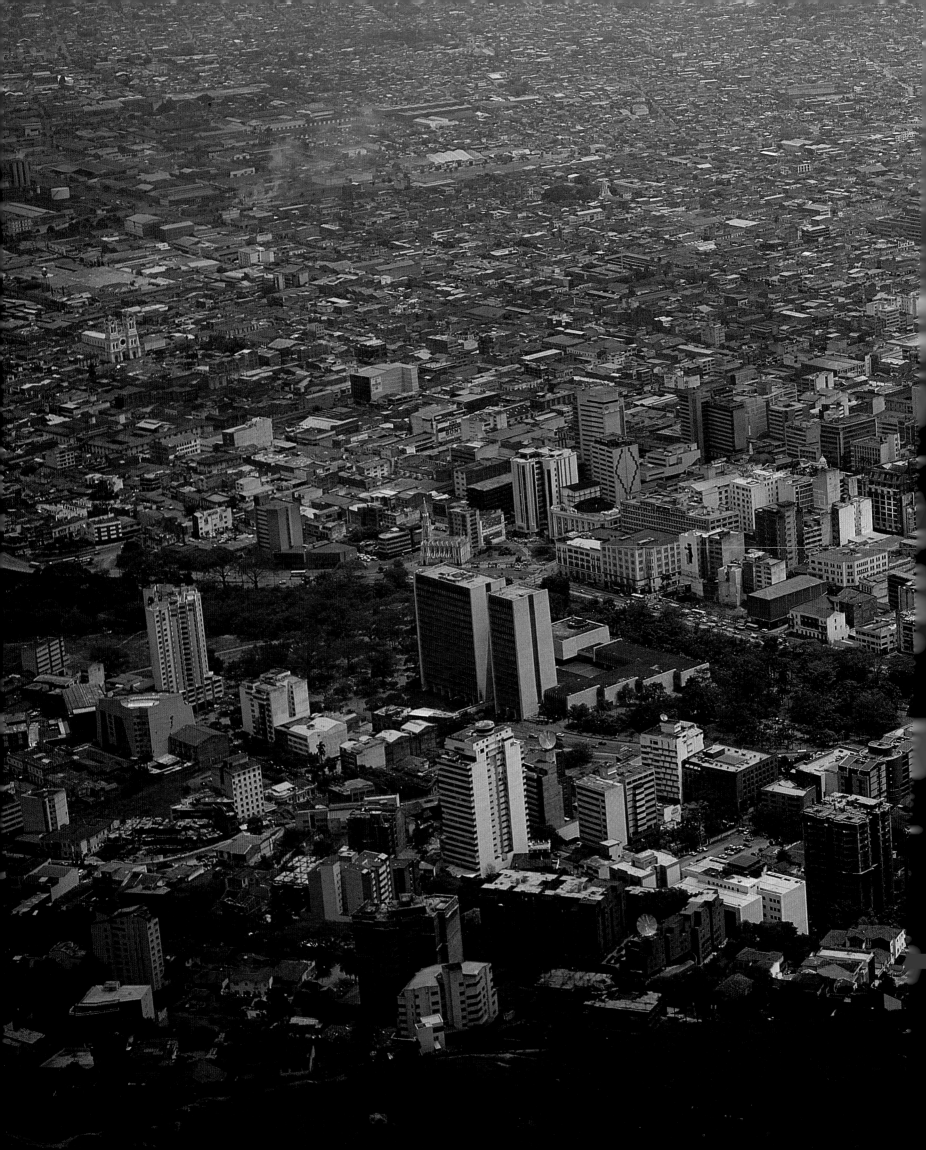

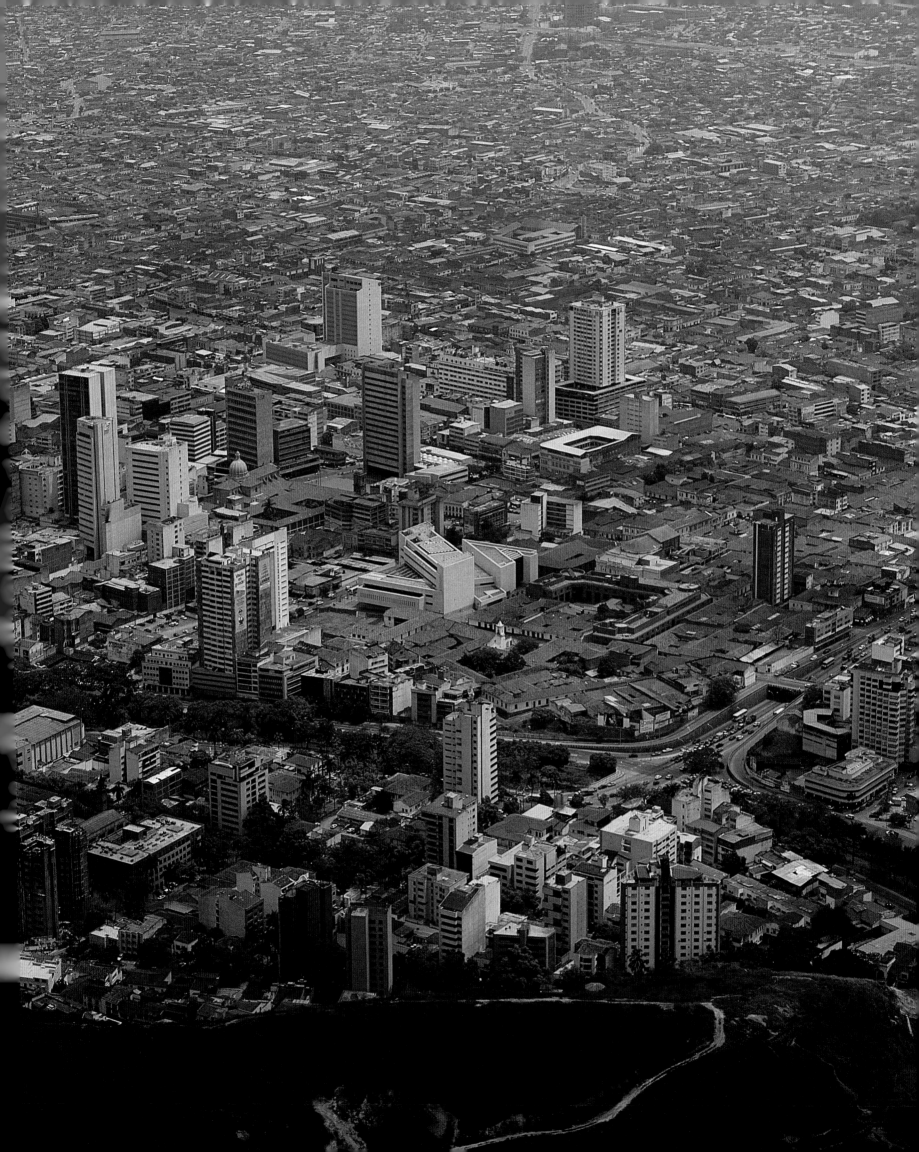

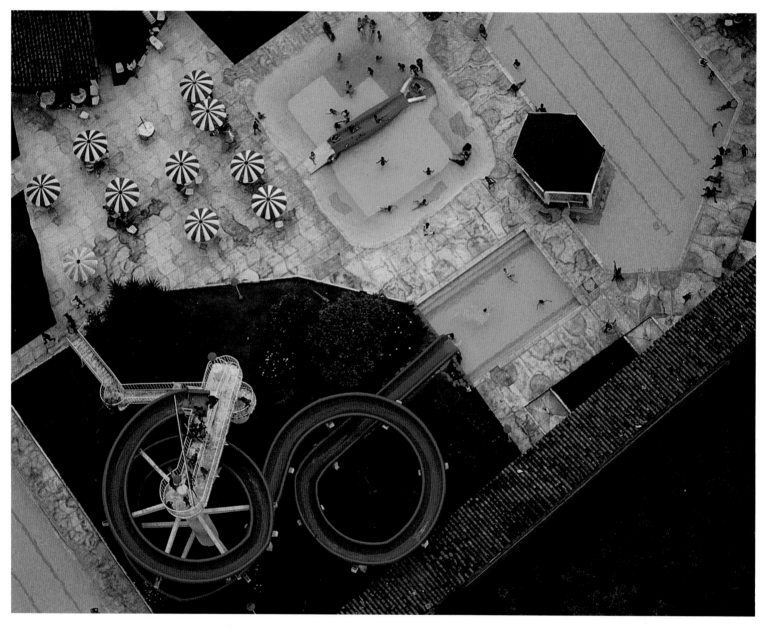

La Caña Recreational Park in Cali, Valle del Cauca.

◌ The city of Santiago de Cali, capital of Valle del Cauca.

Industrial zone of Yumbo on the banks of the Cauca River, Valle del Cauca.

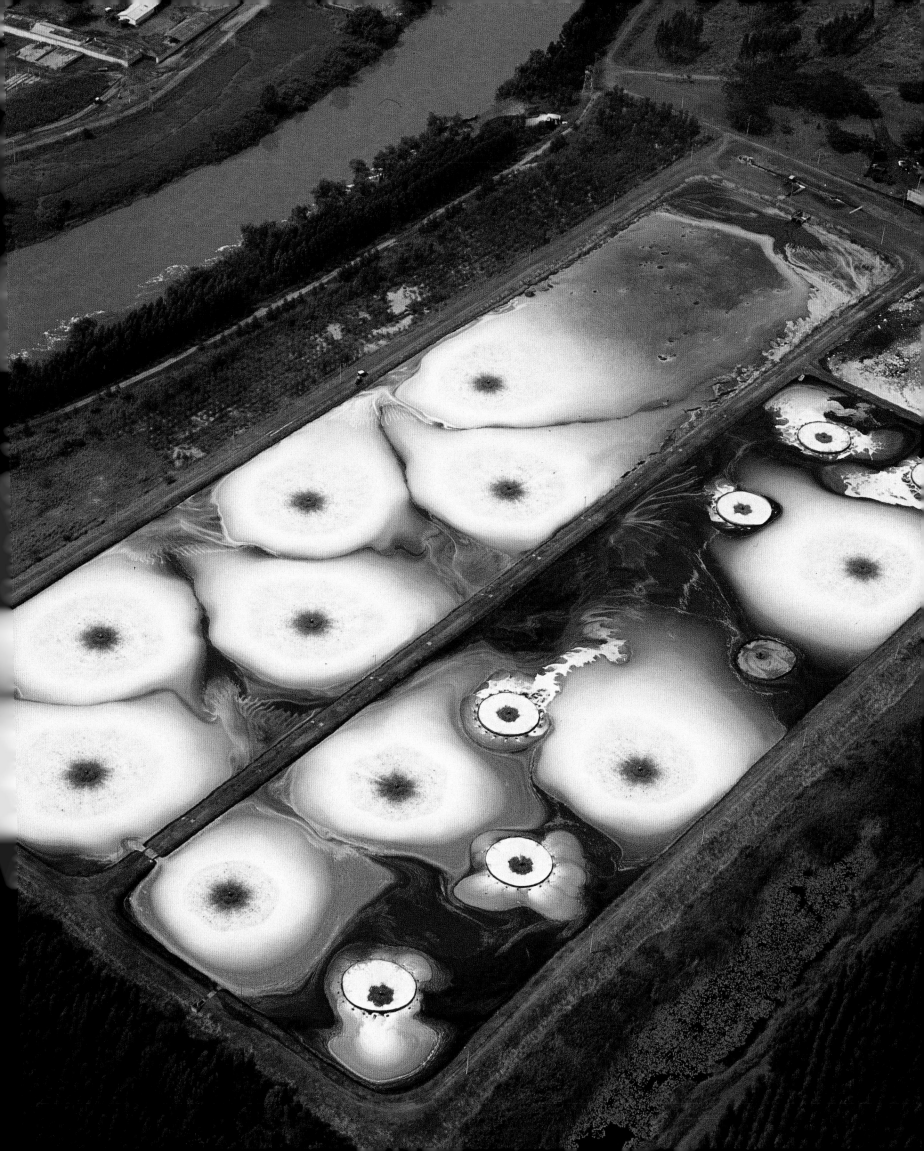

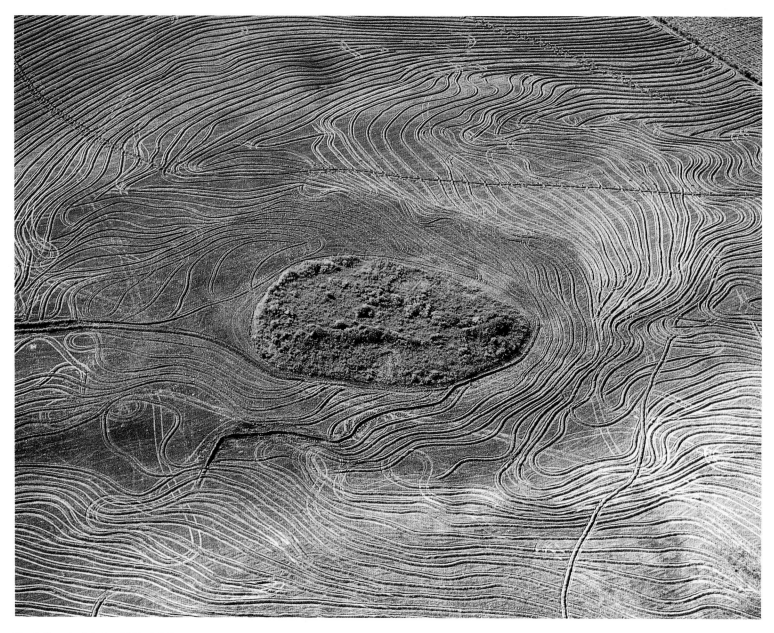

Plantations in Palmira, Valle del Cauca.

Growing sorghum in Buga, Valle del Cauca.

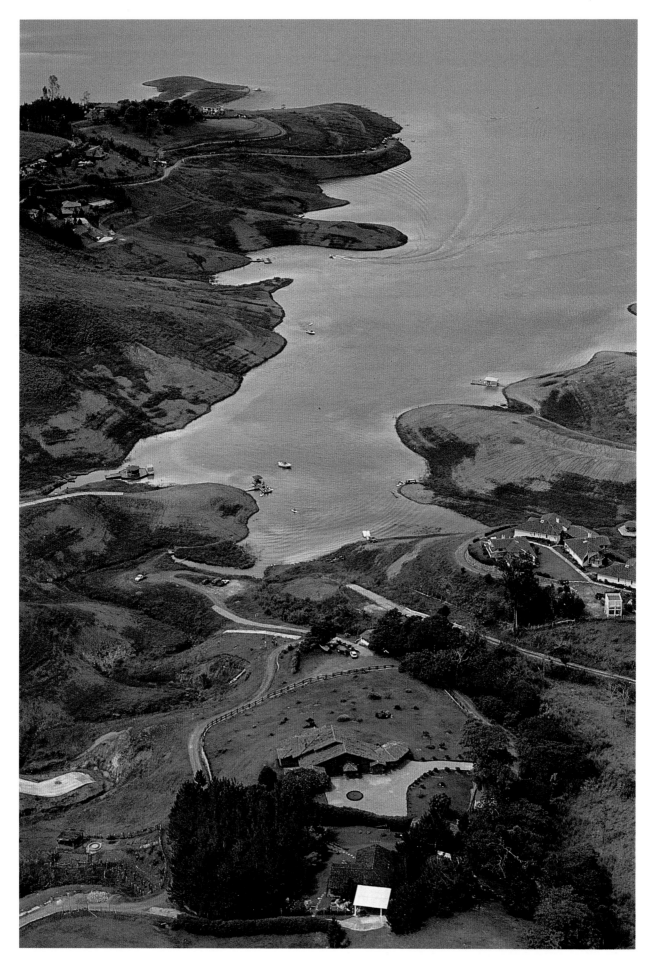

Vacation homes on Lake Calima, Valle del Cauca.

Small holdings in the Quichayá region north of Silvia, Cauca.

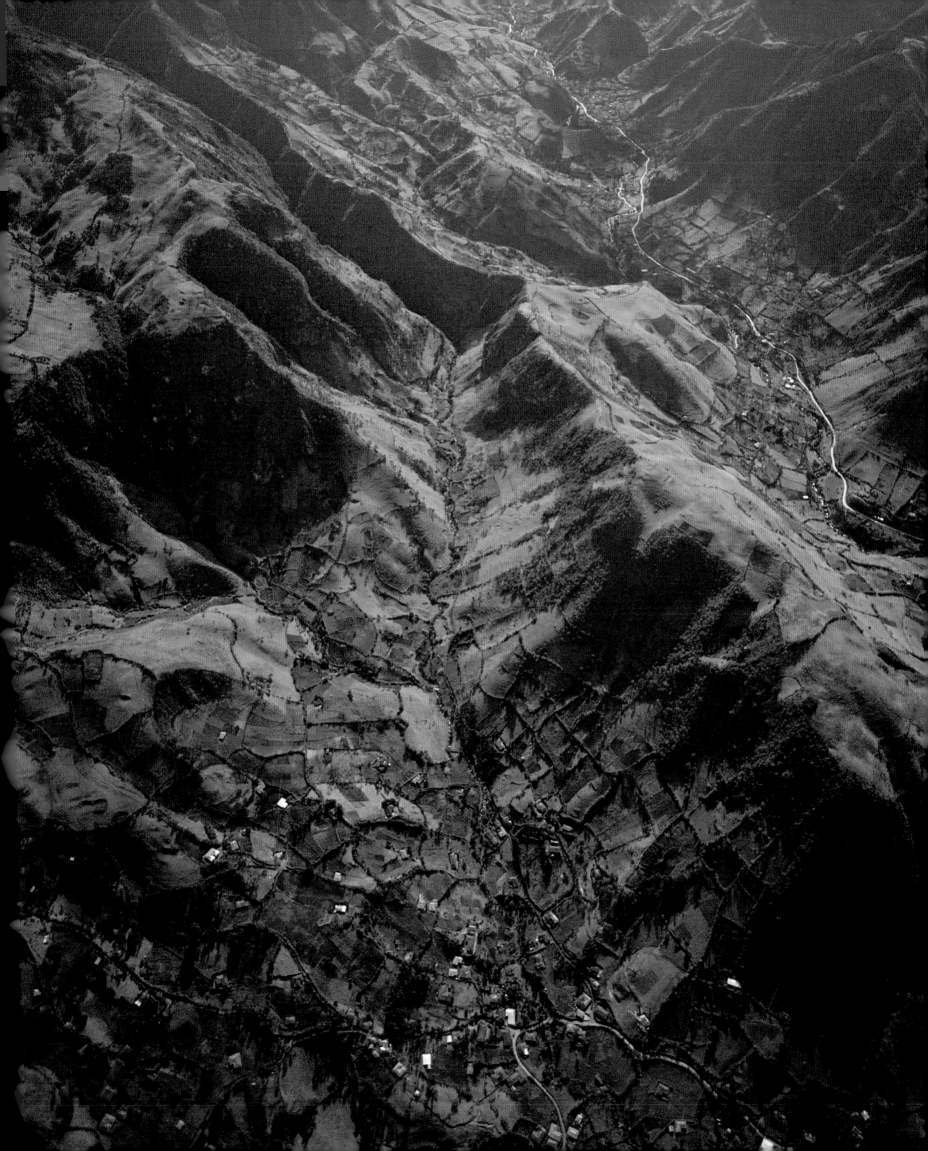

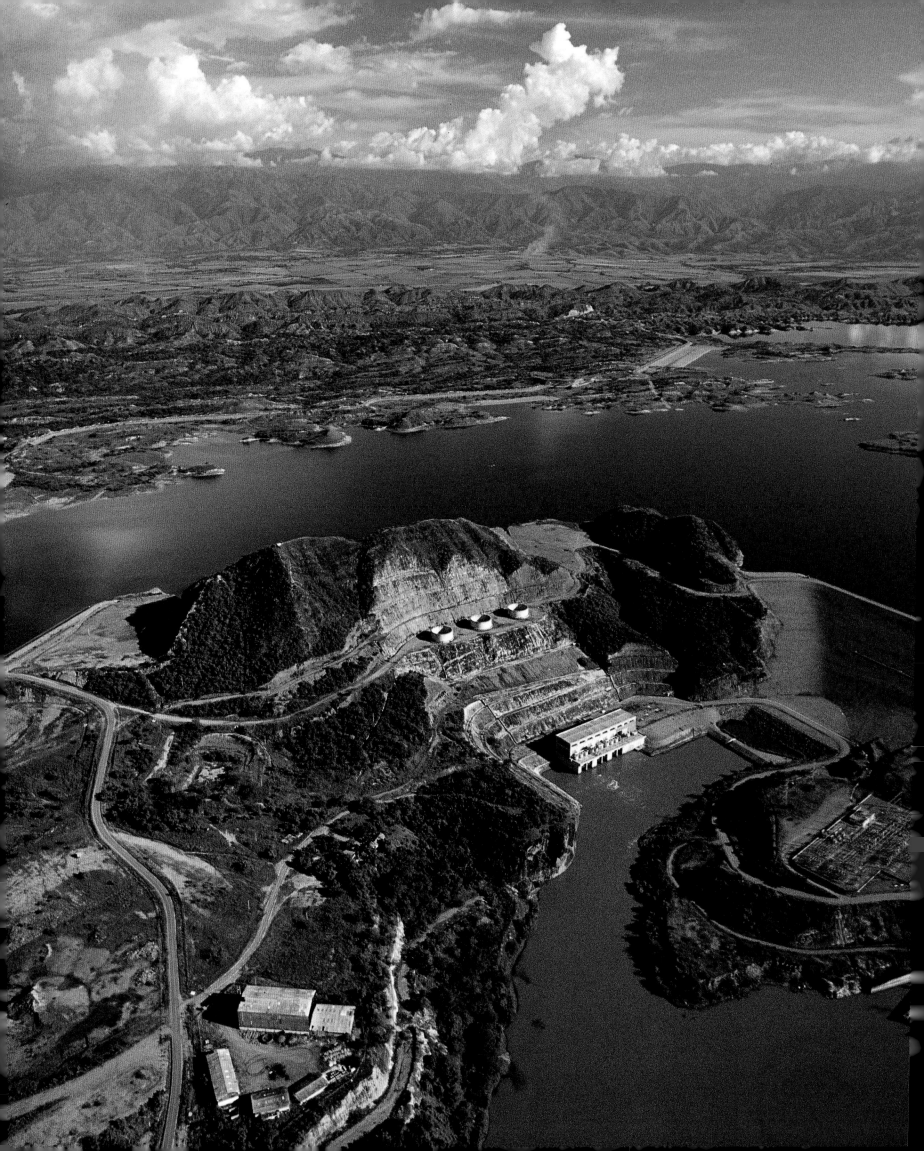

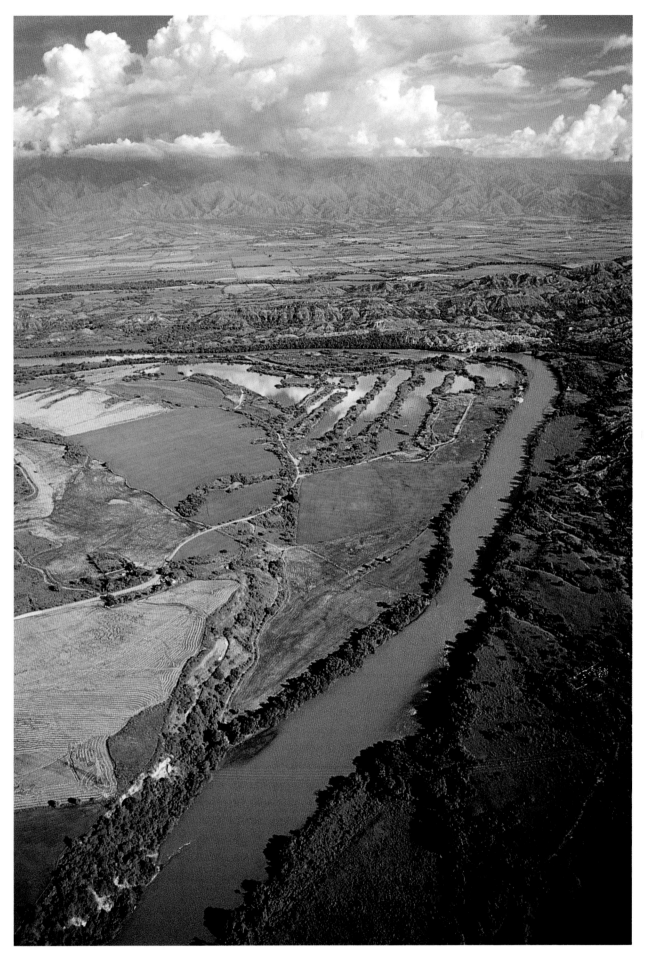

Magdalena River in the upper part of its valley, Huila.

Hydroelectric plants Betania, Huila.

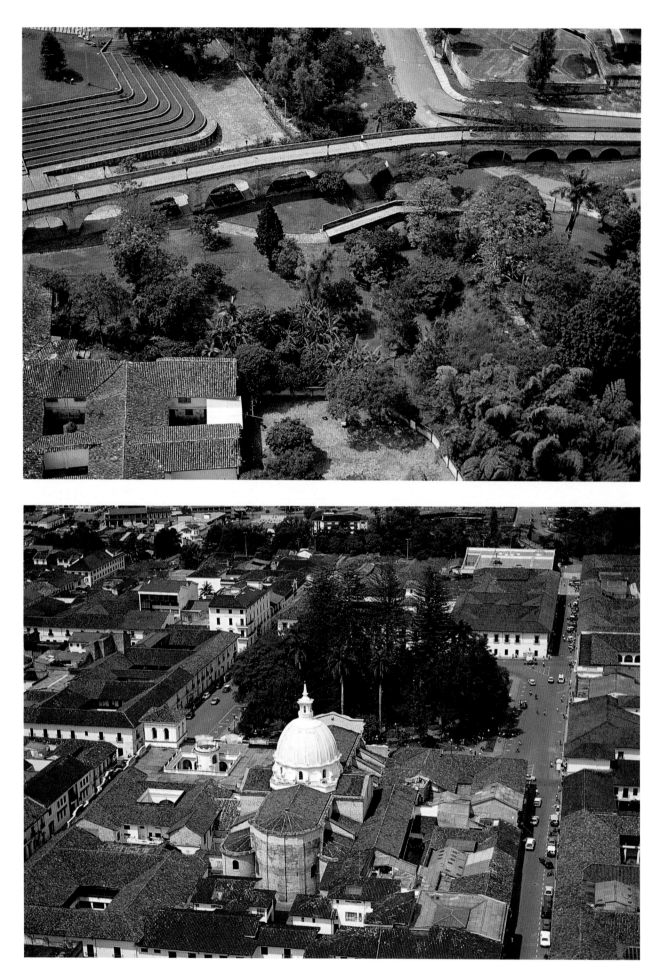

El Humilladero Bridge in Popayán, capital of Cauca Department.

Panoramic view of Caldas Park in the center of Popayán, Cauca.

City of Neiva, capital of Huila Department, with the Magdalena River in the background.

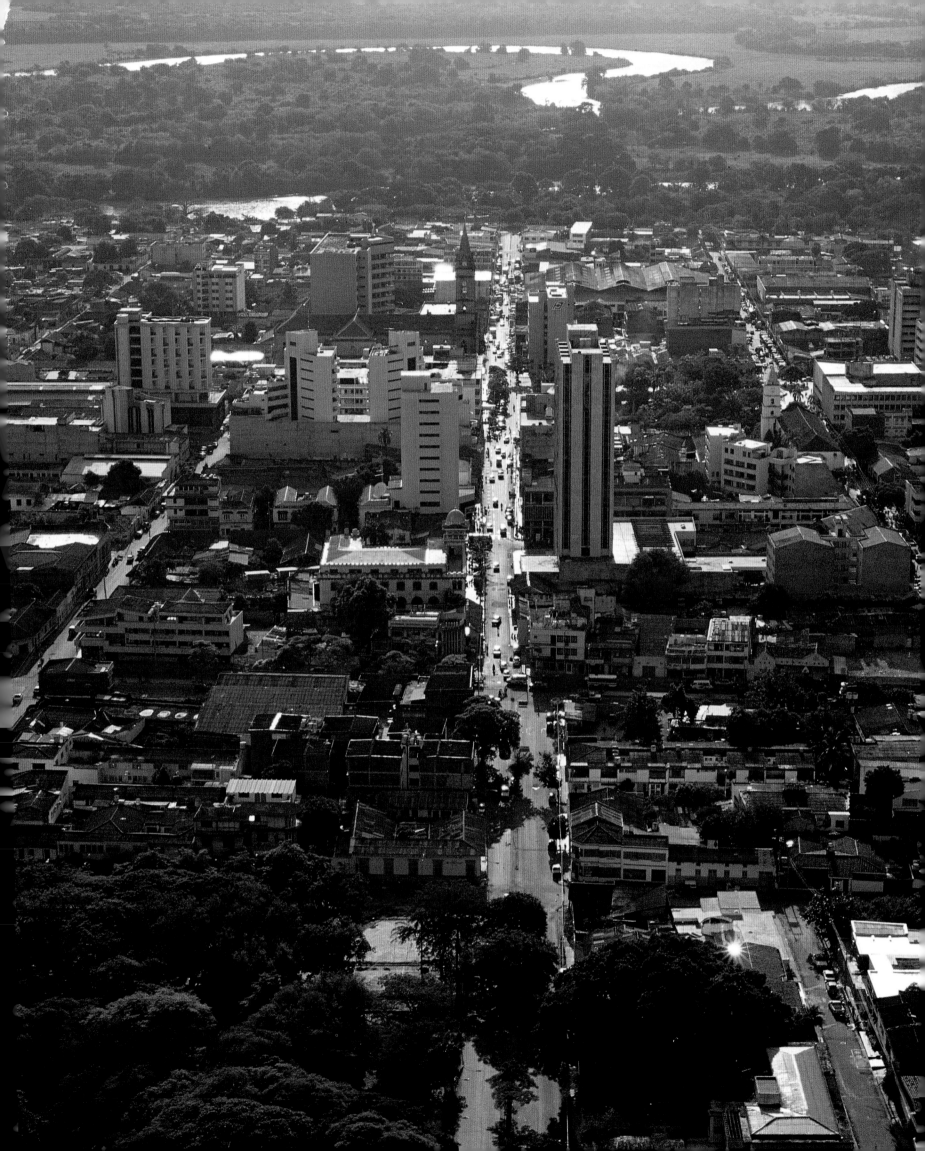

High Place of the Idols in the Archaeological Preserve of San Agustín, Huila.

Typical means of country transport known as "chiva" (nanny goat), Tierradentro, Cauca.

One of the innumerable unnamed lakes on Potato Plateau, Huila.

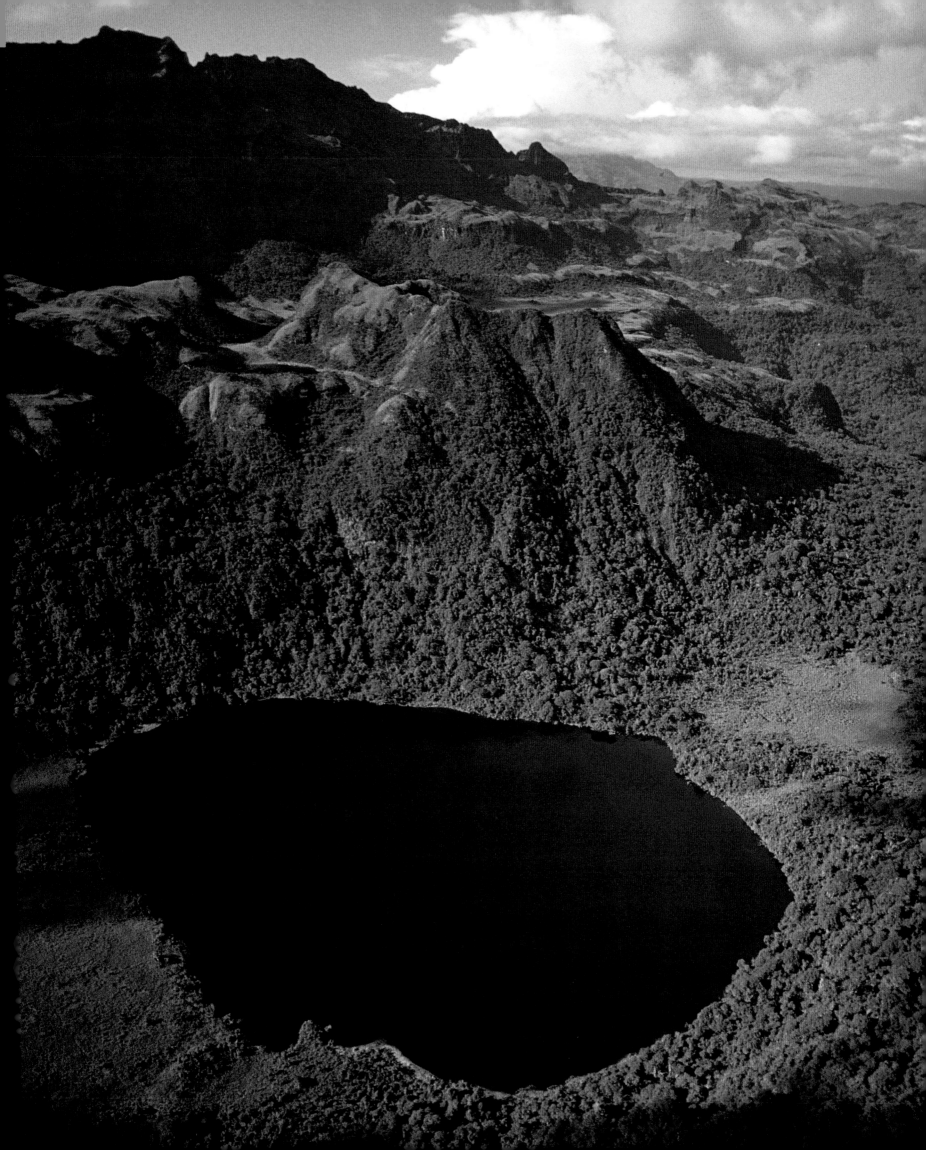

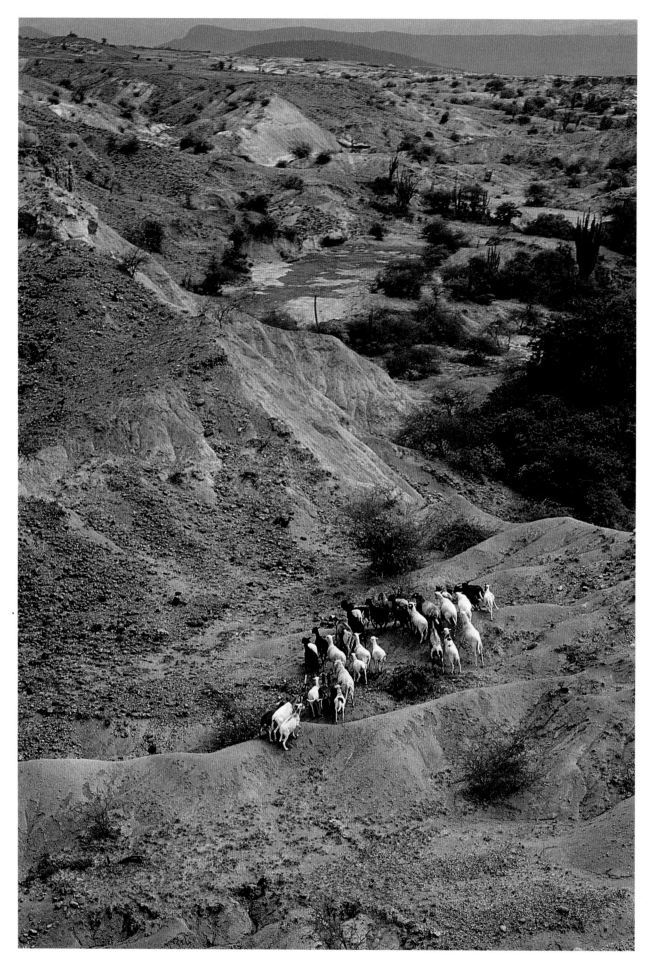

Herd of goats in the barrens of La Tatacoa, Huila.

"Sliced" dunes in the barrens of La Tatacoa, Huila.

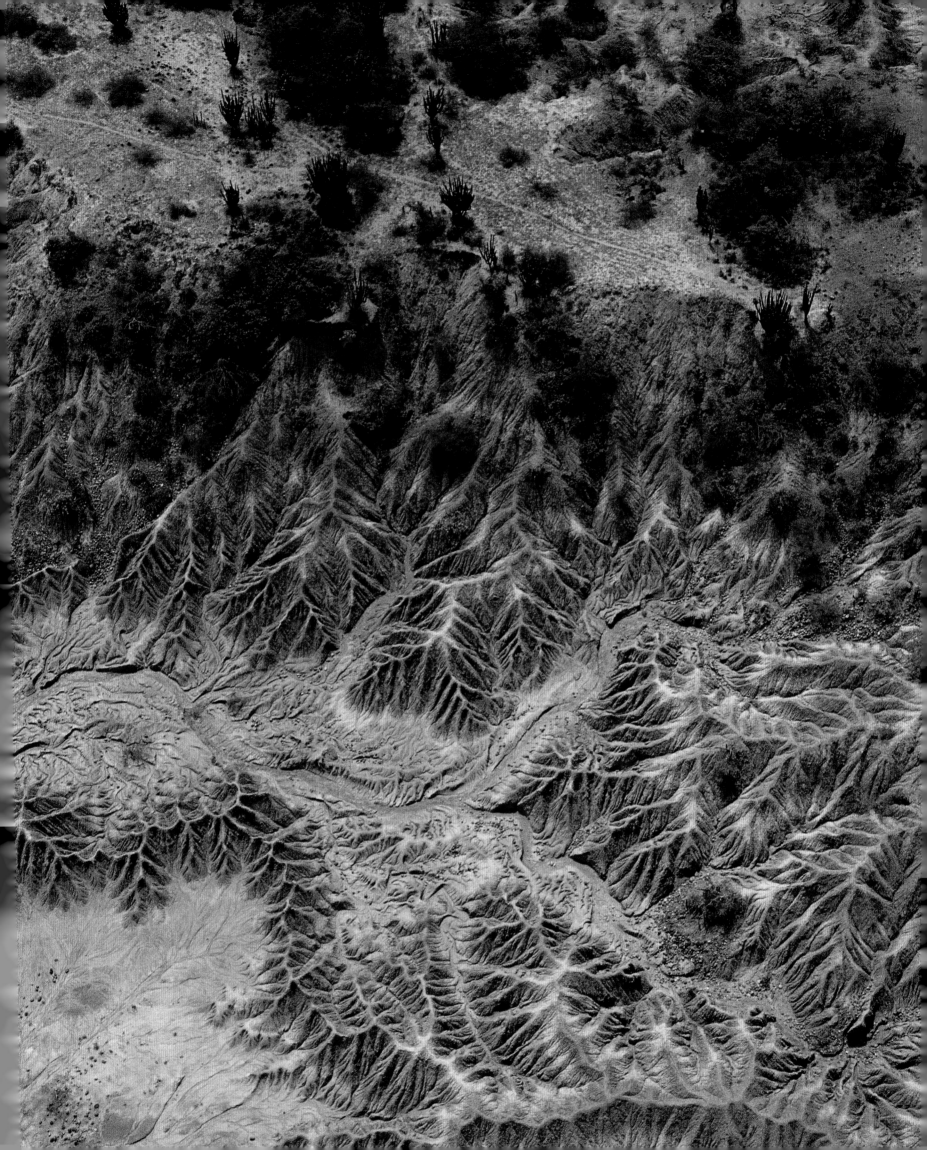

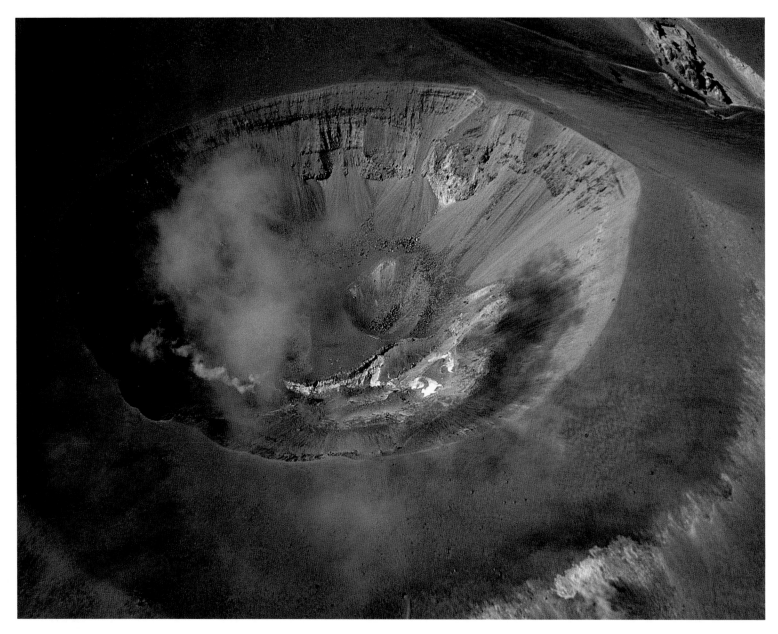

Crater of Puracé Volcano southeast of Popayán, Cauca.

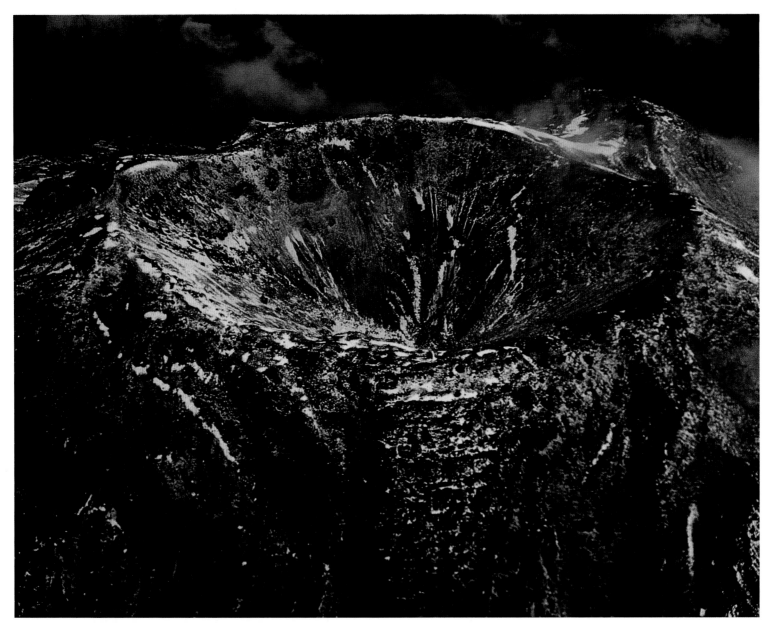

Crater of Cumbal Volcano near the Ecuadorian border, Nariño.

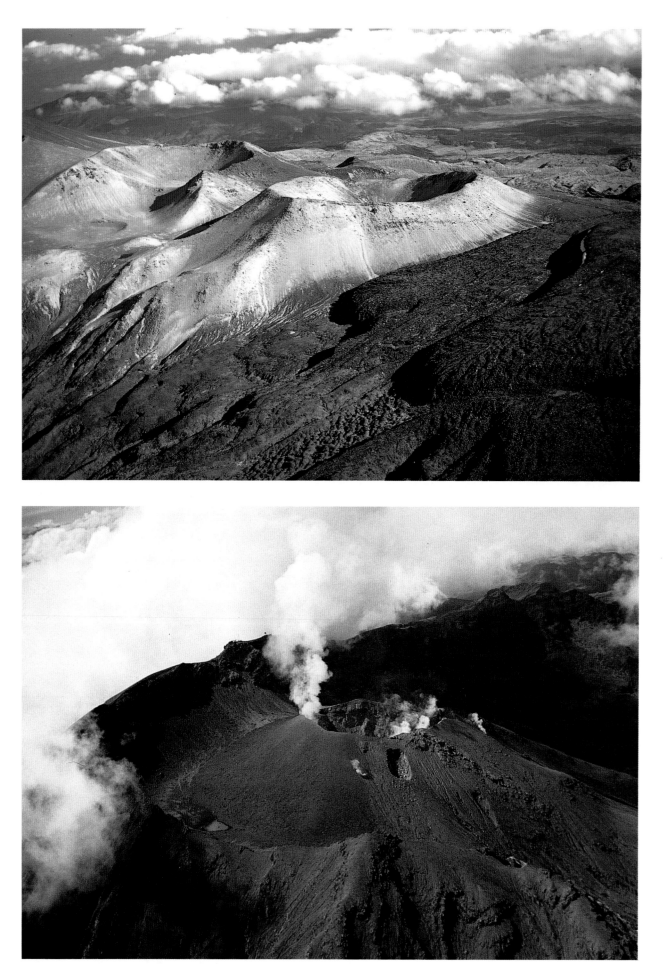

Craters of Los Coconucos Range, Cauca.

Crater of Galeras Volcano west of Pasto, capital of Nariño.

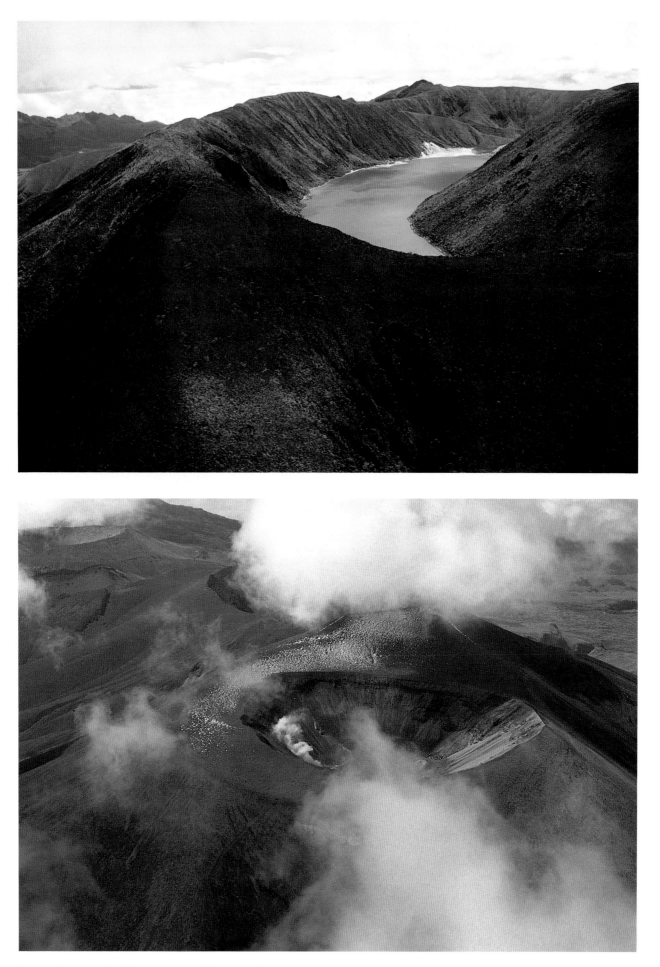

Green lake on Azufral Volcano west of Túquerres Nariño.
Sotará Volcano on the Cauca-Huila border.

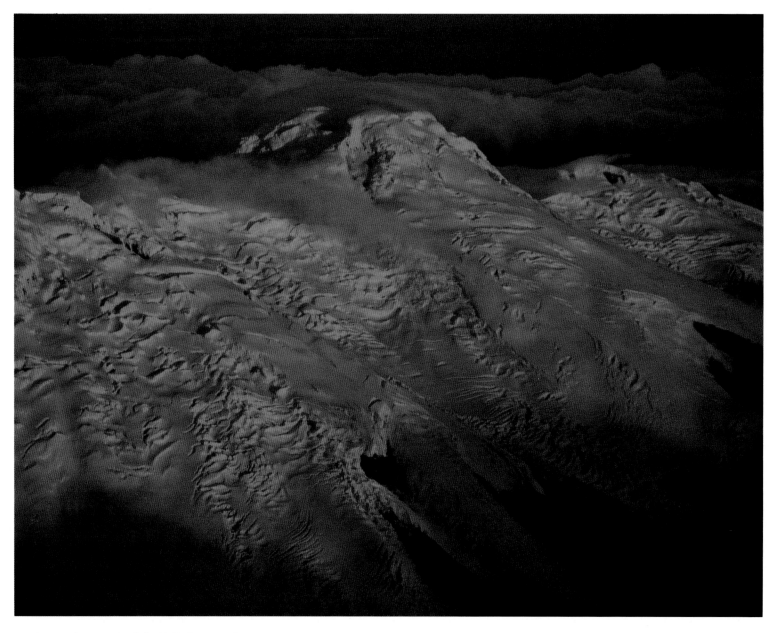

Evening on the summit of the Huila Snow-peak.

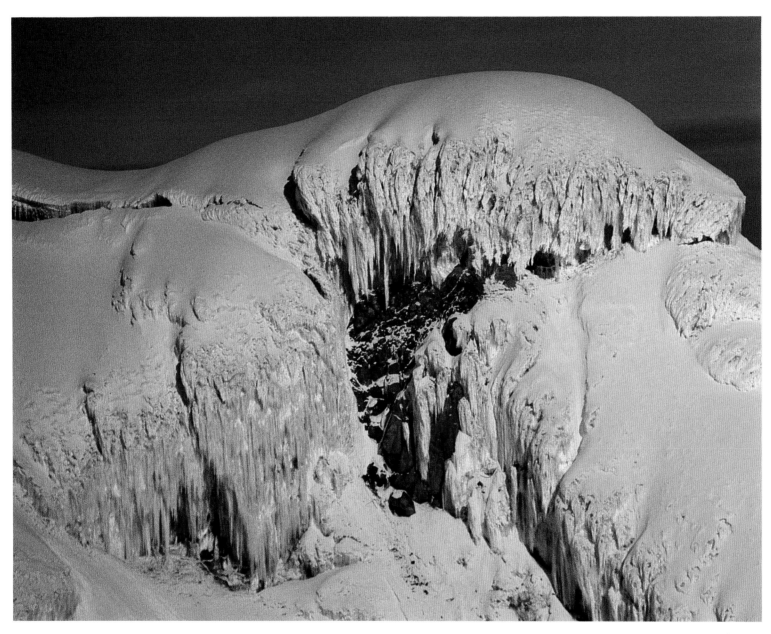

Sulphurous stalactites on the north slope of the Huila Snow-peak.

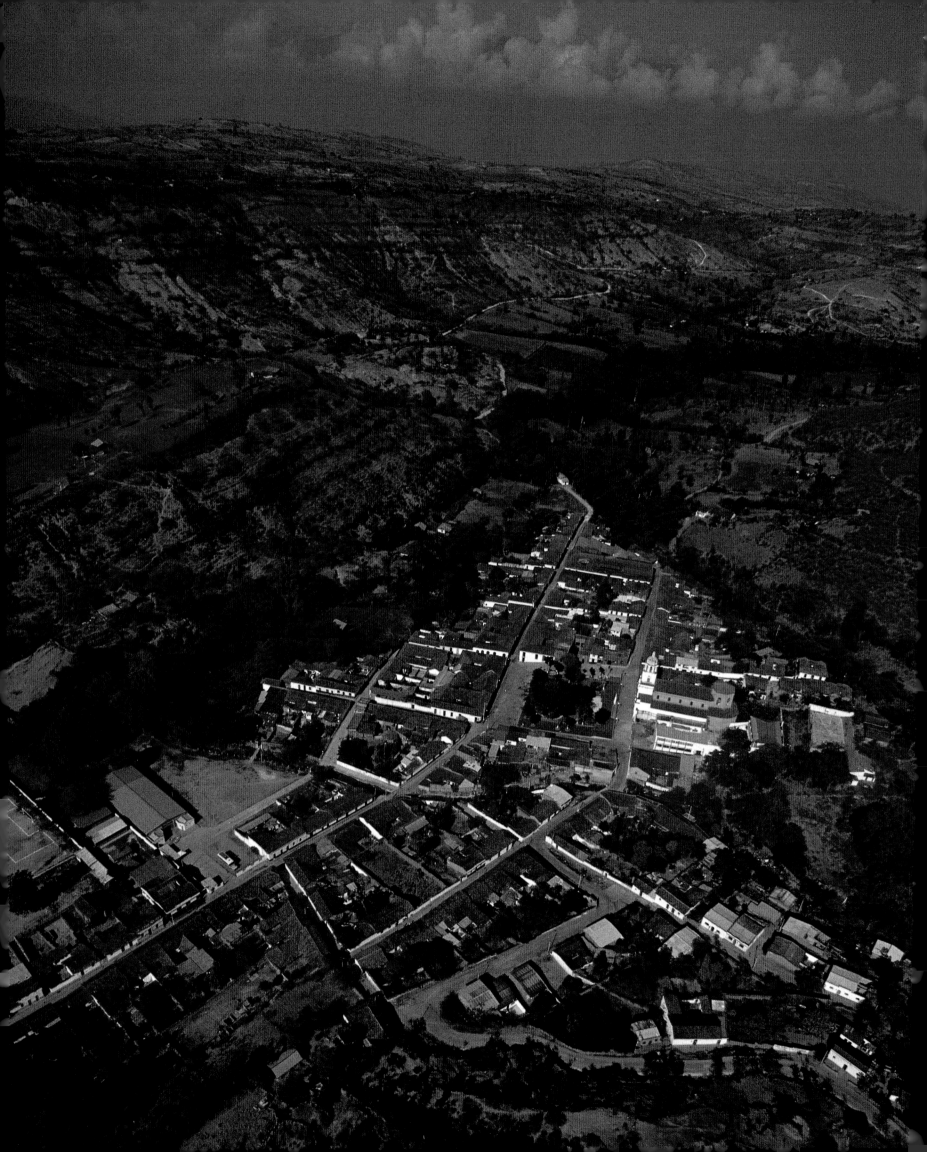

HIGH PLATEAU AND SANTANDERS

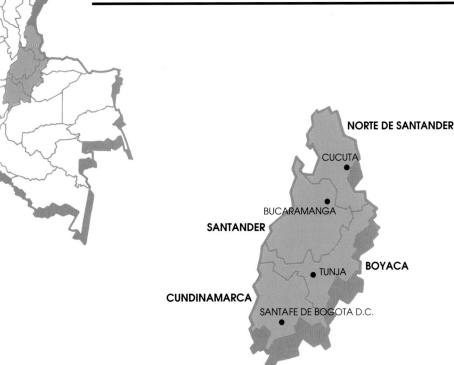

O
n a planet where sixty per cent of all humans live no more than sixty miles from
an ocean shore, seventy-five percent of the Colombians live on fairly high or
downright lofty mountains. Santafé de Bogotá, their capital city, is understand-
ably the largest in the world located above 8,000 feet. (The city regained in
1991 the full name given it by its founder, Gonzalo Jiménez de Quesada, one later shortened
by Bolívar in a display of the new republic's sovereignty.) At the time of its founding, in 1538,
there already existed, scattered over the Savana (High Plain) of Bogotá (there being nothing
then resembling a city in the modern sense) a population estimated by historians at between
850,000 and two million "Muiscas"–Chibcha-speaking Indians native to the high plateau
that covers parts of the present-day departments of Boyacá and Cundinamarca. It is said that
Jiménez de Quesada himself estimated at several million its total population ❏ Today Bogotá
is a city of over six million inhabitants, the undoubted center of the nation's activity. Within
the city limits lie over 86,000 acres of some of the best land in the Americas. On the Sabana
of Bogotá some five thousand acres of ground covered over by plastic greenhouses are given
over to floriculture. At one time the Sabana was a lake. Legend has it that Bochica, a mythi-
cal man with long hair and whiskers, cracked open the mountains to let the lake out, form-
ing the Tequendama Waterfall at the point where the Bogotá River suddenly takes a five-
hundred-foot plunge. In this region are found the 12,500-year-old remains of "Tequendama
Man." ❏ In contrast to the Central and Western Cordilleras, the Eastern–on which the
Sabana spreads like a perfectly smooth tabletop–is not of volcanic origin, although much of
its soil is made up of ash from the volcanos facing it, those of the Central Cordillera. It was
formed by an upward bending of marine and continental sediments as a result of the pres-
sure of the Guiana Shield, just as wrinkles appear when a heavy piece of furniture is dragged

over a carpet. Southward, the Sabana borders the high plateau of Sumapaz, the most extensive example in the world of a type of ecosystem that is the almost exclusive property of the high mountain ranges of Colombia. The Cundinamarca-Boyacá plateau is studded with consecrated ponds: Iguaque, out of which legend has it that Bachué, the mother of the Muisca Indians, emerged; Suesca, Ubaque, Cucunubá, Fúquene, Tota and, most important of all in terms of myth, Guatavita, a small round pond no more than 1,300 feet across and thirty or forty deep. In this pond the ceremonial bath in gold dust of the Zipa, chieftain of Bacatá, gave rise to the legend of El Dorado (The Gilded One). Today the ponds are interspersed with enormous artificial basins, likewise consecrated–only now to industrial development. The place-names of the area still largely reflect the comings-and-goings of the Zipa (or Cipa): Tocancipá, Gachancipá, Zipecón, Zipaquirá–the last the site of the famous underground cathedral in a salt mine. Tunja, capital of Boyacá Department, founded in 1539, retains something of its colonial look. Better preserved is Villa de Leiva, in colonial days a city where viceroys relaxed, today surrounded by a desert full of fossils which attest to its having once been ocean. Nearby, in Saquenzipa, there are traces of a ceremonial observatory which may, for the Muiscas, have fulfilled the same functions as Stonhehenge for the early inhabitants of the British Isles ❏ Another chapter of history that traverses this part of Colombia concerns the campaign of liberation undertaken by Simón Bolívar in 1819, which culminated in the total defeat of the Spaniards in the battles of Vargas Swamp (Pantano de Vargas) and Boyacá Bridge (Puente de Boyacá). Not far off is Samacá where one of the first Colombian textile plants on the model of the Industrial Revolution was located. The atmosphere in Samacá is redolent of cold winds, eucalyptus trees, wheatfields, coke ovens, charcoal. Every Boyacá name has its special resonance for Colombians. Paz del Río: steel plants. Muzo: blue and emerald butterflies. Ráquira: ceramics. Chiquinquirá: religious folklore. In colonial times Chiquinquirá was the meeting-point where the sugar and sweets of Santander were exchanged for Zipaquirá salt. ❏ Entering Santander, things change. The landscape grows harsher, turns wild. The Chicamocha River drills through the topsoil and subsoil and exposes the mountains' anatomy. On the craggy ground of Santander sits El Socorro, cradle of the popular uprising of the eighteenth century which was the first rebellion in the Americas against the Spanish crown. Barichara, a colonial village, is all stone, limestone and earthen tile. And the tableland of Bucaramanga, the capital of Santander, is an intricate triumph of human obstinacy and ingenuity over relentless erosion. Between the two Santanders is situated the province of García Rovira. A highway leading to Cúcuta on the Venezuelan border crosses the bleak plain of the Almorzadero (Lunching-spot) at an altitude of over 13,000 feet. The other face of Santander (and of Caldas, Cundinamarca, Antioquia, Bolívar and Cesar) is the mid-Magdalena, a stretch of 250 miles of the Magdalena Valley between La Dorada and Gamarra where it enters the Atlantic plain at elevations no greater than 3,325 feet above sea level. Until the sixties, the mid-Magdalena was entirely covered by dense jungles, now largely replaced by meadows where cattle graze and plantations of African palm trees. The alligators had disappeared even in the sixties but the *babillas* still inhabited the quagmires on the outskirts of Barrancabermeja. The mid-Magdalena is a zone of pipelines and oilwells and of towns whose very names are scary: El Peligro (Danger), La Viuda (The Widow), Cimitarra (Scimitar)... On the other side of the river, looking out over the Llanos Orientales (Eastern Plains) and close to where the Tunebo Indians still hang on, the El Cocuy, Chita or Güicán Range rises with its lakes and glaciers, and its peaks as high as 18,000 feet, the only mountain heights perpetually snow-covered in the Eastern Cordillera ❏

Lake of Suesca, Cundinamarca.

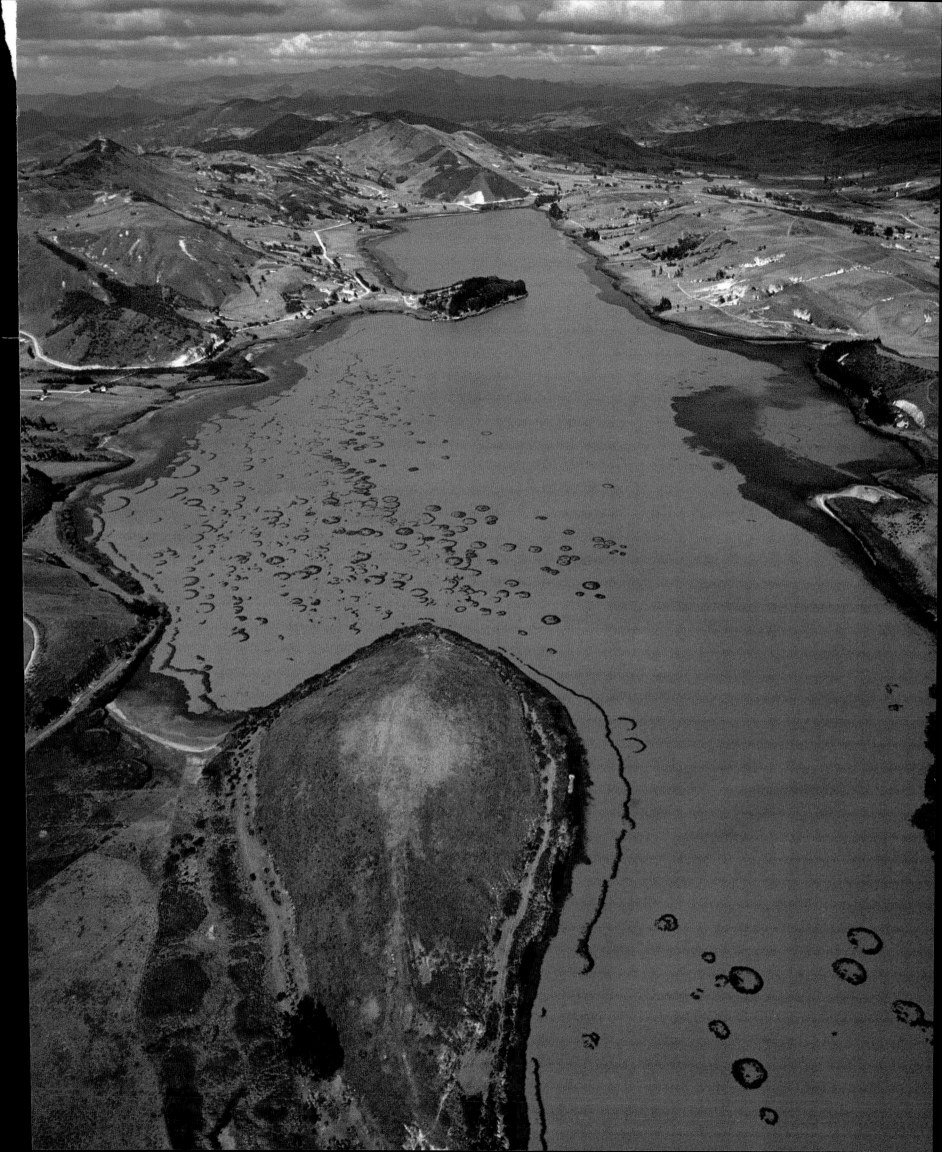

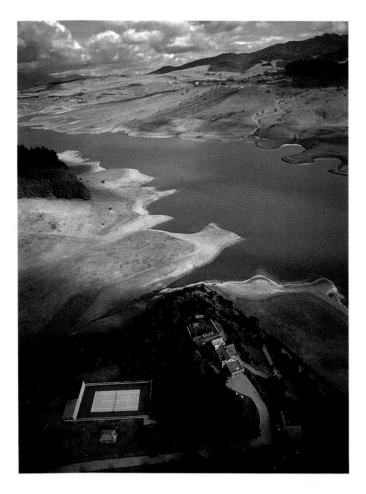

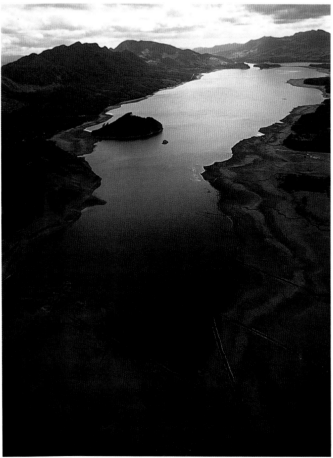

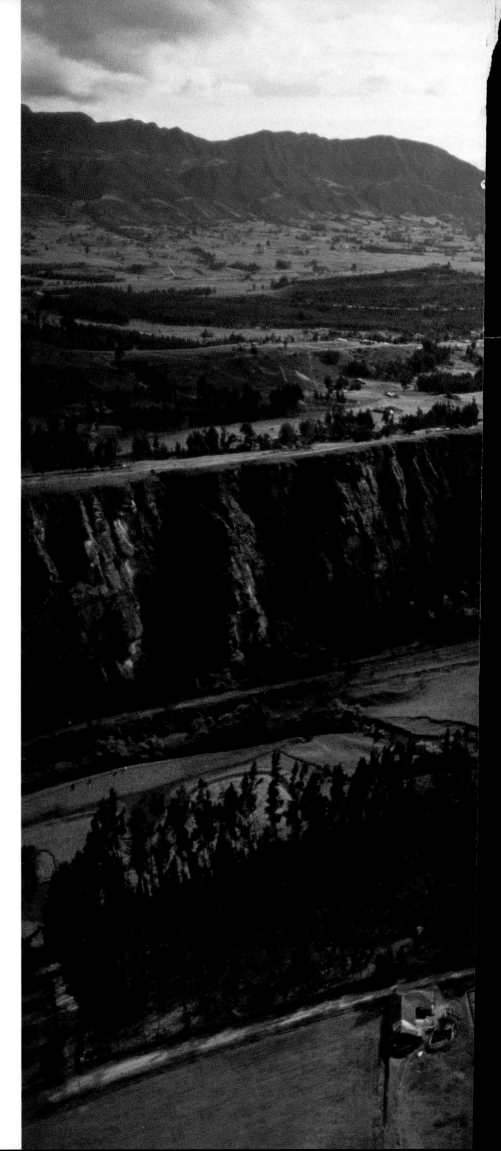

Sisga Dam, Cundinamarca.

Neusa artificial lake, Cundinamarca.

Suesca Rocks and flower cultivation on the Bogotá River, Cundinamarca.

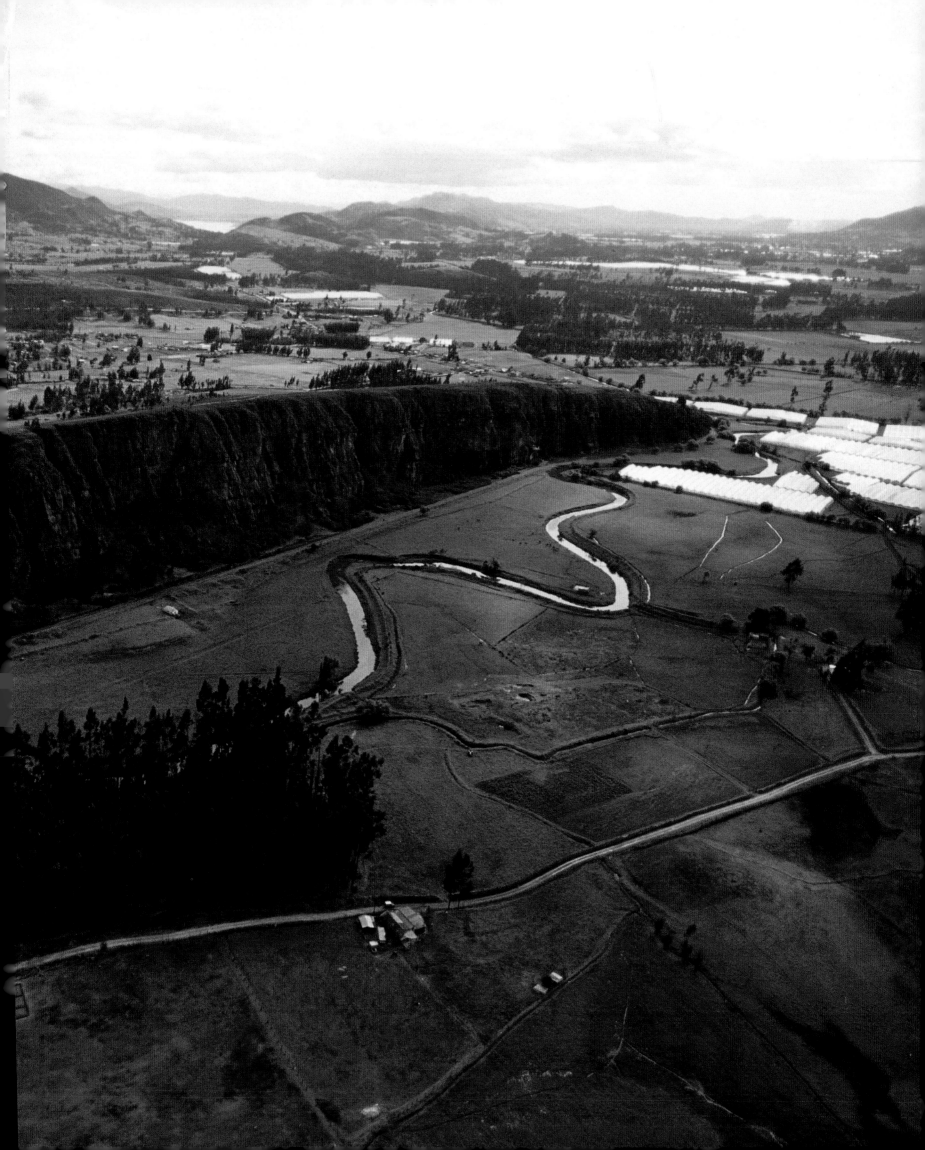

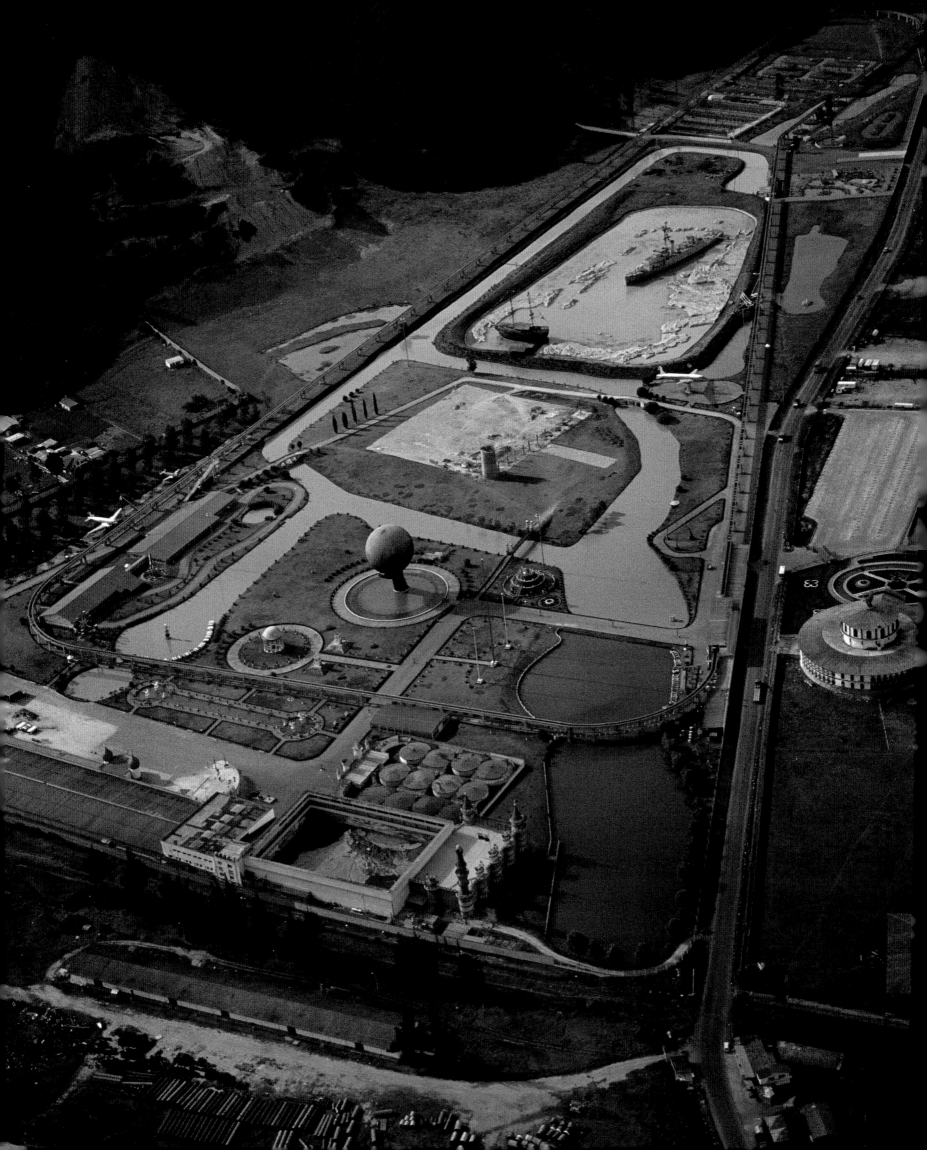

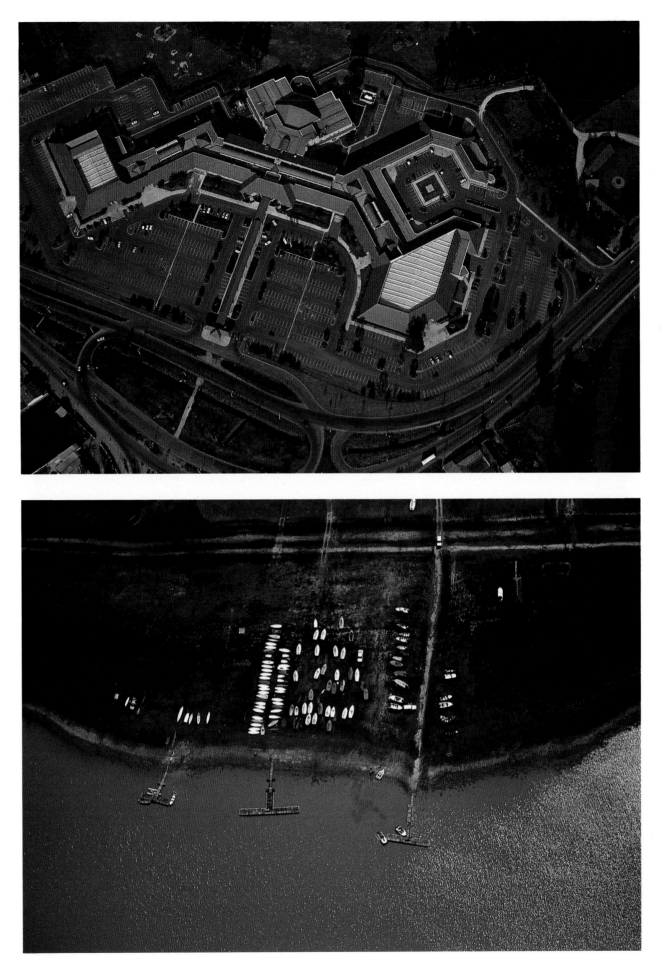

Shopping mall of Chía, Cundinamarca.

Tominé Dam between Sequilé and Guatavita, Cundinamarca.

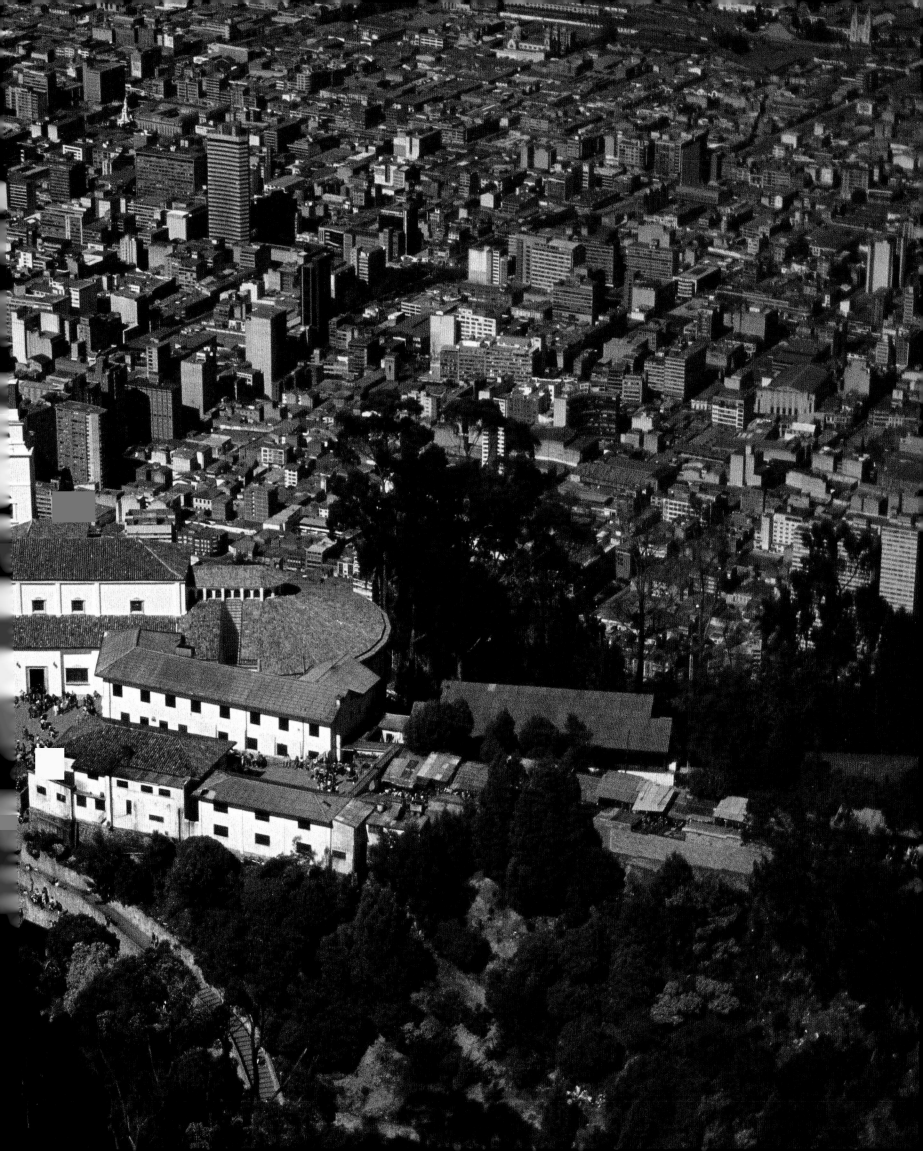

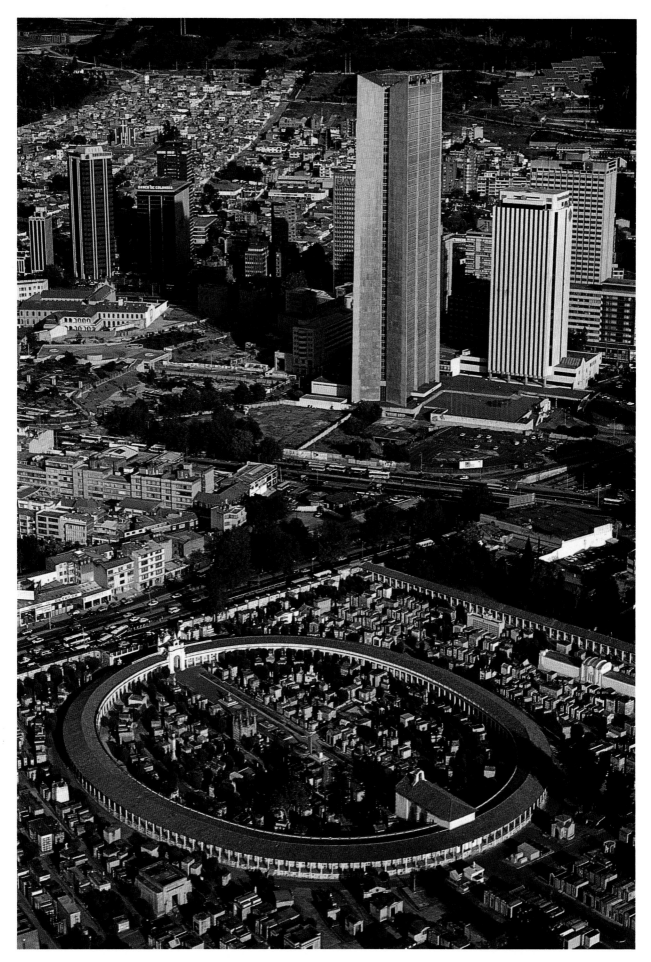

Historic precinct of the Central Cemetery of Santafé de Bogotá.

⌀ Sanctuary on Monserrate Hill with downtown Santafé de Bogotá in the background.

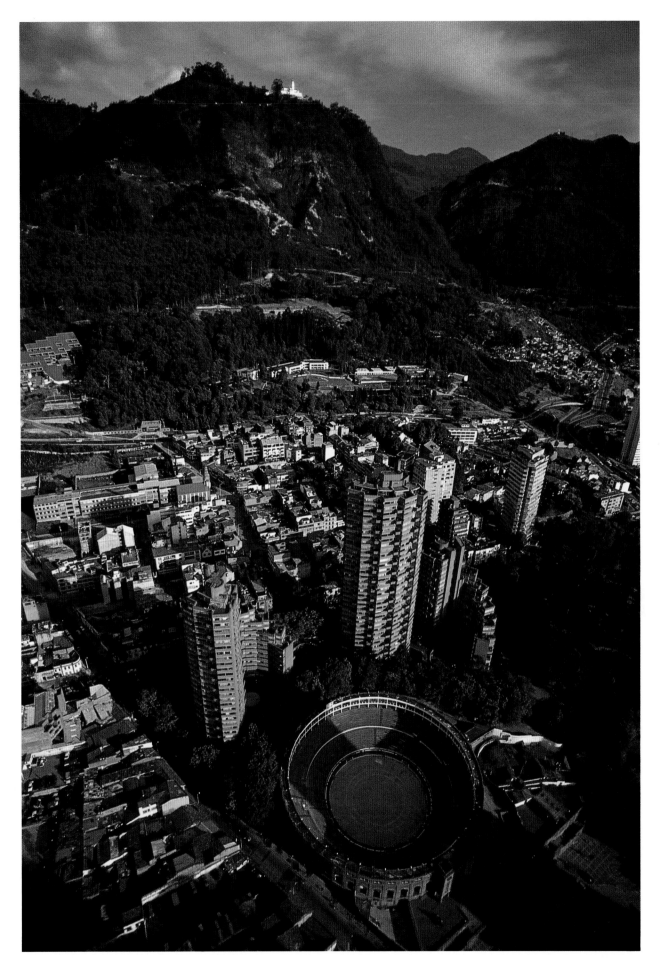

Santamaría Bullring and Park Towers in the International. Center of Santafé de Bogotá.

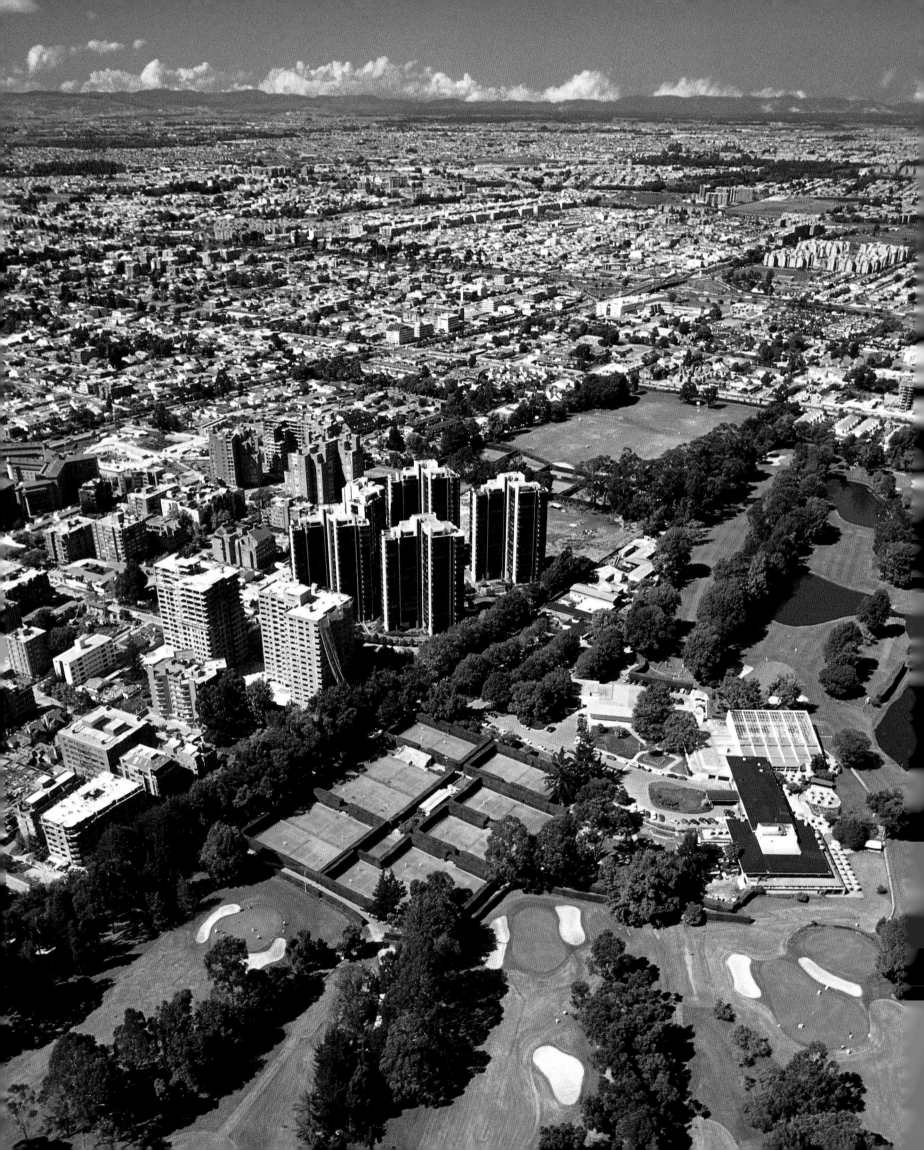

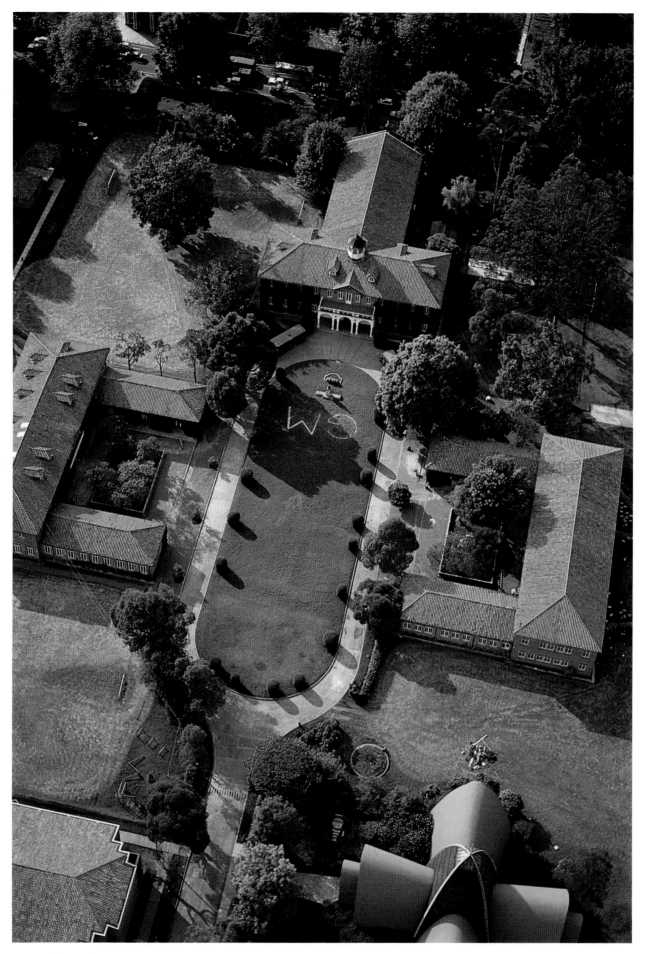

The Modern High School, Bogotá.

Sheds for distribution of market items, Corabastos, Santafé de Bogotá. ↻

The Country Club district north of Santafé de Bogotá.

Breeding grounds for fighting bulls in Sesquilé, Cundinamarca.

Eucalyptus trees on a cattle ranch, Cundinamarca.

Bogotá River at the Tequendama Falls, Cundinamarca.

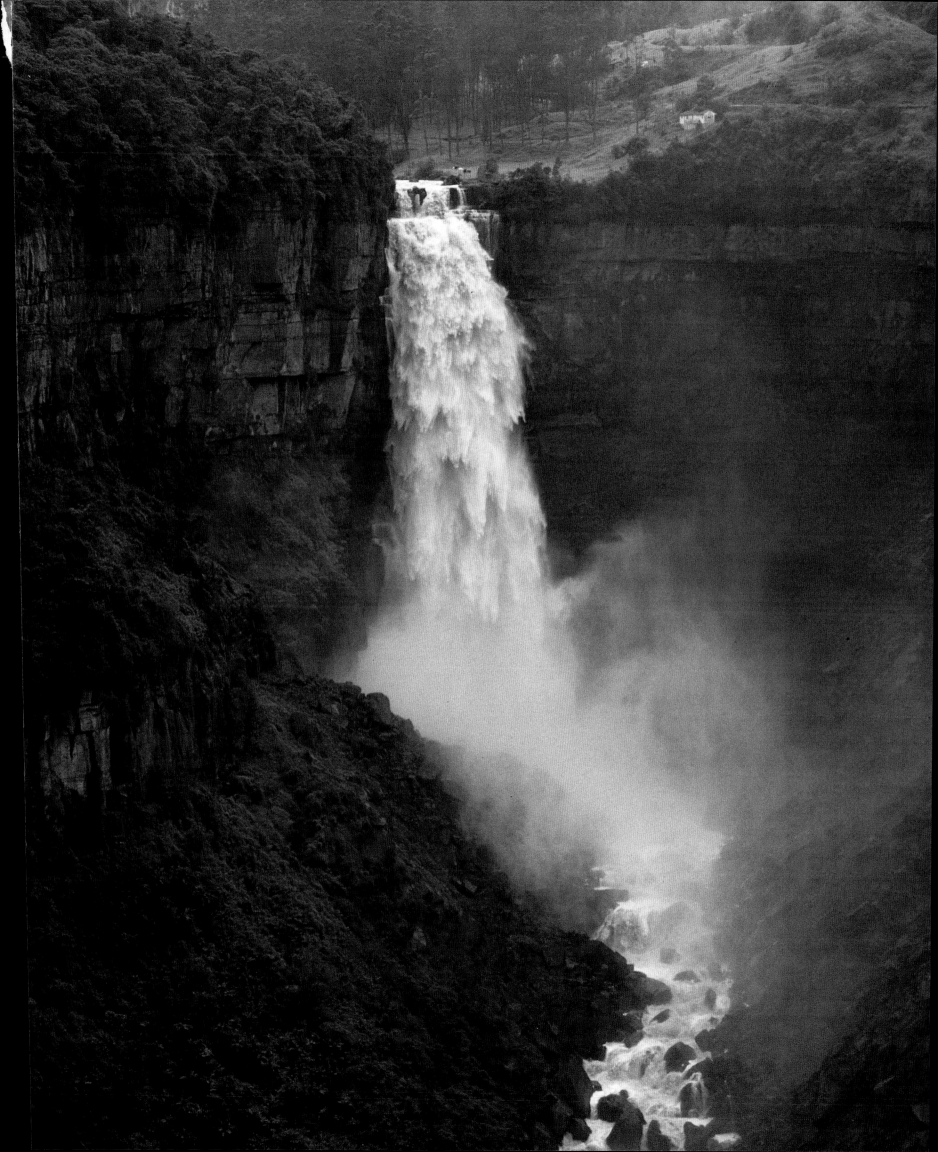

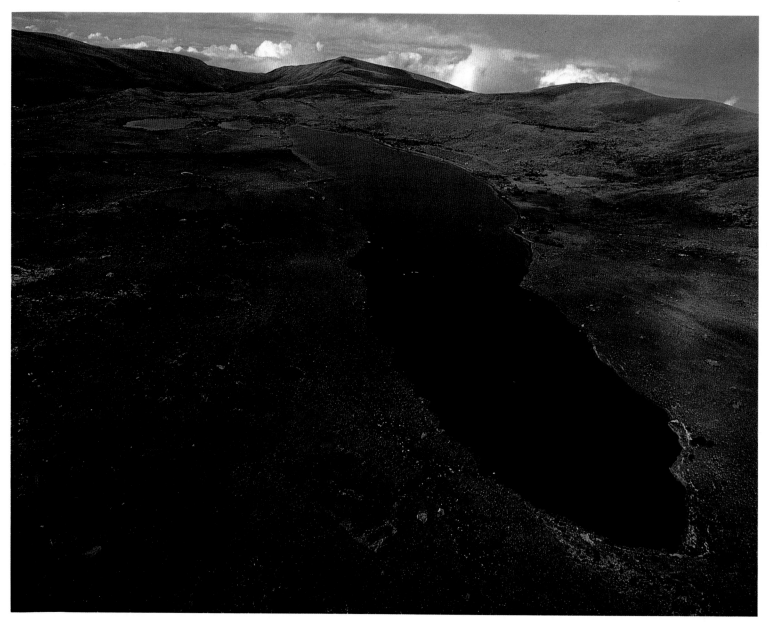

Glacial lake on the Sumapaz Tableland, Cundinamarca.

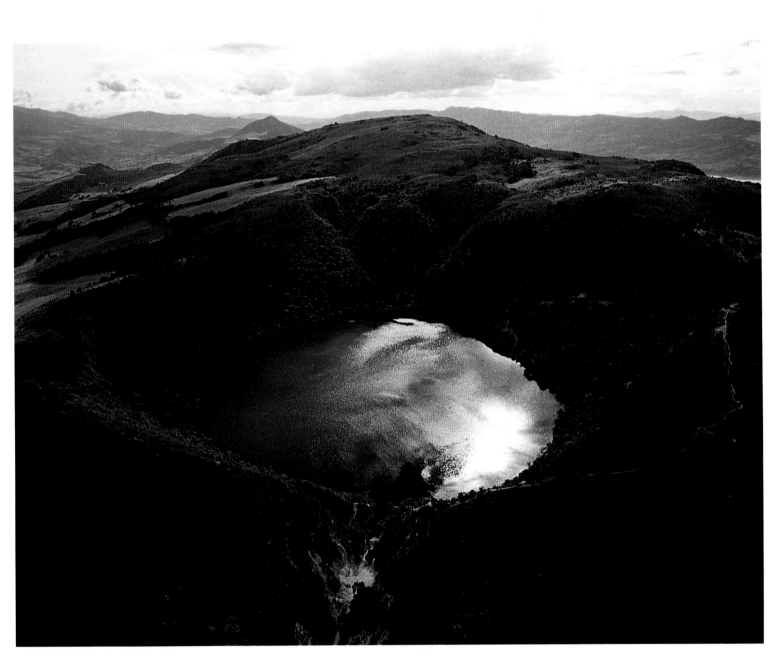

Guatavita Lake, Cundinamarca.

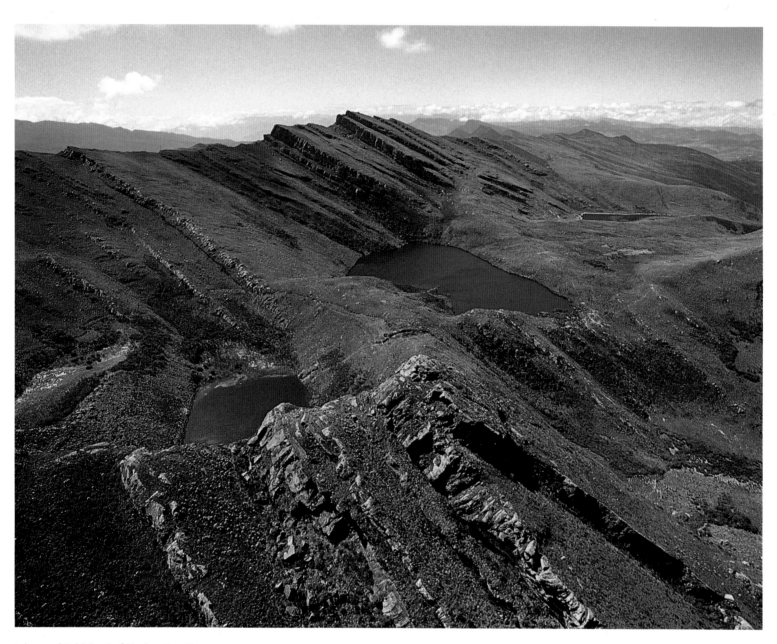

Lakes and Tableland of Siecha, Cundinamarca.

Former coal works, Suesca, Cundinamarca.

Onion fields at the Lake of Tota, Boyacá. ⇲

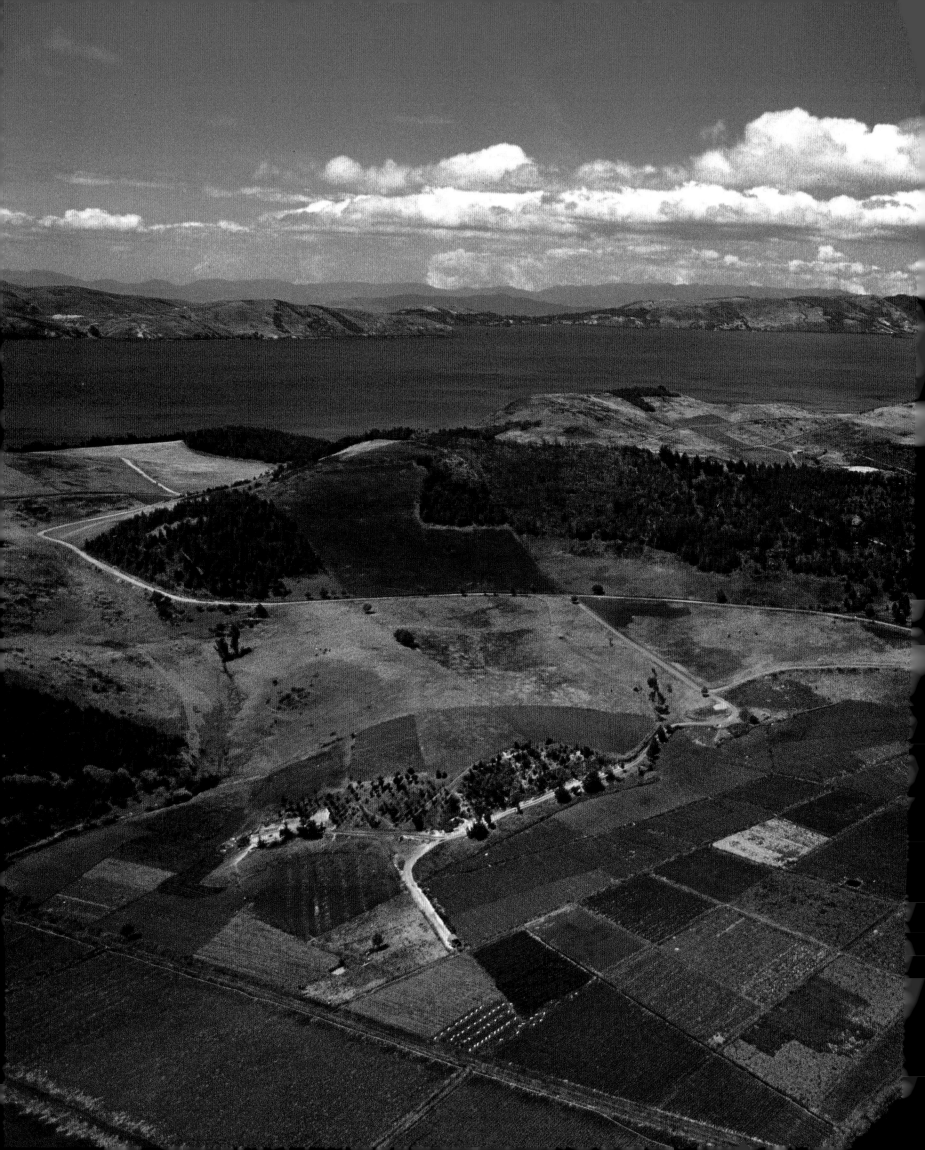

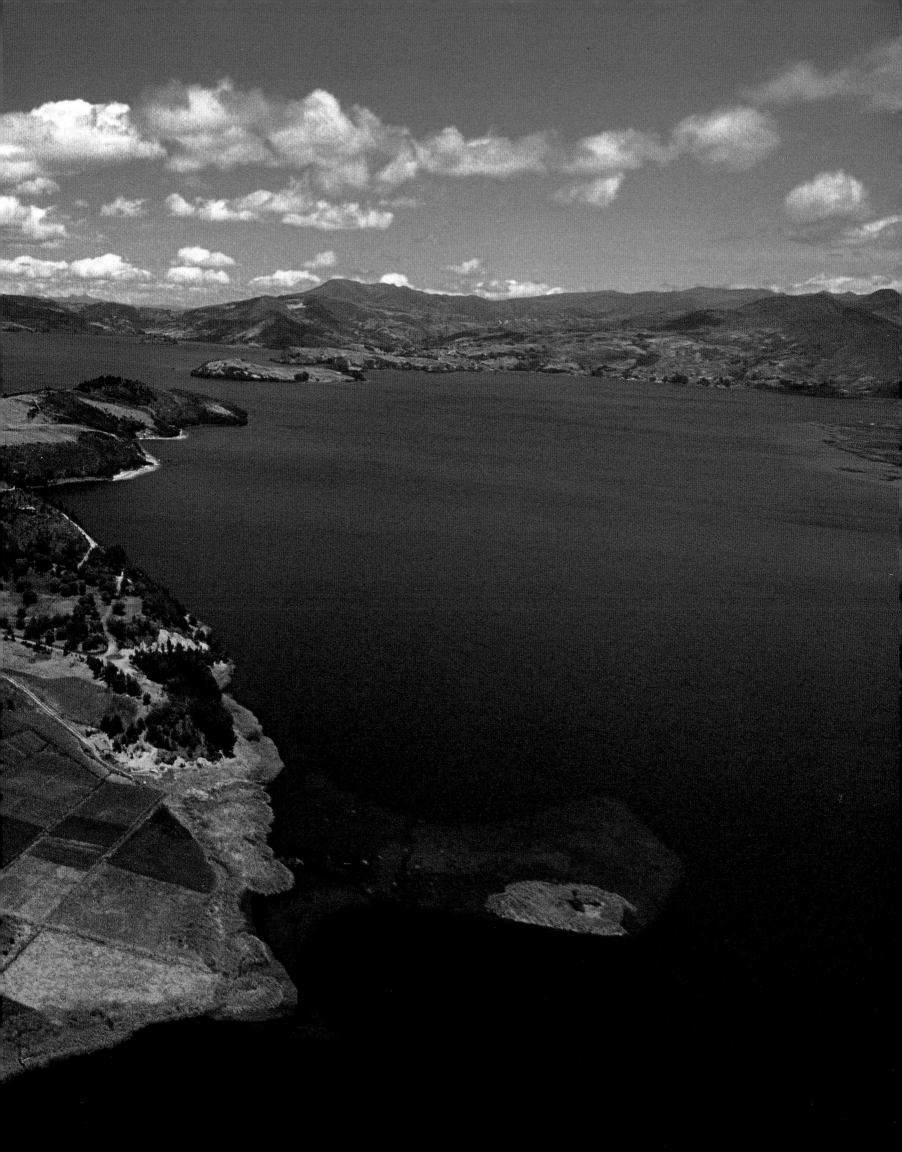

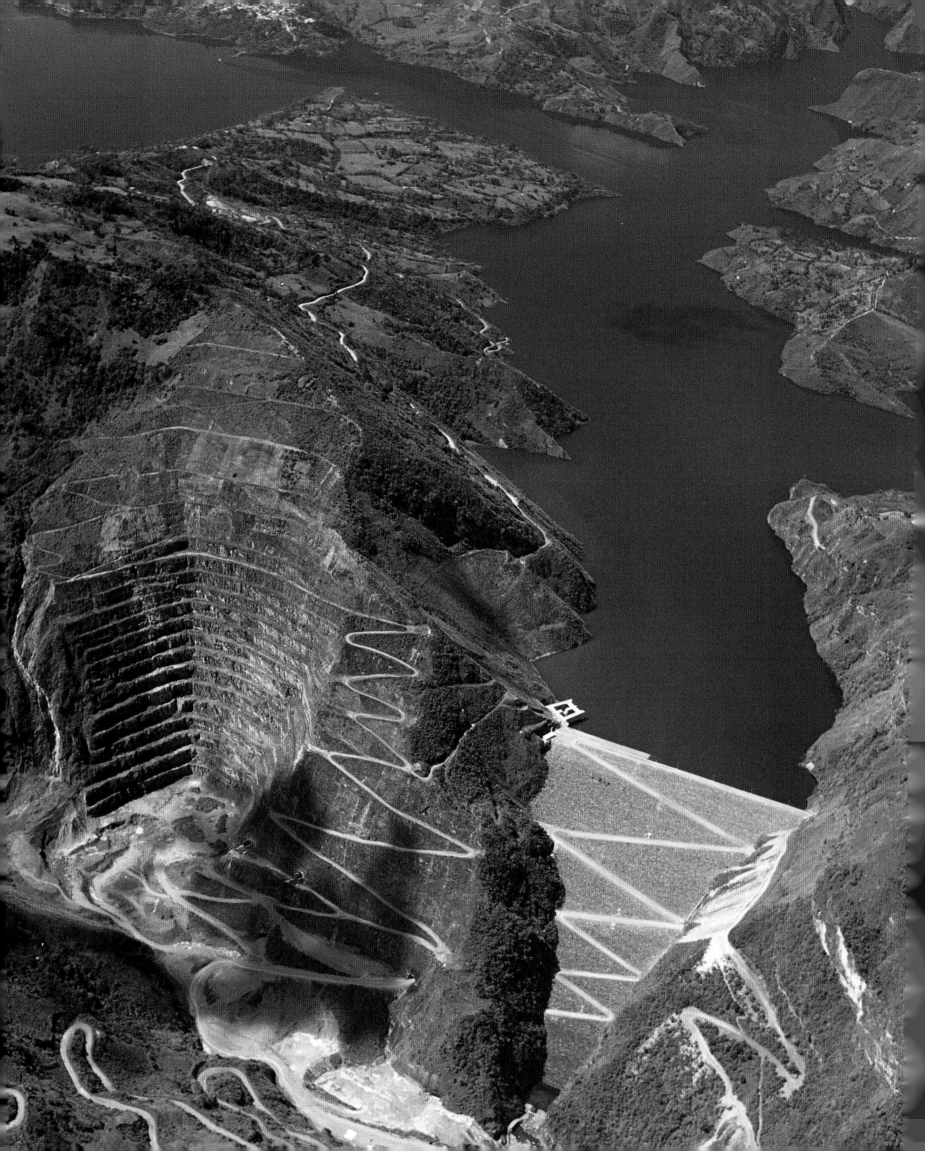

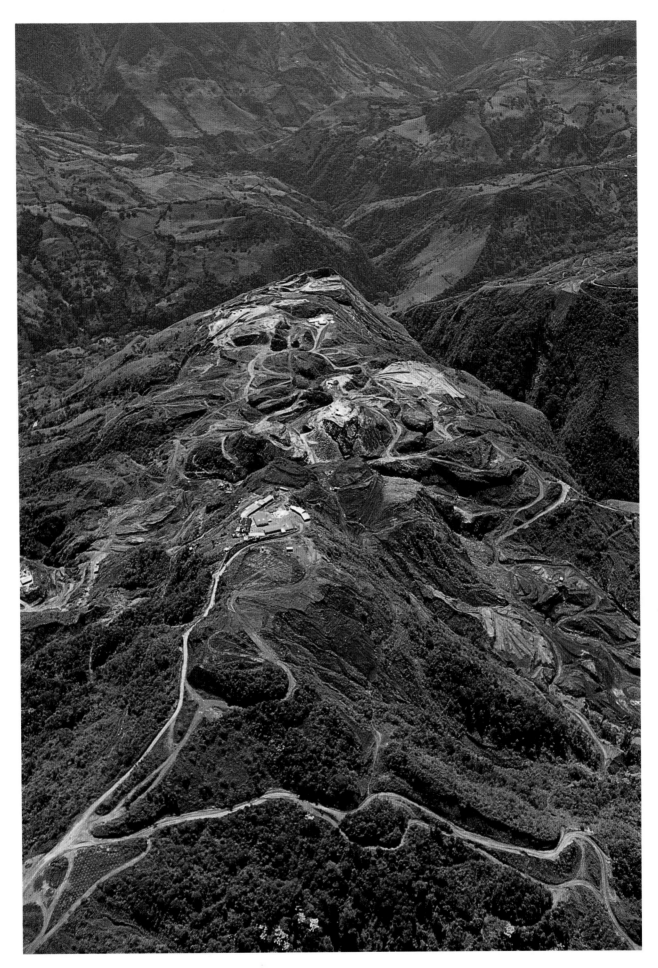

Extraction of emeralds in the Chivor mines, Boyacá.

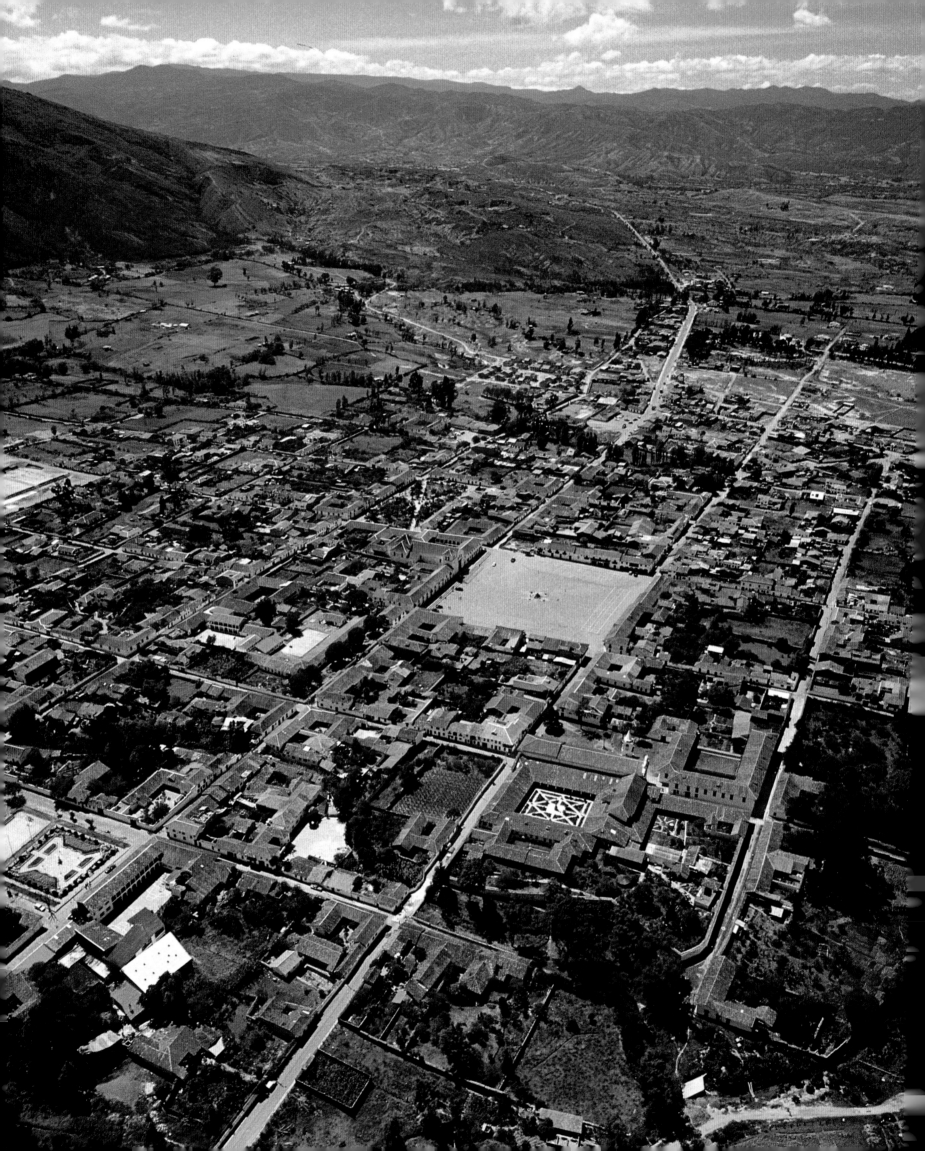

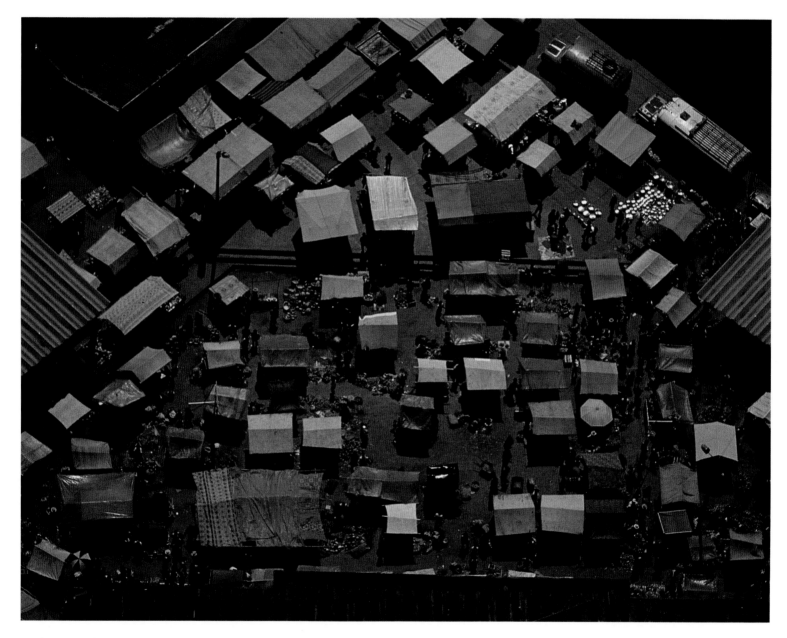

Market square in Garagoa, Boyacá.

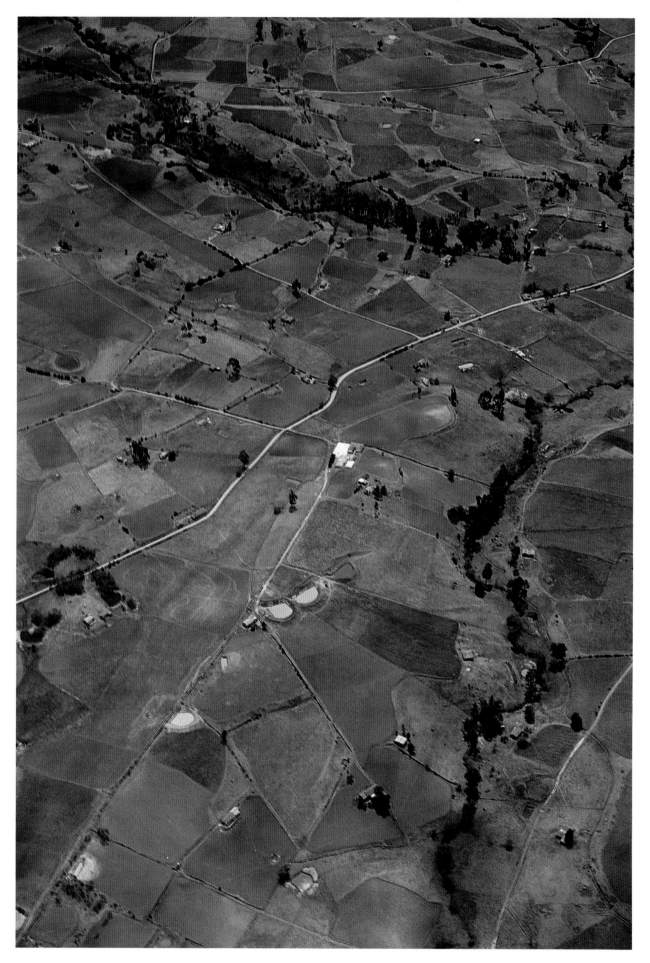

Potato-growing lands in the Sogamoso region, Boyacá.

La Candelaria Barrens in Villa de Leiva, Boyacá.

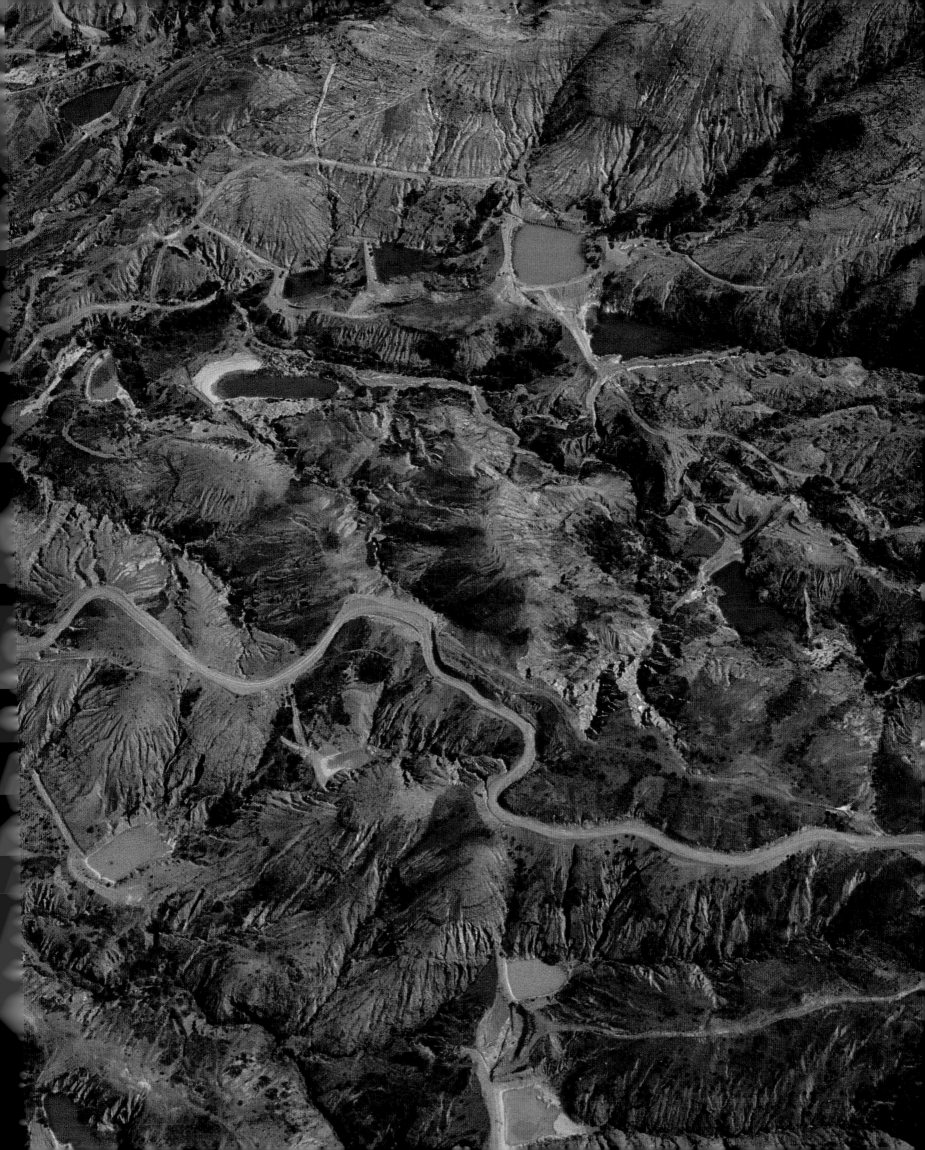

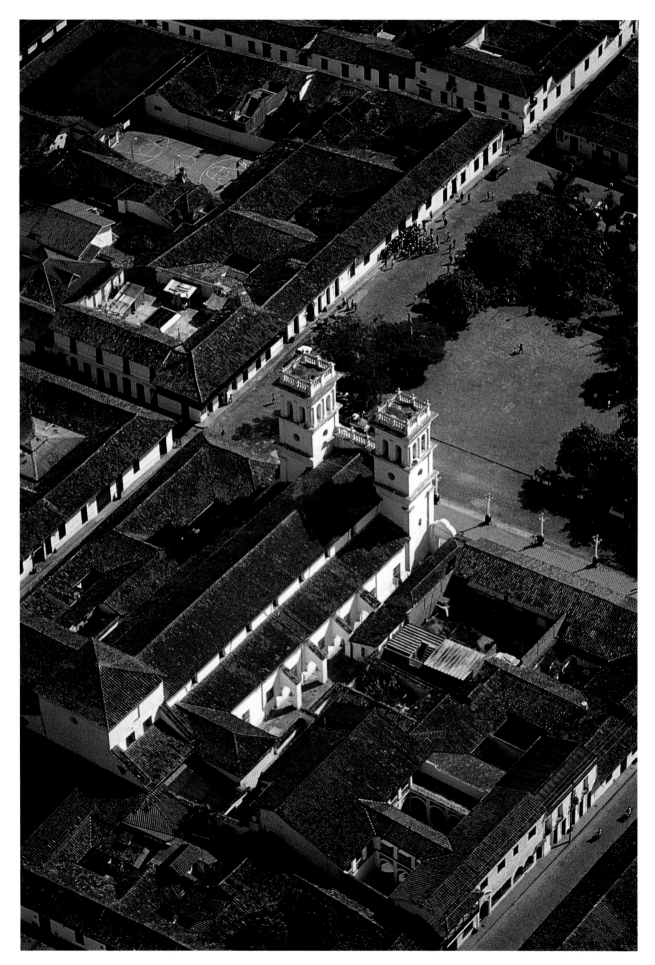

Colonial town of Girón, Santander.

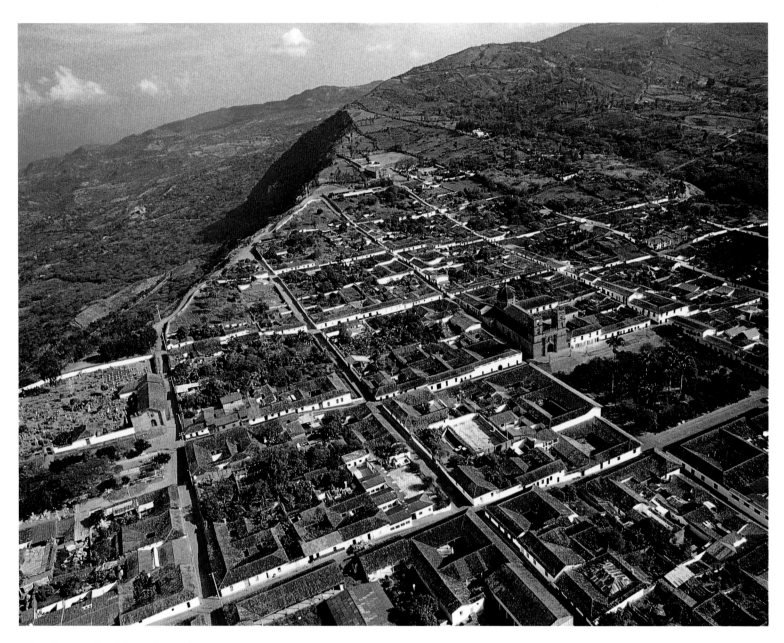

Colonial town of Barichara, Santander.

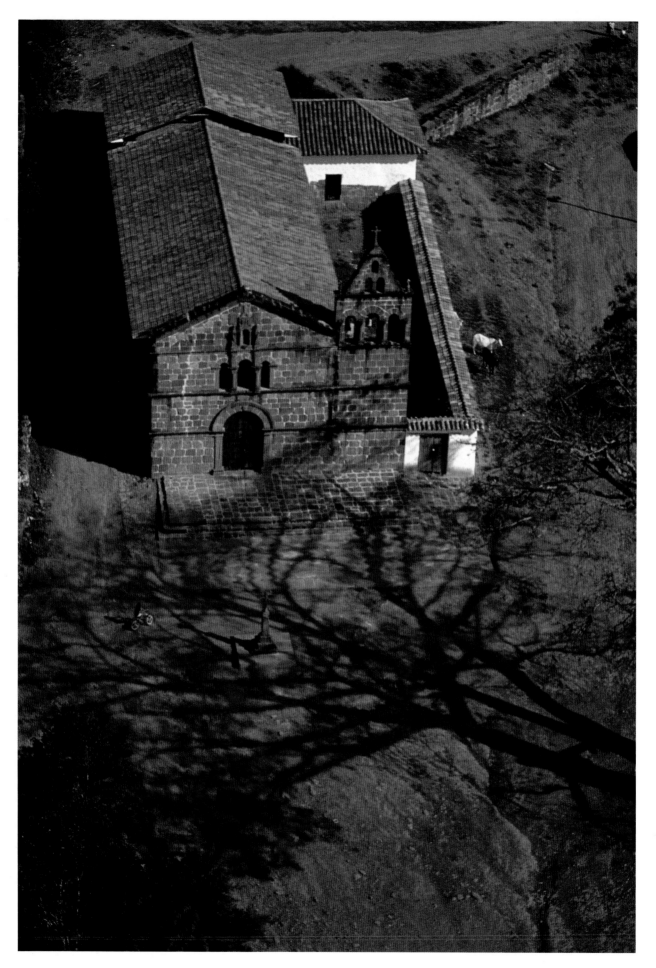

Ancient colonial church, Barichara, Santander.

Knife-edge of Peñablanca Ridge, Boyacá.

Dawn over the Peña Negra Range south of Jericó, Boyacá.

Rural zone of Soatá on the banks of the Chicamocha River, Santander.

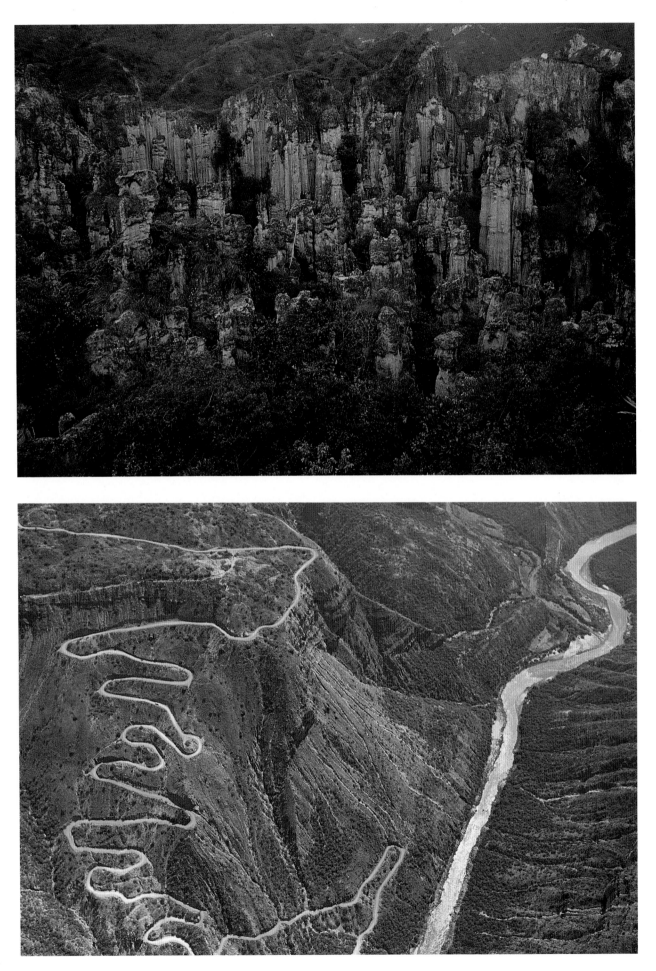

Rock formation in the Nature Preserve of Los Estoraques, North Santander.

Canyon of the Chicamocha River, Santander.

Bridge over the Chicamocha River, Santander.

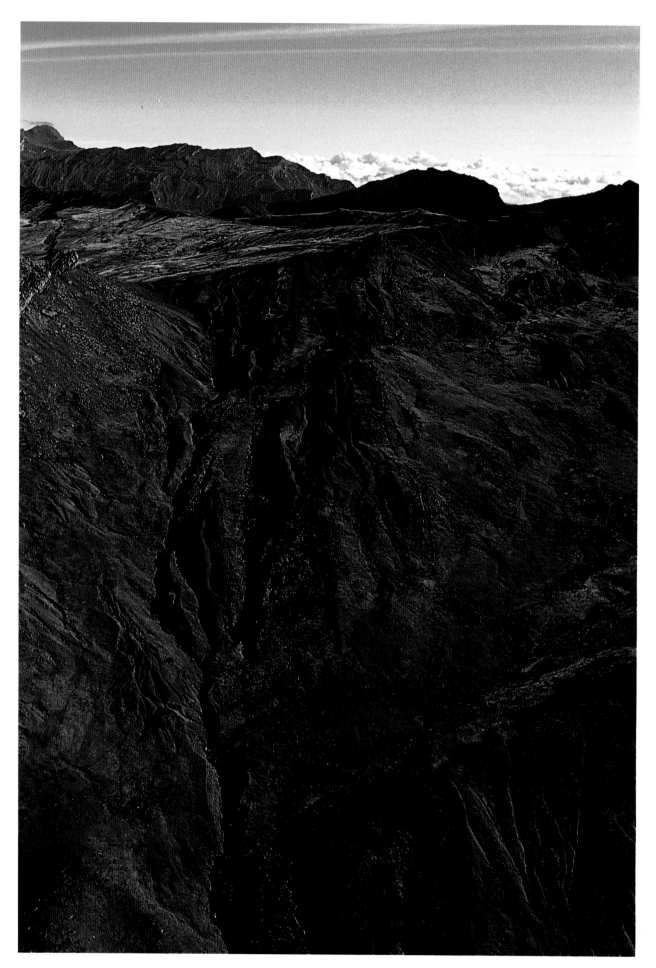

Traces of glacial slippage on the south slope of the Sierra Nevada of El Cocuy, Boyacá.

Corralitos River near Güicán in the Sierra Nevada of El Cocuy, Boyacá.

Summits of Ritacuba in the Nature Preserve of El Cocuy, Boyacá. ⇨

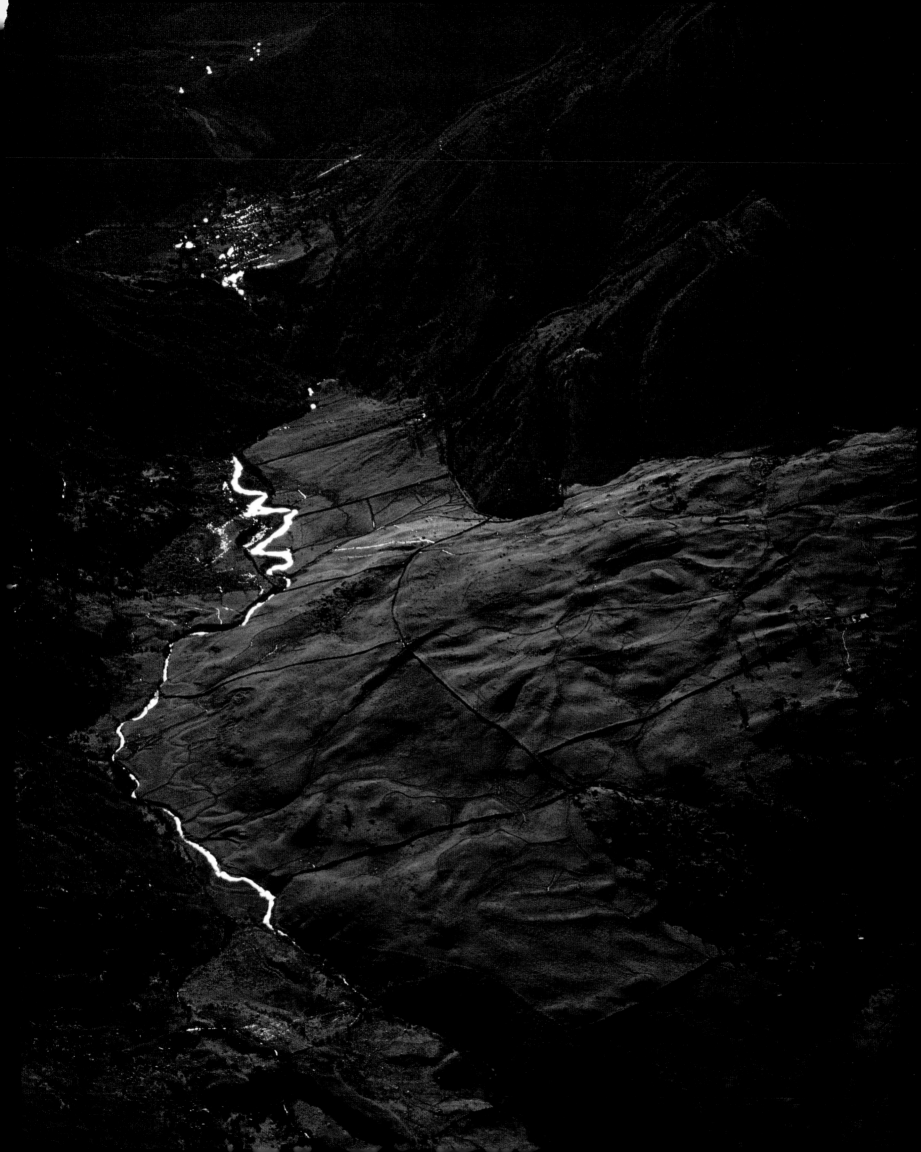

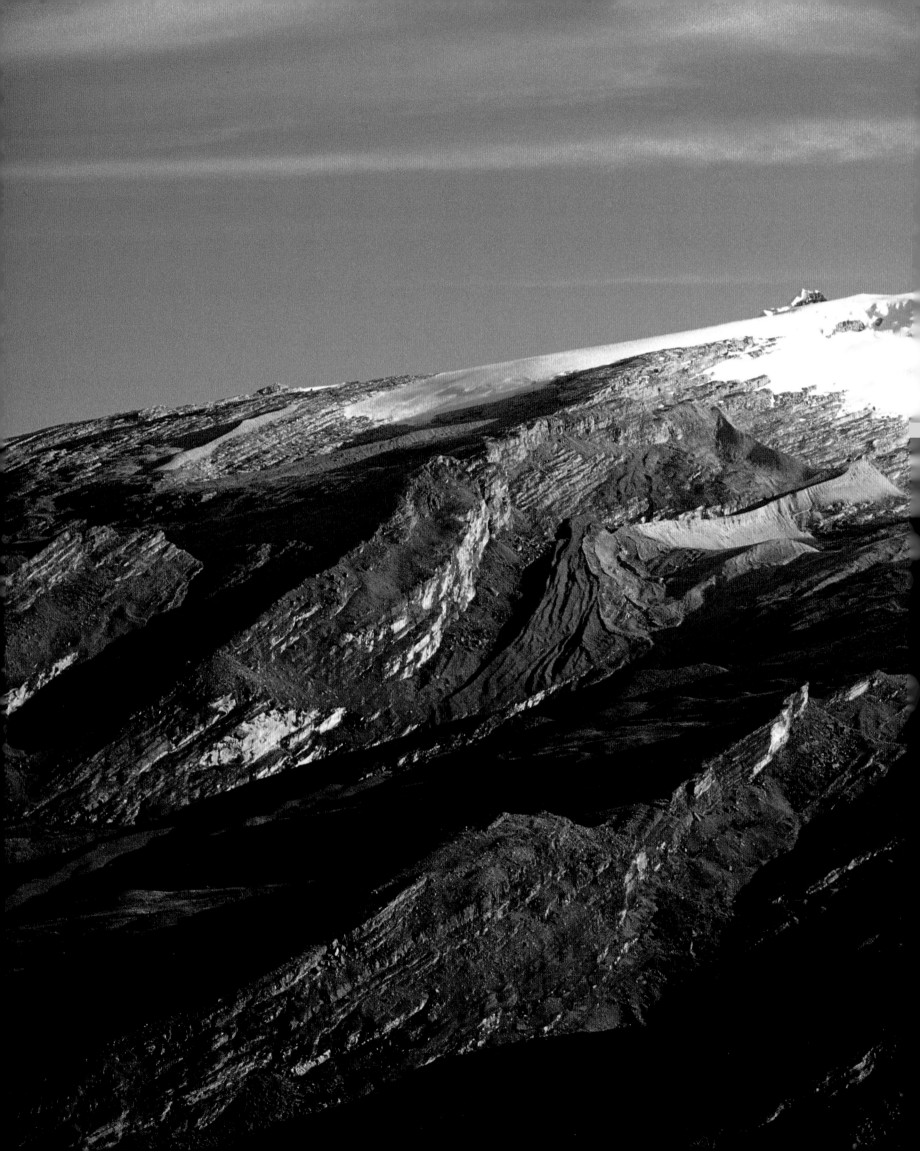

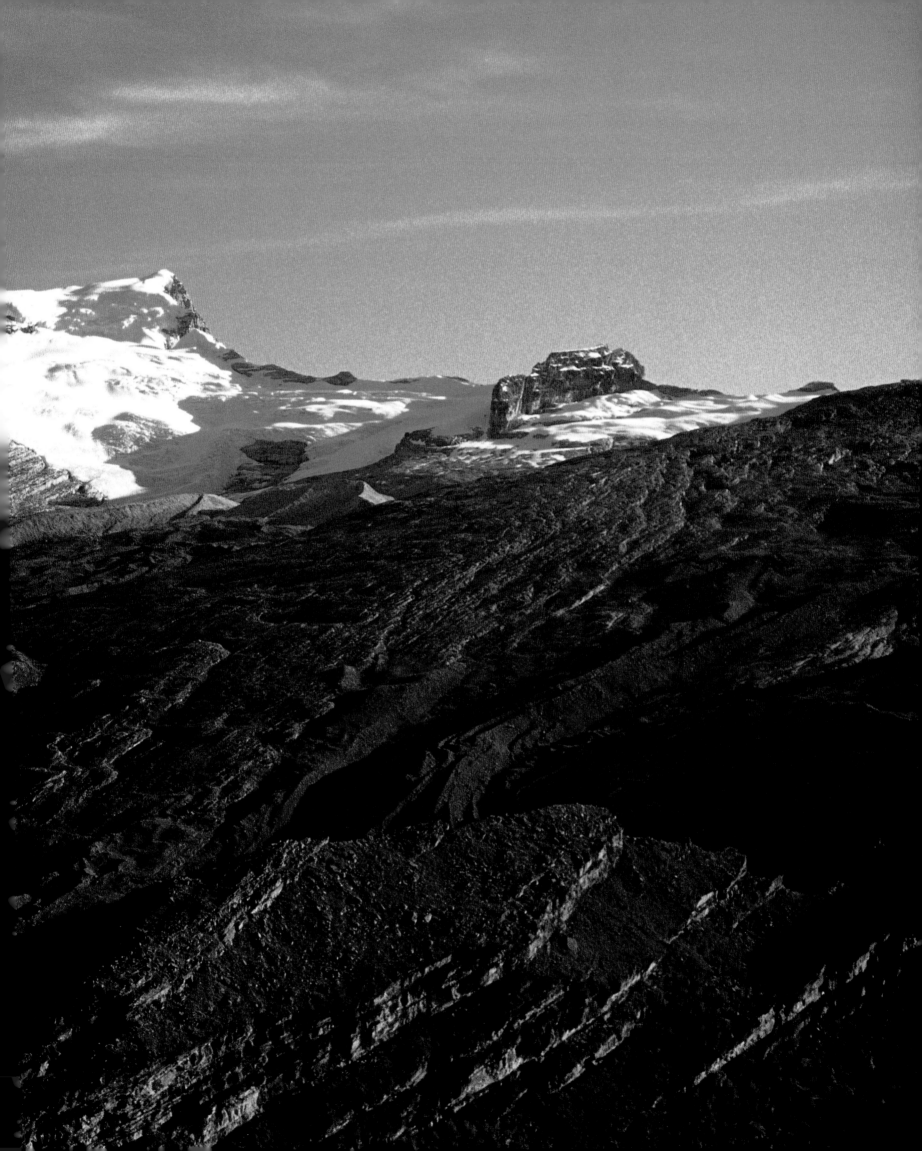

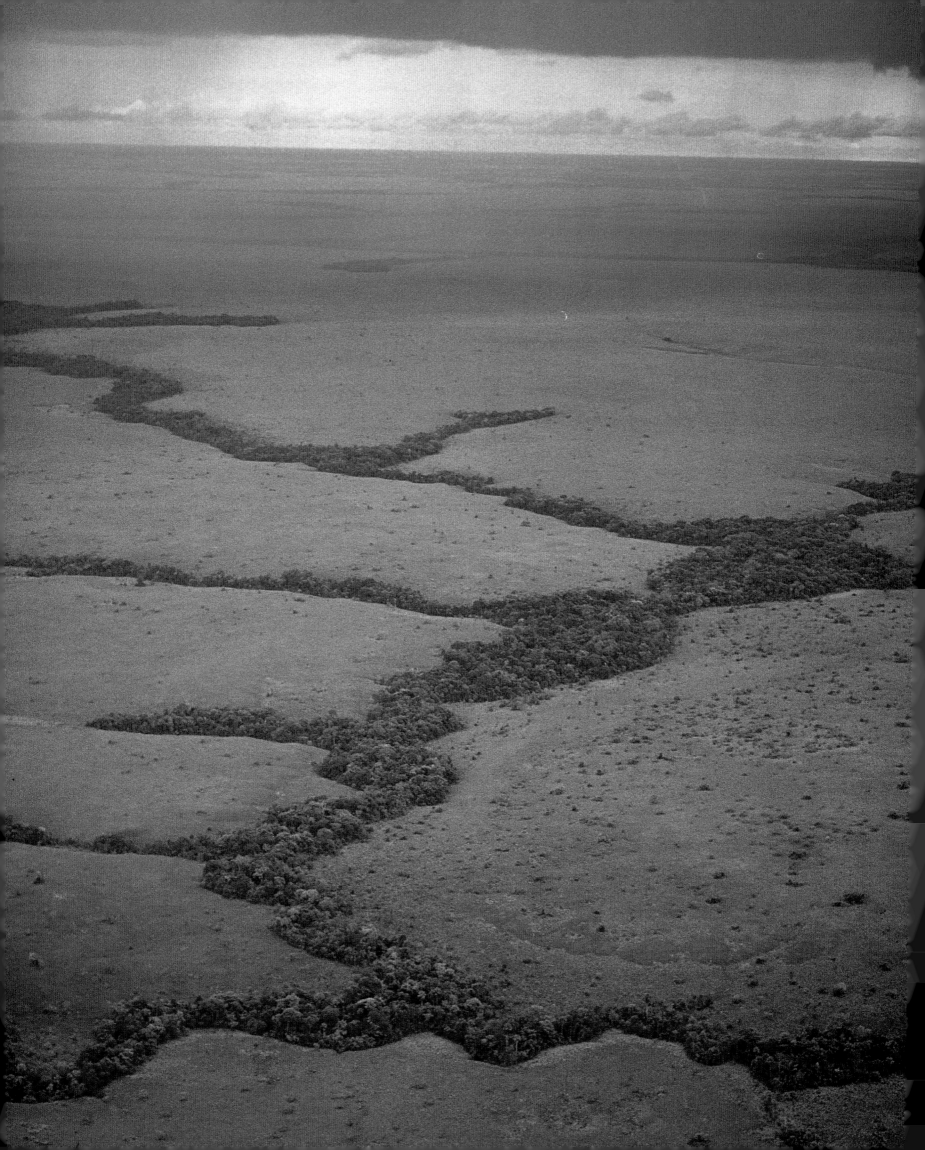

PLAINS AND JUNGLE

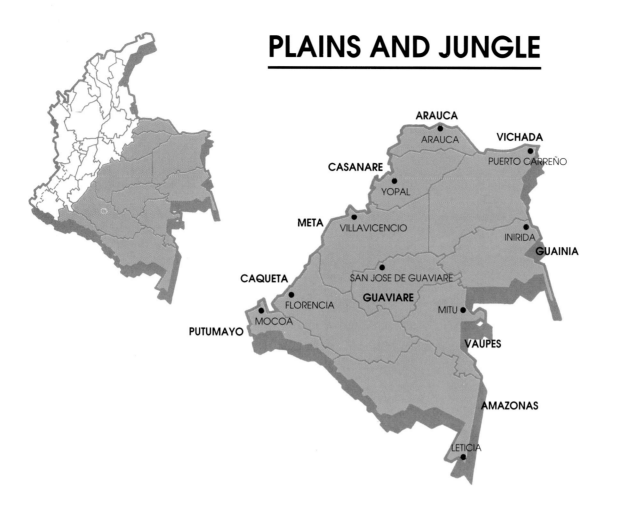

Even though these regions comprise over half the territory of Colombia, less than five per cent of Colombians live in the Orinoco and Amazon basins. Just as well. Because, whereas there has been relentless pressure on the Andes, the low population density has insured the survival almost intact in many parts of the Orinoco and Amazon basins, of fragile ecosystems both in the jungle and on the Plains, and of close to eighty ethnic groups whose numbers represent scarcely ten percent of the native Colombian population. These groups range all the way from populous ones like the Tukano of Vaupés and the Hitoto of Igará-Paraná, to isolated communities, like the Bora of Amazonia and the semi-nomadic Sáliva and Cuiva of Casanare, whose numbers total only several hundred. And from tribes whose cultural identity has been almost destroyed through decades of contact with white colonizers, to the Makú of Vaupés, gatherers of insects, seeds and berries ❑ Looking at the map of Colombia, one might think that the Amazon and Orinoco regions were monotonous and uniform. In fact they are a patchwork quilt on which every particular interaction between soils, flora, fauna, rivers and humans produces its own special conditions. Many of the techniques and patterns of environmental adaptation of the indigenous Andean cultures were learned from the tribes of the Amazon. Many vegetable species, both edible and ritualistic in application, such as the pineapple, the yucca, the peanut and tobacco, as well as the *yajé*, the *yopo*, and coca originated and were domesticated in the humid tropical jungles and somehow spread to the cordilleras in pre-Hispanic times ❑ The Colombian Orinoco is a territory of nearly 100,000 square miles included between the Eastern Cordillera (a wrinkle of the Guiana Shield as it presses upon the Andes), the plains of Venezuela and the Inírida and Guaviare Rivers, south of which Amazonia begins. The Orinoco region comprises the area of the present Departments of Arauca, Casanare, Meta, Vichada and part of Guaviare. (While de-

"Observation gallery" woods on the savannah of the Vichada.

partments named after the Republic's founding fathers abound in the Andean region, all those in the Amazon and Plains country take their names from their principal rivers.) The ecology of the so-called Eastern Plains is shaped by their expanses of pasturelands, their *morichales* (plantations of coconut palms), their savannahs flooded much of the year, their "observation gallery" jungles lining the banks of the watercourses, the patches of jungle dotting the savannahs–each an ecosystem with a cycle of its own and a fauna quite distinct in morphology and habits. Shaped, too, by endless cattle ranches which since colonial times have supplied the Andes with meat ❑ For some time now, as well, exploitation of oil deposits has been transforming the economy and the day-to-day life of the Plains country. The first Spanish settlements on the Eastern Plains were San Martín (1540), San Juan de Arama (1556) and Chámeza, settled and resettled several times between 1566 and 1600. At the end of the eighteenth century Orocué, on the banks of the Meta River (a tributary of the Orinoco) was an important port of trade between Colombia and Europe via Ciudad Bolívar in Venezuela. Villavicencio, the most important city of the Colombian Plains, was founded in 1842 by cattle-men and traders. Other capital cities of Amazonia and the Plains, such as Mitú and Puerto Carreño, date only from the twenties and thirties of this century ❑ The Amazonian region covers some 156,000 square miles between the Inírida and Guaviare Rivers on the north and the Amazon and Putumayo on the south. It numbers a population of about half a million, eighty percent of whom are immigrants and settlers. Politically speaking, it is divided among the Departments of Guaviare, Guainía, Vaupés, Caquetá, Amazonas and Putumayo. Each section of Amazonia is a complete universe, inimitable, exuberant and fragile. In this region there are jungles that grow on terraces immune to flooding; the natives call them "restingas." "Igapó" they call the riverbanks which, when the rivers rise, fill up with deep, dark, transparent waters rich in vegetable tannins. The "tahuampas" or "várzeas" are great expanses of jungle made fertile by rivers of "white" water laden with sediments washed down from the Andes. (In Amazonia biodiversity does not stop at cultures, flora and fauna; it takes in riverwaters as well.) The natural economy of the Amazon basin depends essentially on the life gestated in the *várzeas*. An expert, Mario Mejía, sees as the only kinds of long-term agriculture possible in the dank South American tropics: *várzea* agriculture, the utilization of terrain made fertile by the mire left behind by the periodic rises of the rivers), and the "tenant garden" (called "conuco" or "chagra"), "the piece of ground the native borrows from nature for two or three harvests." These are age-old practices of mutually respectful accomodation between communities of the Amazon and ecosystems of poor soils, under conditions which in "Western" terms would appear to be totally inhospitable and insalubrious ❑ Just as there are patches of jungle in the midst of the Plains, so there are stretches of plain in the middle of the jungle. Wherever the rocky substratum surfaces or the soils are sandy and chalky the vegetation is stunted. "Tepuy" is the name given to an often enormous outcropping of rock which unexpectedly surfaces in the midst of the jungle; the *tepuy* of Chiribiquete, for example, is some 5,000 feet high. The natural reserve of La Macarena Range, in the Department of Meta, covers some two and a half million acres. It combines features of the Amazonian, Orinoco and Andean regions, giving rise to phenomena not found anywhere else in the world, biogeographically speaking. Within its seventy-five-mile length and its nearly twenty-mile breadth, in its valleys, tablelands and mountain peaks (which rise to over 8,000 feet) it contains a complex system of rivers and twenty-seven per cent of the bird species of Colombia. Leticia, founded in 1867 at an angle of the "Amazonian trapezoid," on the Amazon River, is the southernmost city of Colombia ❑

La Garganta del Diablo (The Devil's Throat Gorge) in the Araracuara canyon, Caquetá.

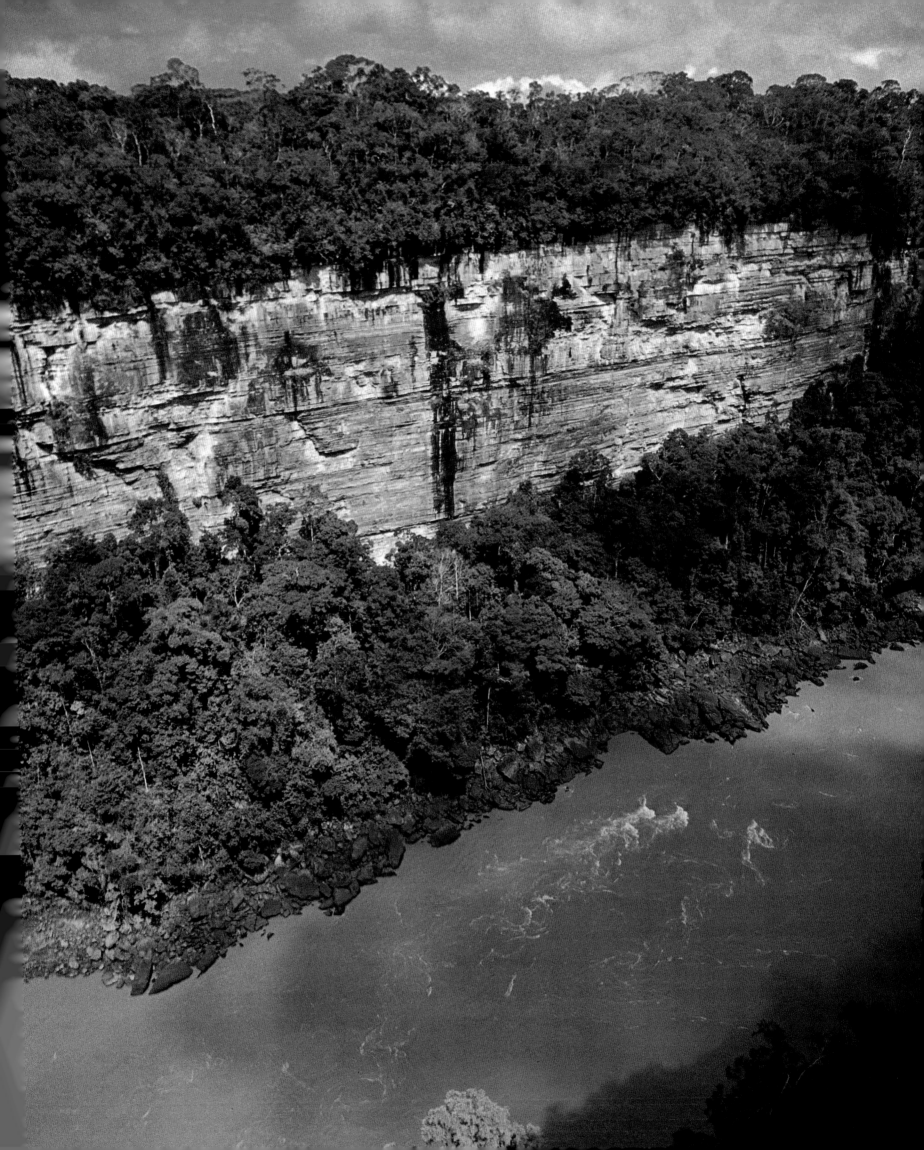

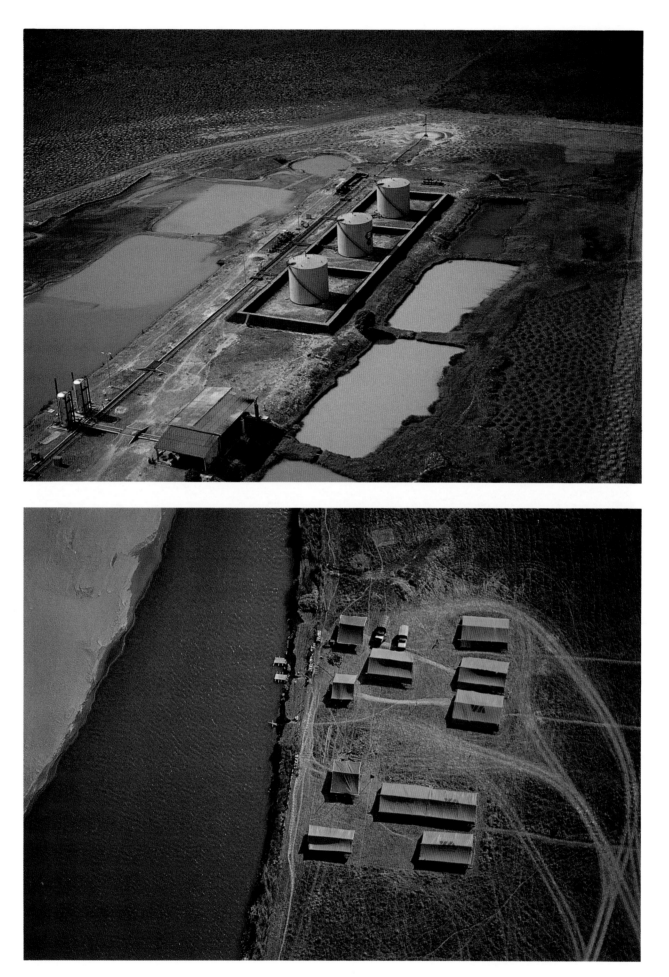

Storage tanks at an oil field, Casanare.

Seismic camp during prospecting for oil, Casanare.

South Cravo River with Yopal, capital of Casanare, in the background.

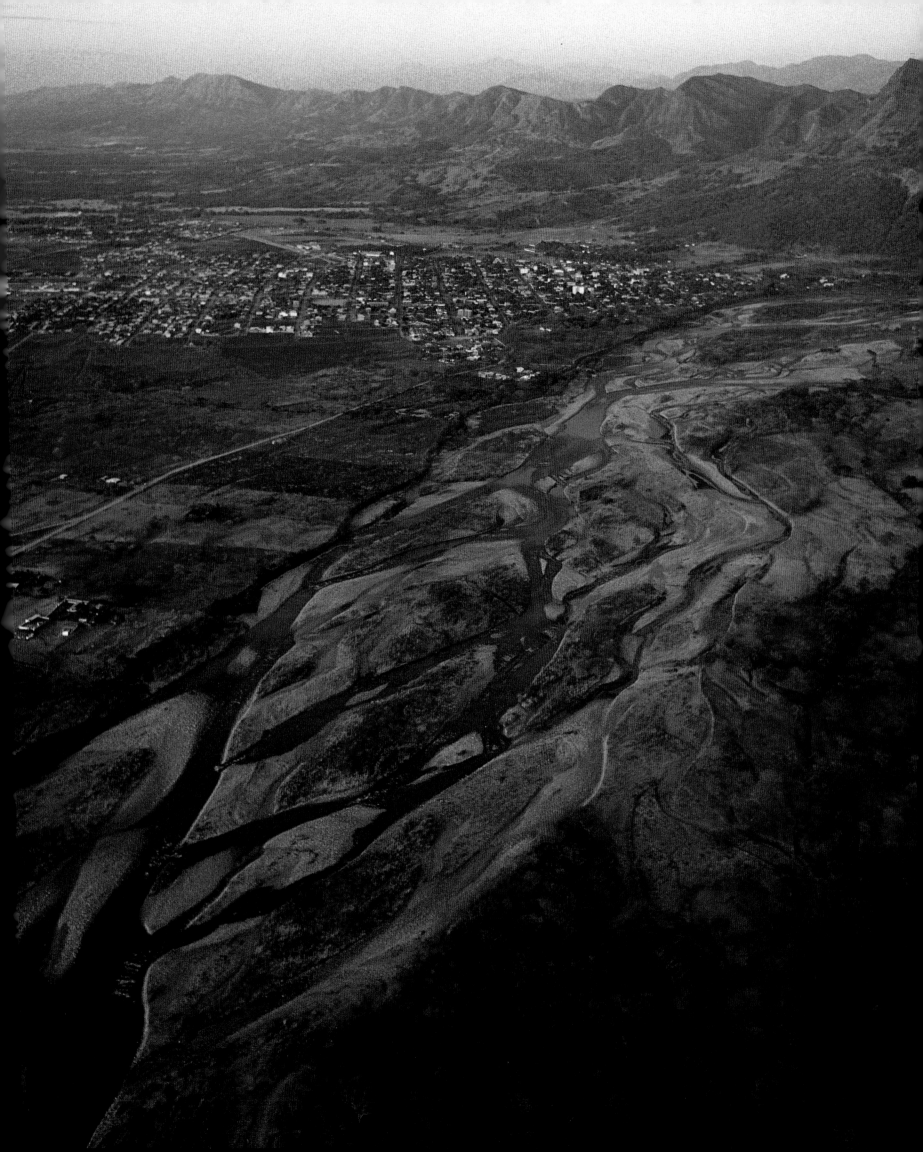

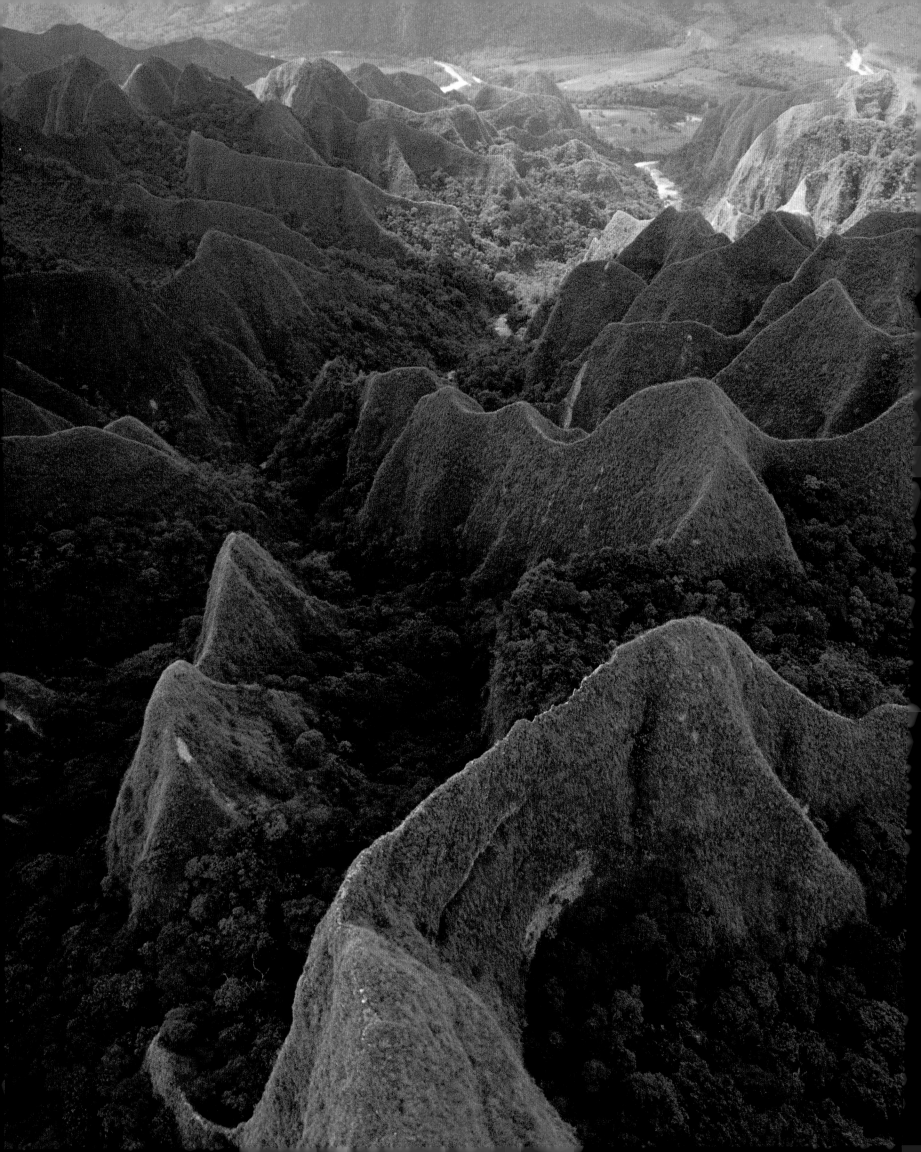

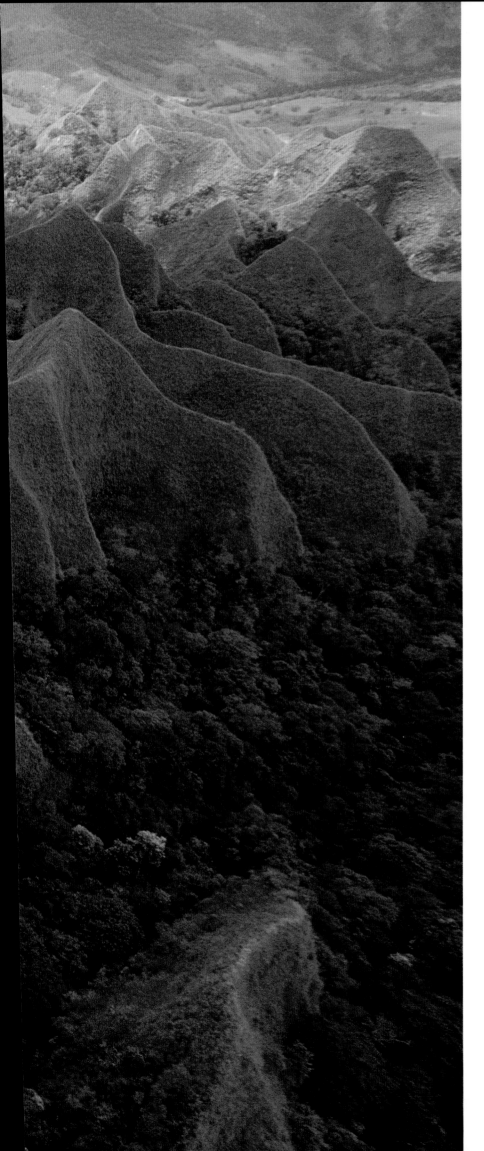

"Observation gallery" jungle after burnover, Casanare.

Flowering *chicalá* tree on the Meta plains.

Zorro (Fox) Ridge on the Casanare-Boyacá border. 165

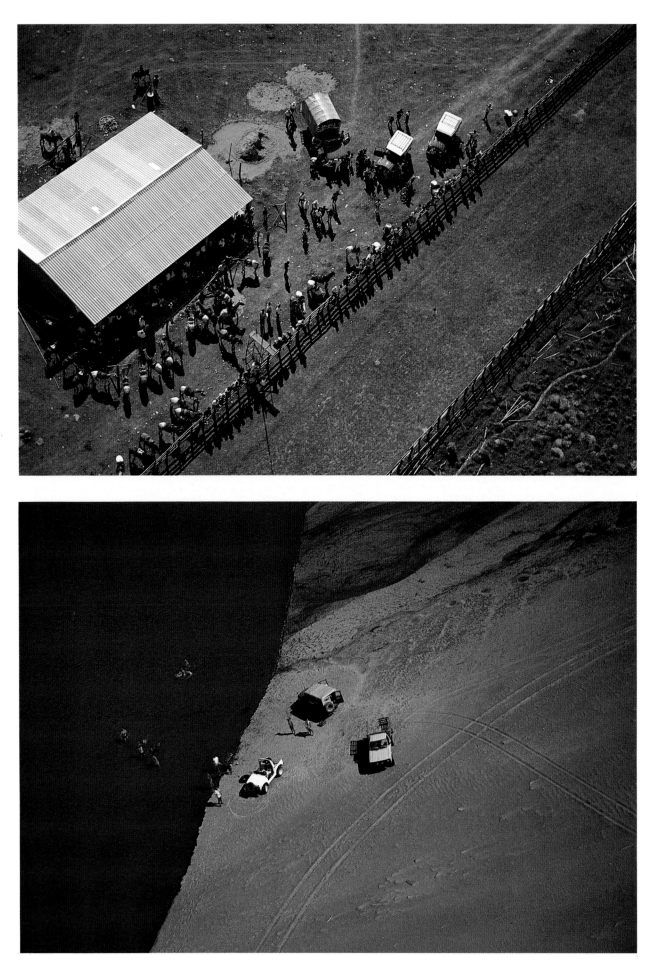

"Tail-pulling" track, La Maporita, Plains of the Casanare.

Bathers on the beaches of the Meta River, Meta.

Cattle ranch on the banks of the Pauto River, Casanare.

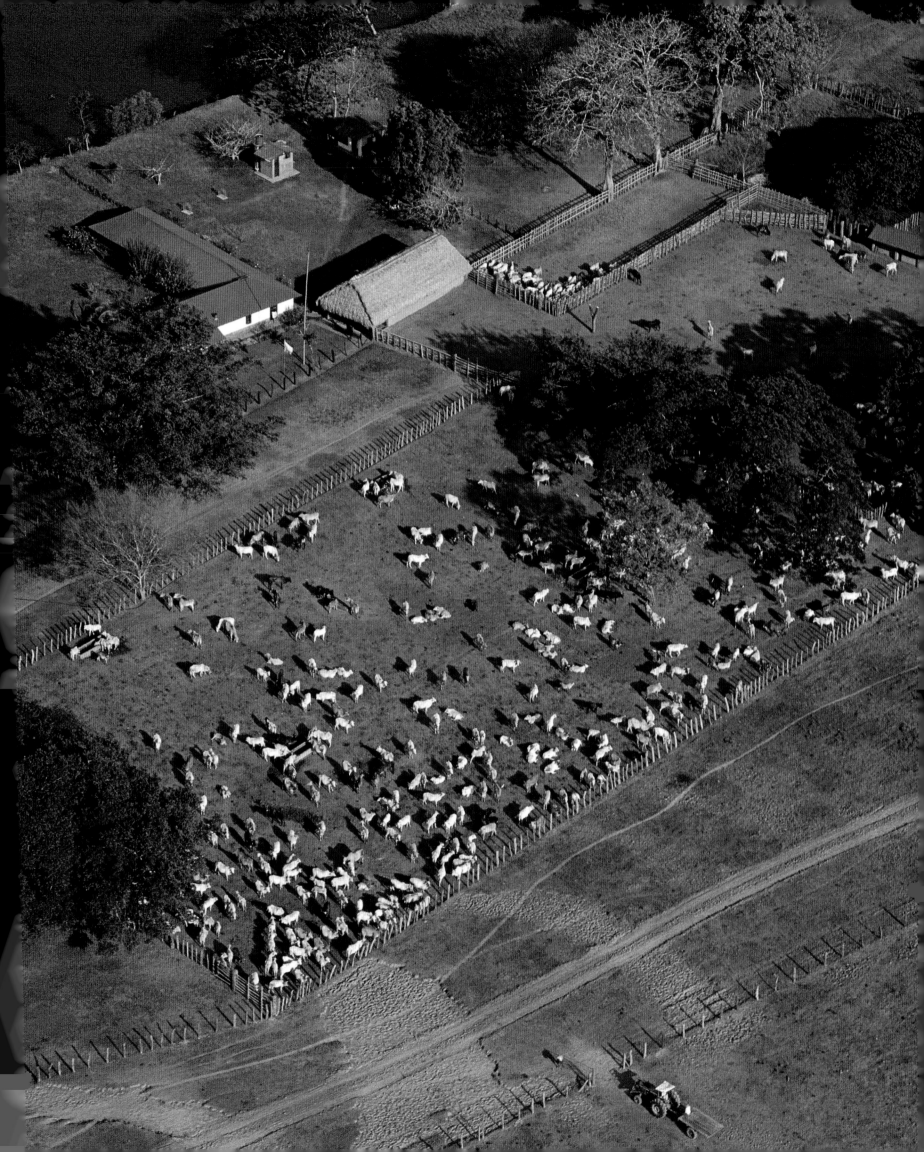

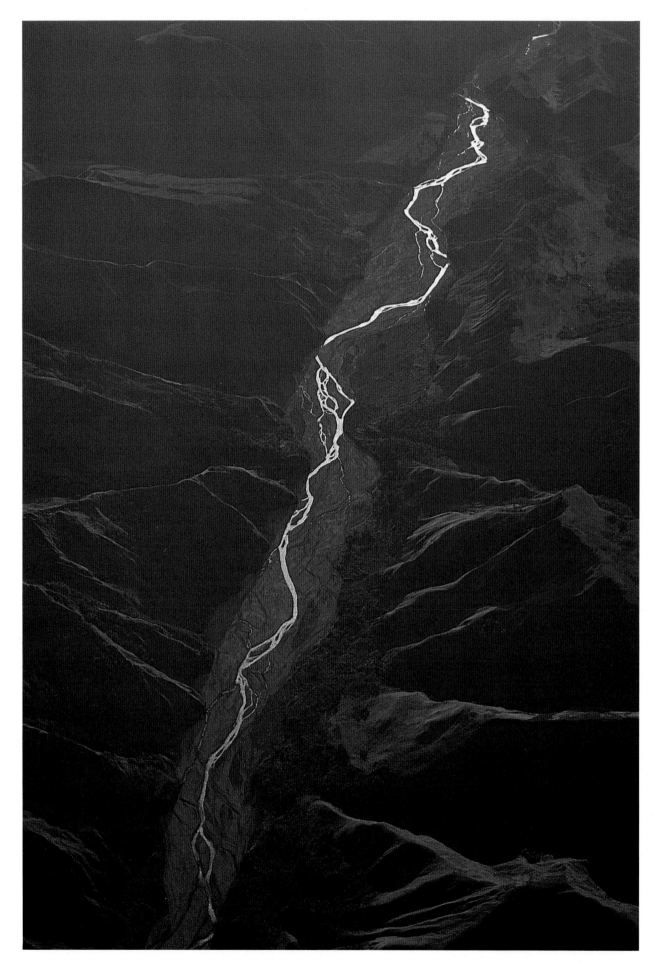

Casanare River flowing down from the Eastern Cordillera, Casanare.

Dawn on the Tocaría River, Casanare.

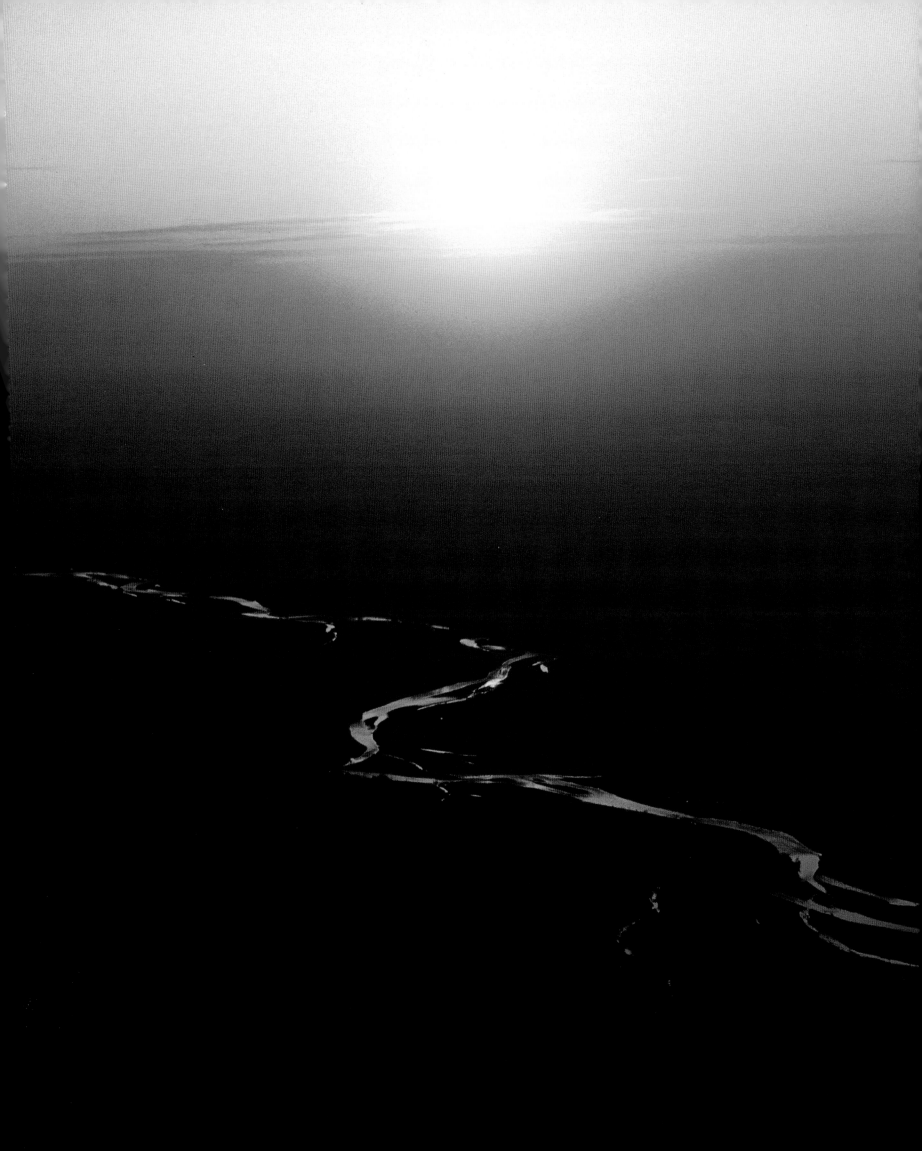

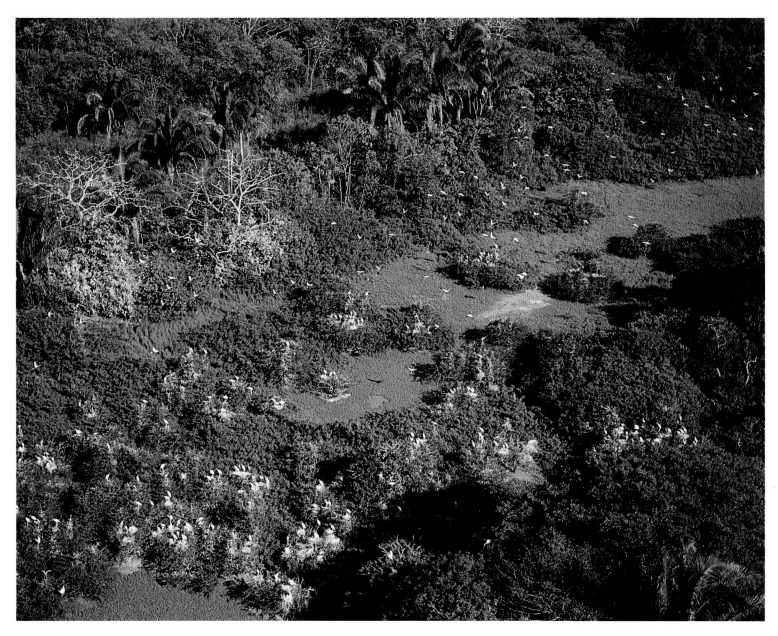

Heron colony in a swamp on plains of the Arauca.

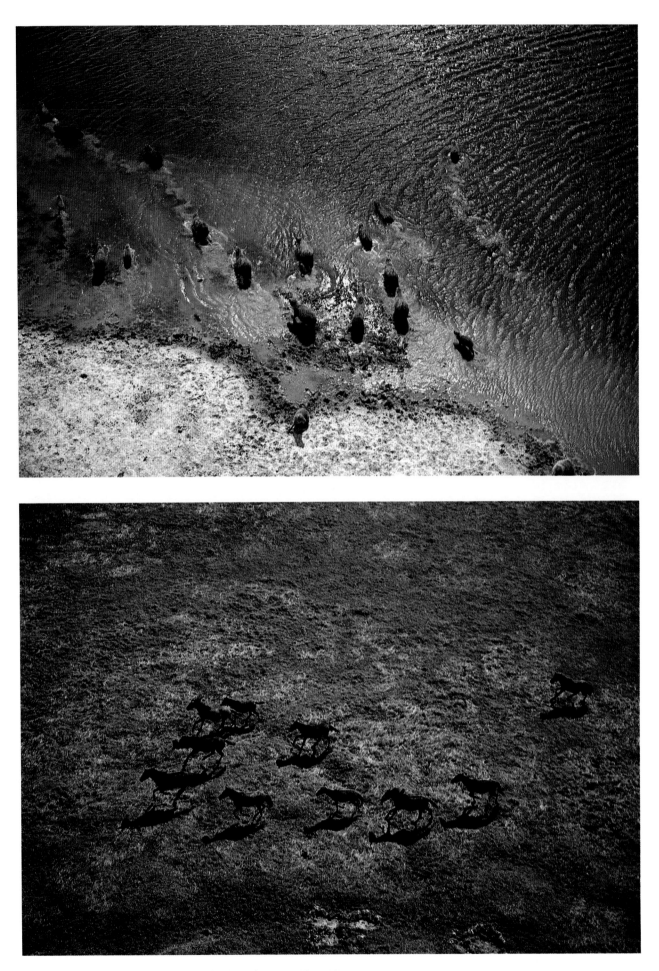

Pack of *chigüiros* in a watercourse running into the Meta River, Meta.

Cattle-herding horses on the savannahs of the Arauca.

Beaches on the Vichada River in summer, Vichada. ⇨

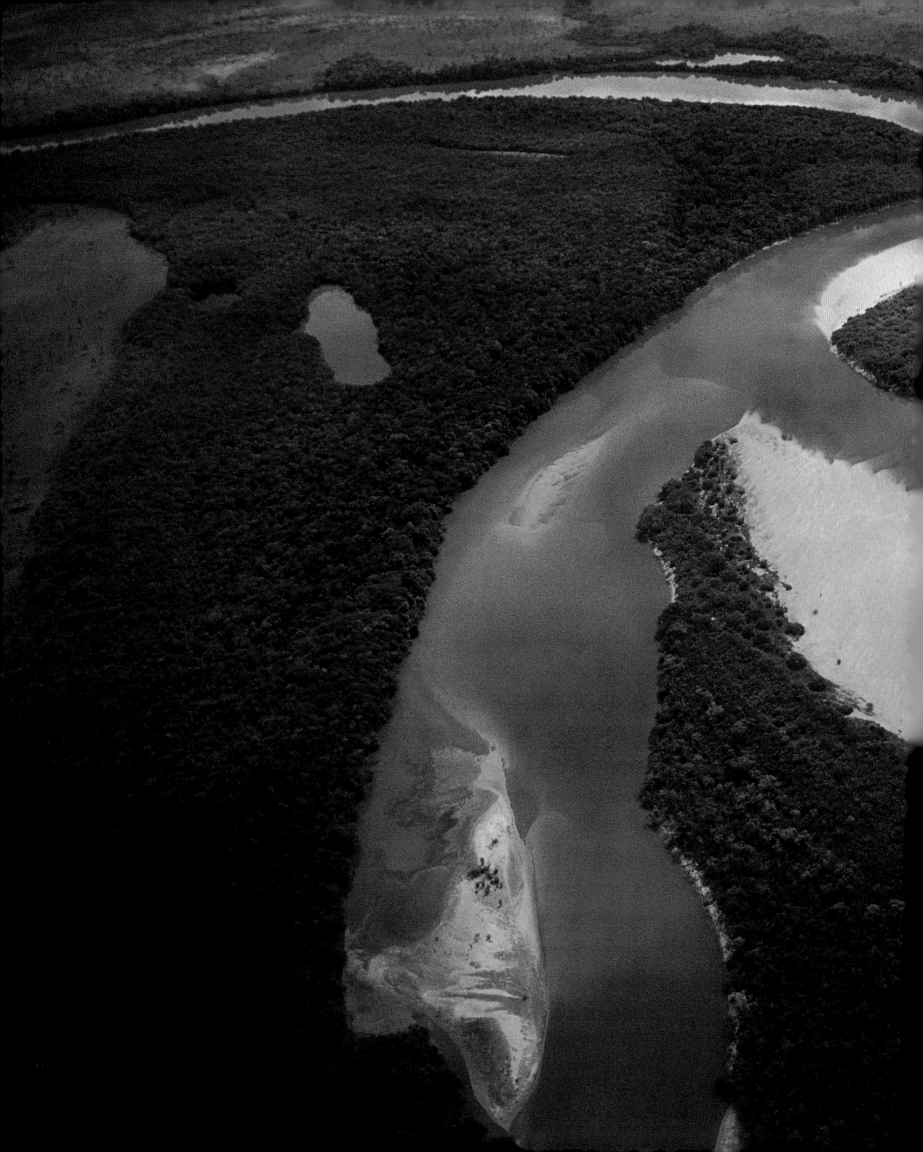

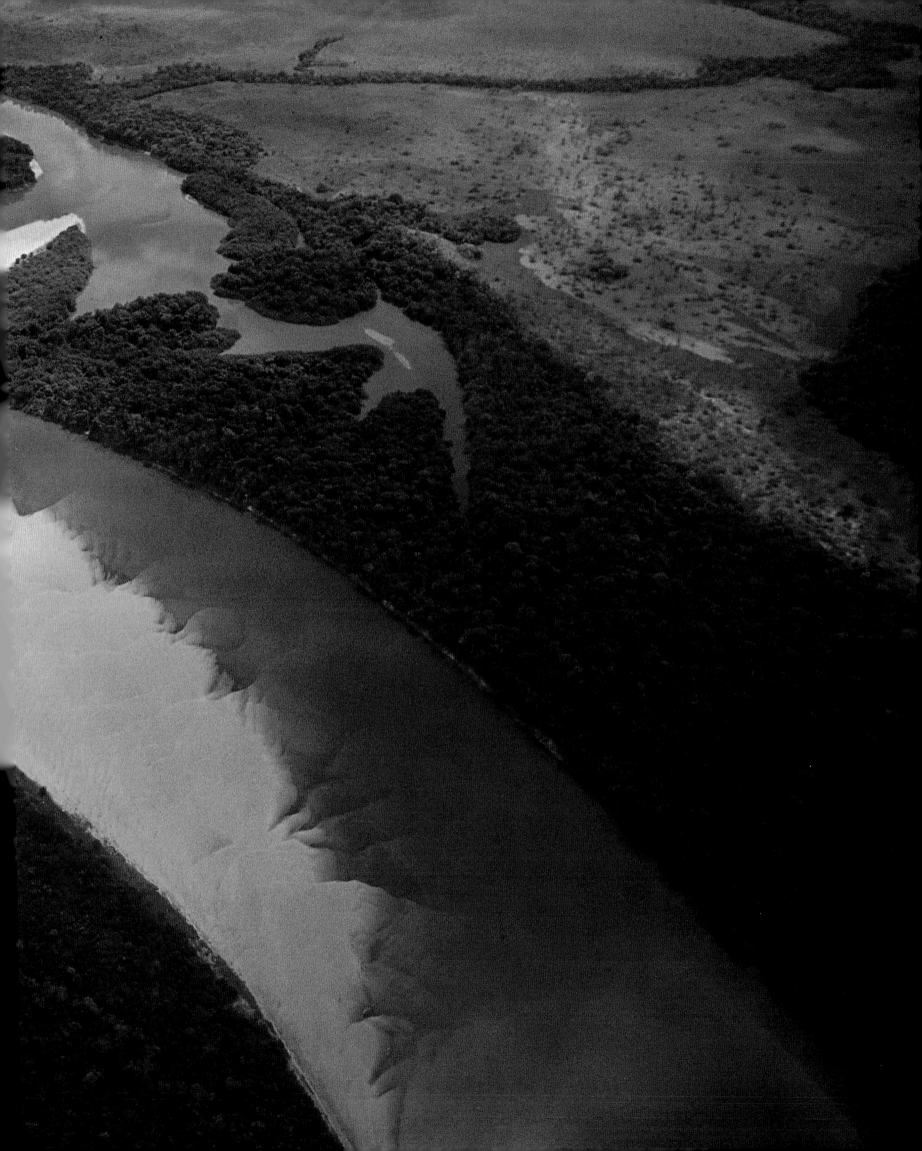

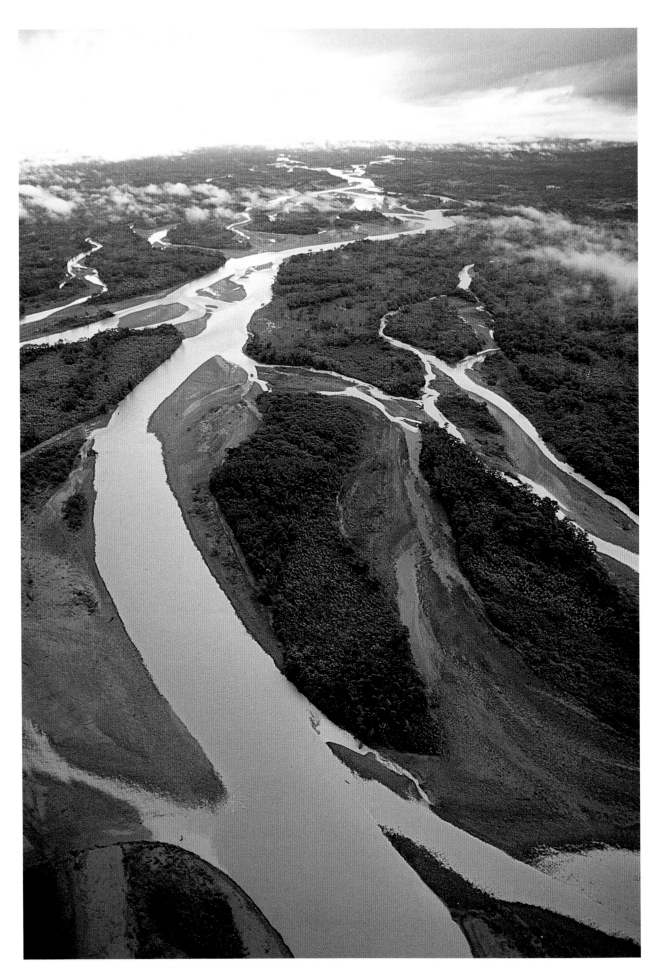

Headwaters of the Caquetá River on the Andean piedmont, Caquetá.

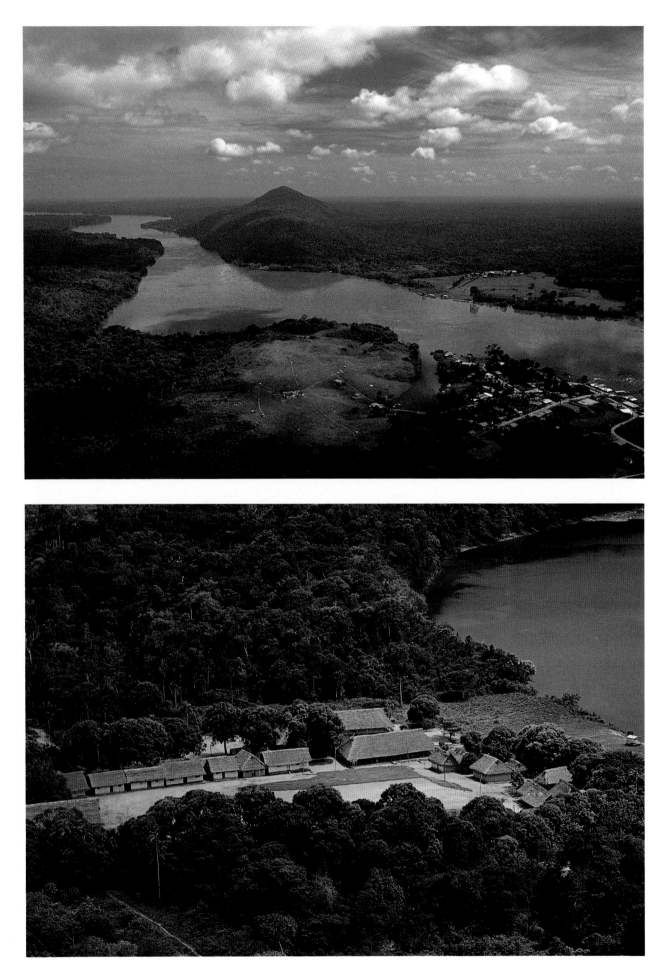

Town of La Pedrera on the Caquetá River near the Brazilian border, Amazonas.
Indian village of El Remanso on the Inírida River, Guainía.

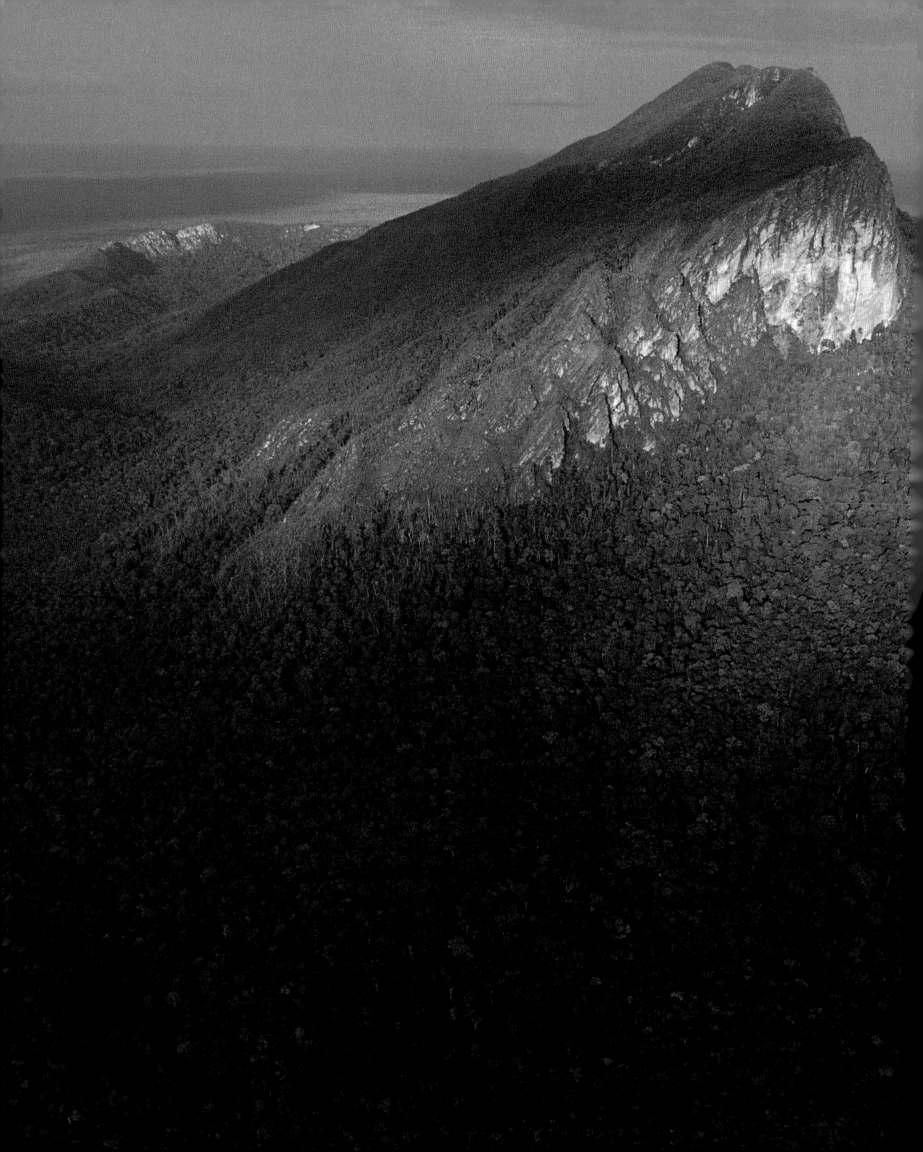

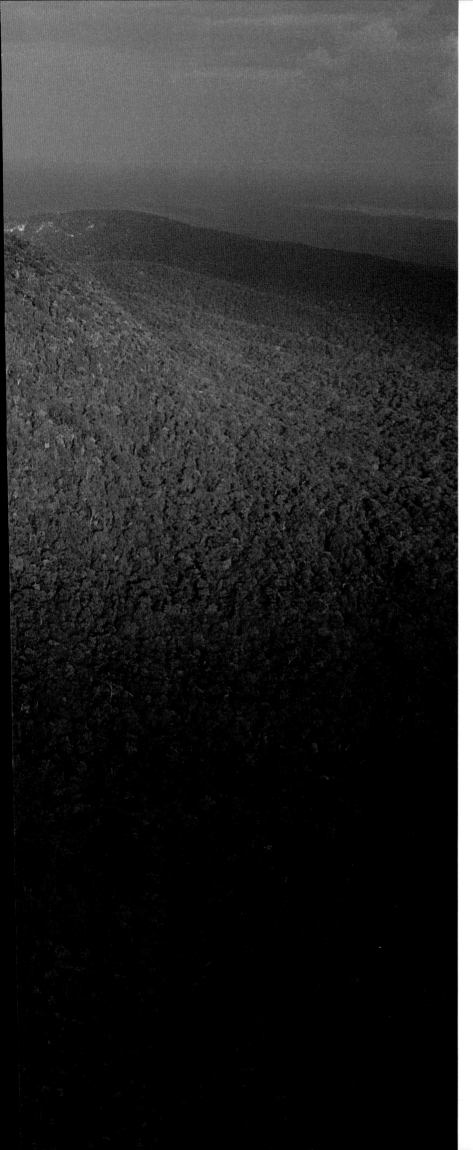

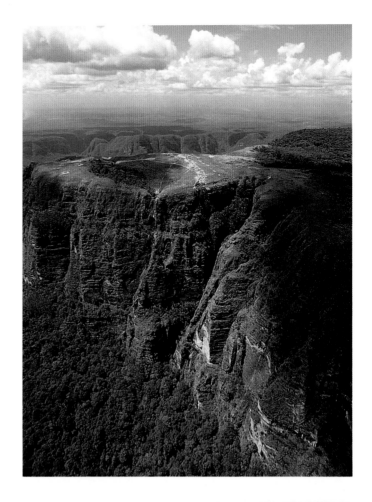

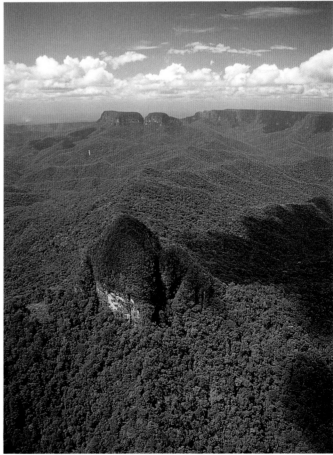

Sierra de la Macarena Nature Preserve, Meta.

Naquén Ridge, a *tepuy* in the south of Guanía. 177

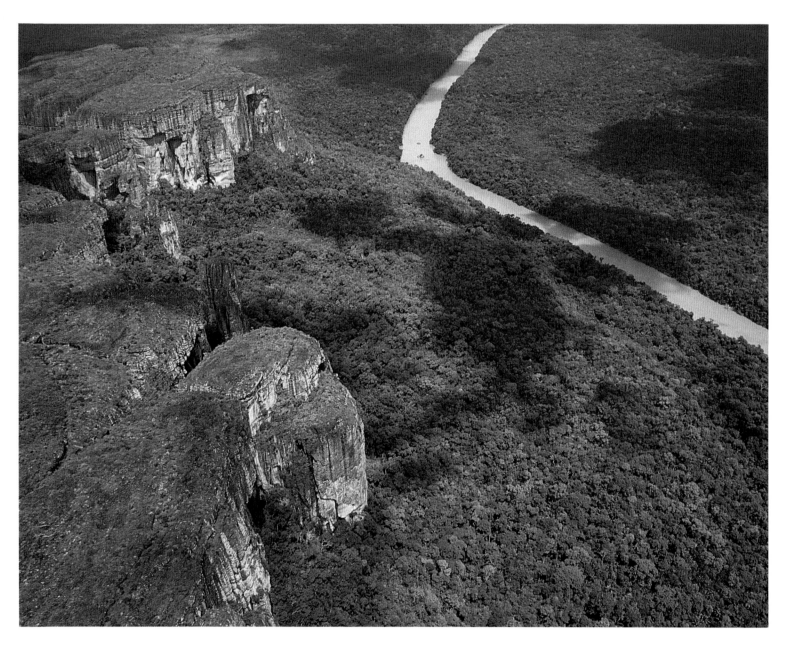

Chiribiquete Nature Preserve on the Apaporis River, Guaviare.

Amacayacú National Park on the Amazon River, Amazonas.

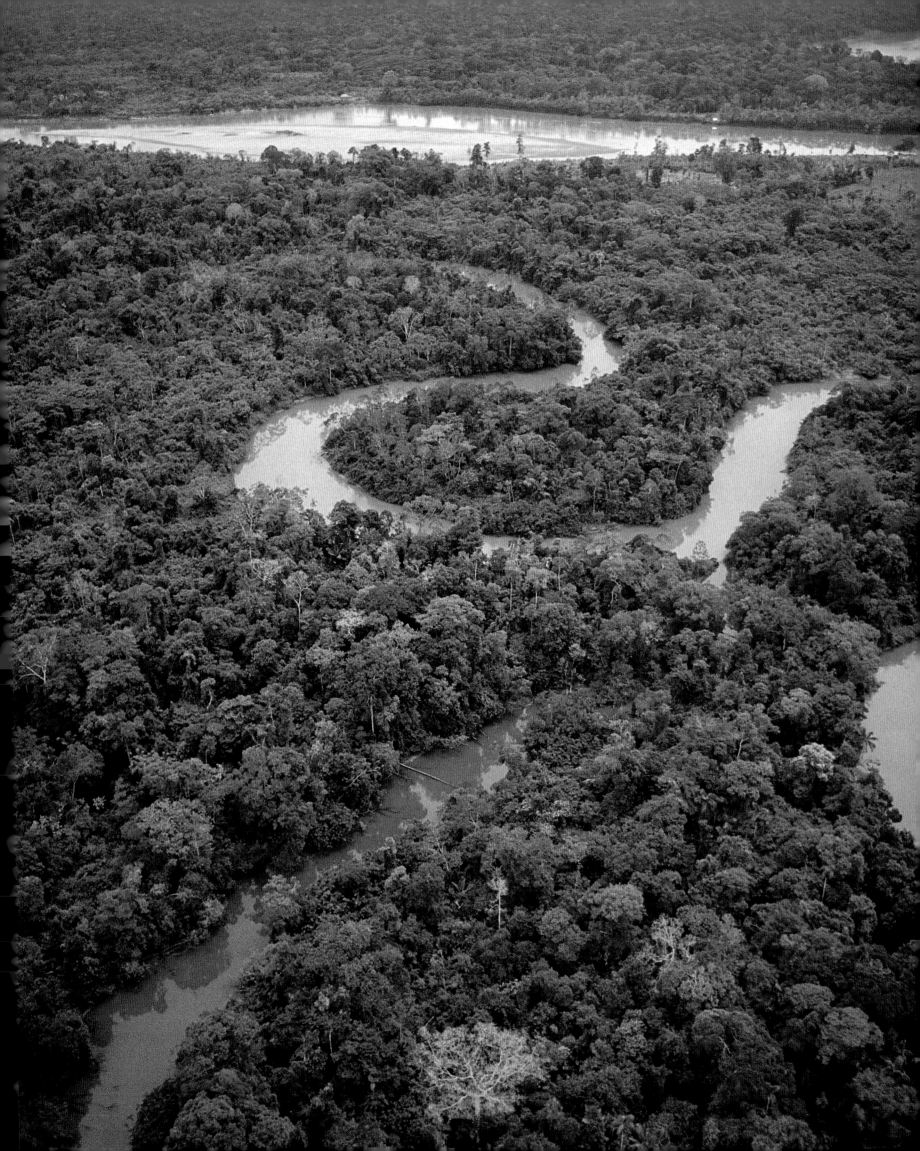

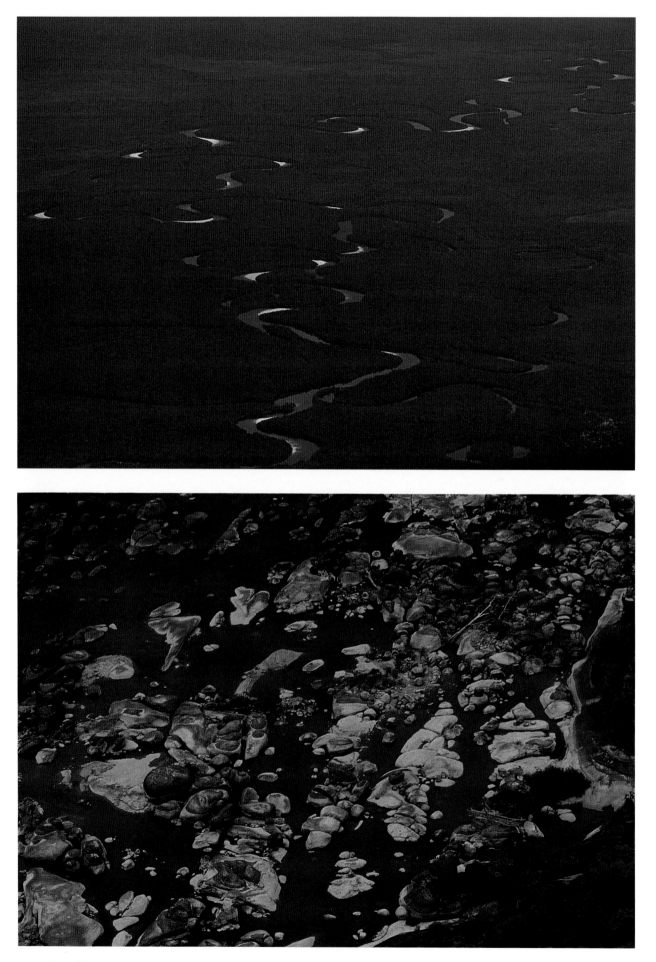

Meanders of the Querarí River, Vaupés.

Maipures Rapids on the Orinoco River at the Venezuelan border, Vichada.

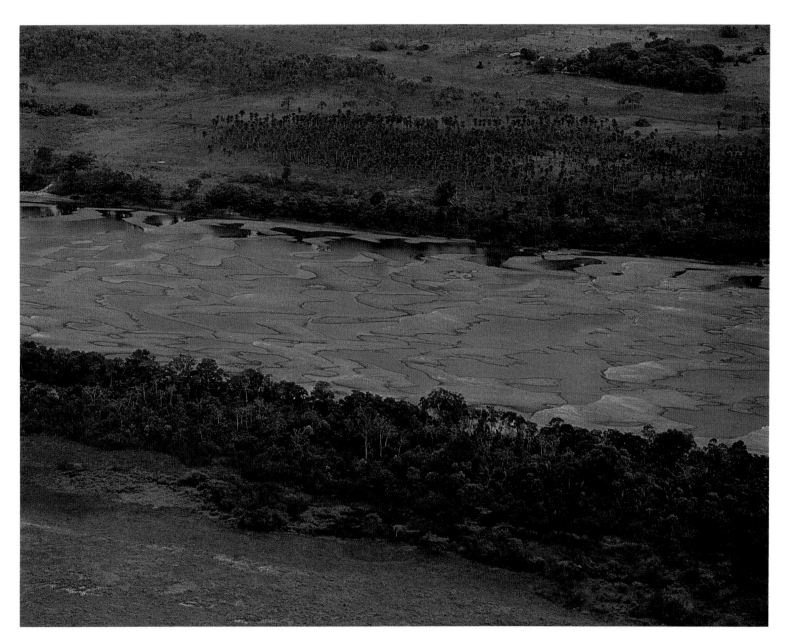

Sand flats in the bed of the Orinoco River in summer, Vichada.

Summer afternoon on the beaches of the Vichada River, Vichada. ↪

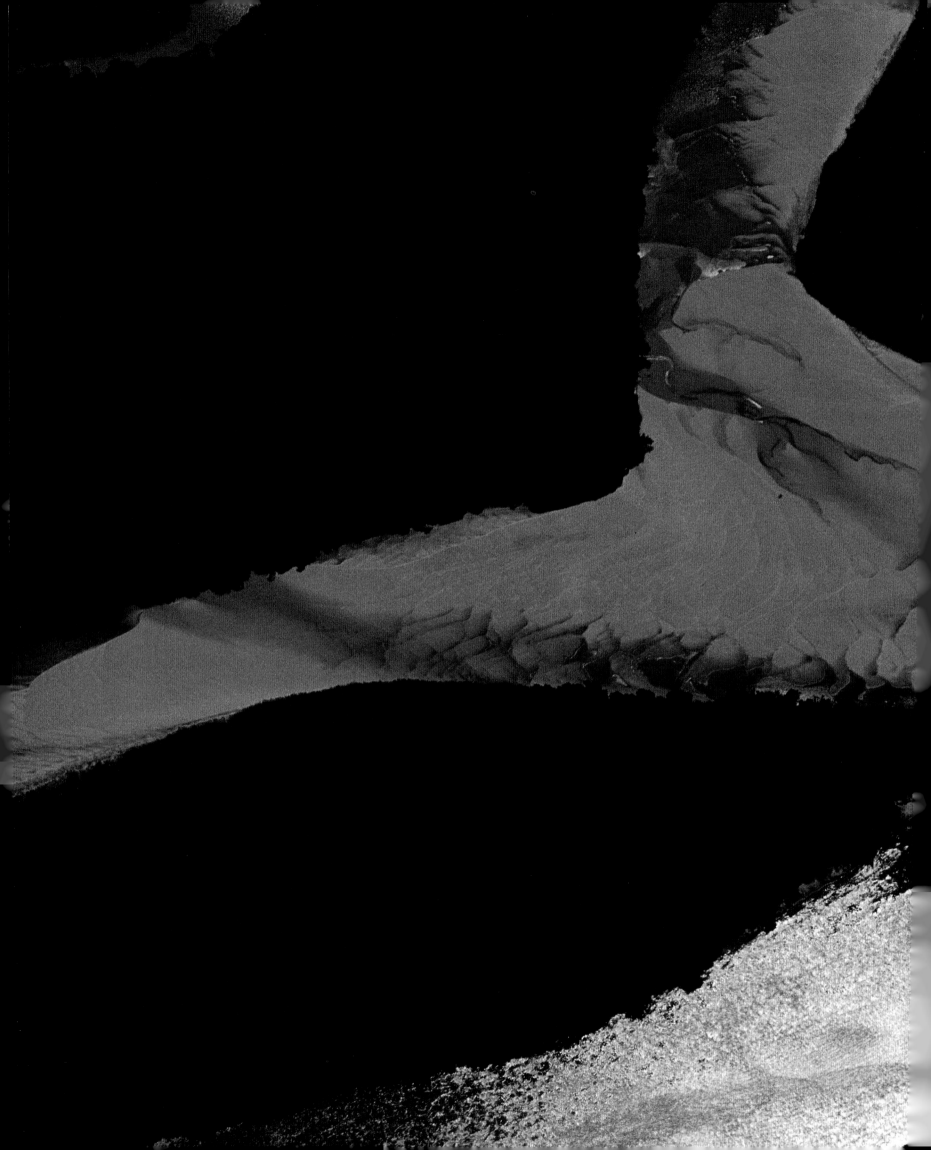

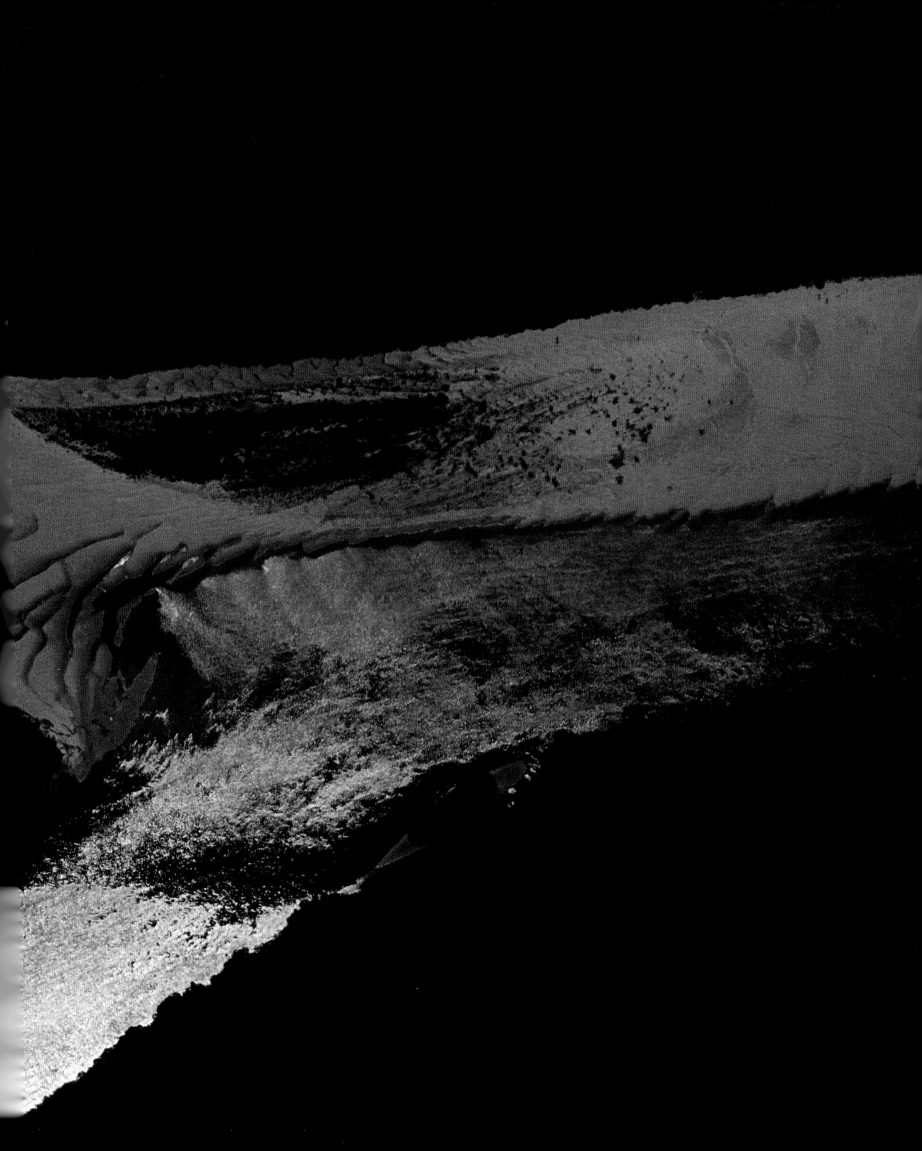

BACKGROUNDS TO THE PHOTOGRAPHS

ATLANTIC COAST

Jacket, 22/23. For Colombians the name Manaure–like Galerazamba and Bahía Honda–has always savored of sea-salt. Until the end of the last century, the working of salt was a source of conflict between the states of the Atlantic, which claimed the salt flats ast heir own, and the central government, which in 1885 managed to gain exclusive possession of them as property of the nation. According to historians, at the end of the last century the extraction of salt, whether from mines or from the sea, became, after customs duties, the main source of income of the central government. We learn from the chronicler Juan de Castellanos that from remote times the natives of La Guajira traded in pearls and sea salt with the tribes of the Sierra Nevada ❑

2/3, 15,30. The Sierra Nevada of Santa Marta holds the double distinction of being the planet's tallest mountain that has a continental coastline at it foot, and the mountain range that rises the highest in proportion to the area of its base. Bolívar and Colón Peaks (19,000 feet above sea level) are the highest in Colombia. Less than twenty-five miles from these peaks, as the crow flies, are the waters of the Atlantic ❑

8, 27. The 37,000 acres of El Tairona, declared a national park in 1964, are spread over altitudes varying between zero and three thousand feet. Lower still, beneath the waters of the sea one finds significant coral formations–with more then fifty different species–and beds of phanerogams (seed-producing plants) which constitute important links in the chain of life in the park. In it one finds nearly three hundred different species of birds, among them the condor, which comes down from the summits of the neighboring Sierra Nevada of Santa Marta; more than a hundred species of mammals; and several turtle species, archaeological remnants of precious pre-Hispanic colonies; and many gulfs that are take-off points for the soaring Sierra Nevada ❑

12. The peninsula of La Guajira is populated by Wayuú Indians, of the Arawac family, once pearl fishers, now goatherds and blanket-weavers and engaged also in the extraction of sea-salt. Although the open coal mines of El Cerrejón, the largest such in the world, and natural gas production have changed the economic and cultural face of La Guajira and have absorbed a significant proportion of the indigenous population, the Wayuú are determined to protect to the maximum their identity, intimately bound up with the xerophytic (minimally humid) features of life in the region and its windy plains ❑

16/17, 26. The community of Nueva Venecia (New Venice) was started in 1847 as a result of a resettlement of fishermen seeking more healthful surroundings and better fishing. Along with Buena Vista and Trocas de Cataca, two other palafitte settlements–groups of houses built on piles over water– Nueva Venecia or El Morro constitutes one of the three main human agglomerations in the Ciénaga Grande (Great Quagmire). Ecological changes caused by the building of the Caribbean trunk highway, which put a stop to the interchange of fresh and salt water and killed off the mangrove swamps, have also had a grave effect on the livelihood of the area's fishermen ❑

18. The first geographical point of present-day Colombia sighted and named by European conquerors and mapmakers was the Cape of La Vela. It was so named by Alonso de Ojeda, Amerigo Vespucci and Juan de la Cosa in 1499. They had been exploring what is now the Venezuelan coast. Surely even then the sandy barren soil was worn into tracery evocative of river basins, root shapes, veins and crackling lightning ❑

19. There is no unanimity among geologists regarding the character of the Sierra Nevada of Santa Marta and of the small ranges that wrinkle up the La Guajira peninsula: Jarara, Macuira, Simarua and Parash. Whereas some hold that these mark the final upward thrust of the Andes, others insist that they are isolated orographic formations. To the Wayuú Indians, geology is scarcely a concern. In those mountain ranges of La Guajira, nowhere higher than 2,600 feet above sea level, there are sacred places where the earth "holds on to your soul" if you enter them without showing due reverence ❑

20. At the end of the sixties there began in La Guajira one of the largest and most up-to-date workings of coal in the entire world: the mines of El Cerrejón. Through Puerto Bolívar on Portete Bay, a maritime installation able to accomodate ships of up to 150,000 tons, as many as fifteen million tons of coal are exportable annually ❑

21. Riohacha. On the maps of the English pirate, Sir Francis Drake, this appears as "Río de la Hacha" (River of the Ax). The city, located at the mouth of the Ranchería River and capital of the present-day Department of La Guajira, has today a population of 120,000 ❑

24. Along the Caribbean coast, one after another, appear gulfs and bays, the most varied and eccentric coastlines formed by the age-old contact of land and sea. In the vicinity of Santa Marta, today the most ancient city of South America (founded in 1525 on the bay of the same name by the Spanish conquistador Rodrigo de Bastidas), one encounters the bays of Taganga, Concha Gairaca, Neguage, Cinto and Guachapita in territories and territorial waters of communities devoted to fishing ❑

25. Usiacurí, one of the many small centers of crafts in the Colombian Caribbean zone, allows itself the luxury of having a museum devoted to the memory of Julio Flórez, one of the bright stars of Colombian Romantic literature, author of numerous poems to be found in every self-respecting popular collection. Usiacurí is a good and representative example of innumerable towns along the Caribbean coast ❑

28a, 29. Before the Spanish conquest, the Tairona, ancestors of the present-day inhabitants of the Sierra Nevada, reached still unsurpassed levels of harmony and "togetherness" with nature. The so-called "Lost City" or "Buritaca 200," discovered by Western archaeologists in the seventies, a city which may have had as many as three thousand inhabitants, is a sample of the pre-Columbian stone cities whose terraces, walks and walls have the evident function of assuring the distribution of rainwater and the retention of soil on steep gradients. A thousand-year-old example of what is known today as "sustainable development." ❑

28b. Nabusímake, a village of fifty houses (called San Sebastián de Rábago by the Capuchin missionaries who resided there until 1970) is the capital of the Arhuaco or Vintijua Indians, present-day inhabitants, along with the Kogi and the Kankuama, of the Sierra Nevada of Santa Marta ❑

31. *The Sierra Nevada is a replica of the cosmos. So is each individual mountain and likewise each temple, each house, down to the smallest object–a honeycomb or a calabash shell to keep lime in. We can see only half–the mountain, the temple–but the knowing ones, those who see beyond the world, are aware that every mountain, every object, has its counterpart, its exact but inverted likeness, beneath the image perceived.*
Gerardo Reichel-Dolmatoff (1947) ❑

32/33. The peculiar location of the Sierra Nevada de Santa Marta in the so-called Neotropics enables it to reproduce altitudinally, from the seashore up to its enormous ice-fields, the different ecosystems characteristic of the planet Earth latitudinally between the equator and the poles. At the foot of the Sierra Nevada one finds humid jungle, warm underfoot; at its summit, the so-called snow floor ("citurna" the Tairona called it), the region of everlasting snow. Many ecosystems or biomas lie in between ❑

34a. The "continental" island of Barú, separated from the mainland by the Canal del Dique (Dike Channel), is a peninsula that stretches southwestward from the Bay of Cartagena to the vicinity of the Islas del Rosario (Rosary Islands), closing off the Bay of Barbacoas (Barbecue Bay) on the north ❑

34b. The vegetation of Capurganá, on the spurs of the mountains of Darién which come down into the Gulf of Urabá, marks an advance of the natural world of the Pacific on the Caribbean coast ❑

35. On what has been called "the most beautiful bay in the Americas," at the foot of Santa Marta, are the beaches of El Rodadero (The Sliding Place), today a popular shore resort framed by buildings replete with tourists eager for a glimpse of land- and seascapes. El Rodadero owes its name to an enormous natural formation of soft sand that is used for tobogganing ❑

36. At some stage several million years ago, the Magdalena River emptied into what is now the Gulf of Maracaibo in Venezuela. When the Perijá Range arose, on the border between La Guajira and Venezuela, the river began discharging into the so-called Momposina Depression, an "inland delta" which still remains under water much of the year. After that, it emptied where the Ciénaga Grande (Great Quagmire) now is. Today it reaches the sea at Bocas de Ceniza (Ashy Mouths) outside Barranquilla, the main sea and river port of Colombia and the most important commercial and industrial zone in its Caribbean region. Barranquilla was founded in the eighteenth century by country people and fishermen. The Caribbean trunk highway crosses the Magdalena River outside of Barranquilla on the Pumarejo Bridge, the longest in Colombia ❑

37a. The island of Salamanca is an "arrow of land" that separates the Atlantic Ocean from the Ciénaga Grande de Santa Marta, occupying what at some stage was the estuary of the Magdalena. The abundance of birds, close to two hundred species, some of them migratory, caused the upwards of 50,000 acres of the "island" to be declared a national park in 1964. The relentless pressure to which the swamps have been subjected and the stopping-up of the natural channels through which the Ciénaga and the sea exchanged fresh and salt water have gravely altered the ecology of this region. Nevertheless, over nearly a third of the "island's" area several species of mangrove may still be found: the red mangrove, the "booby" mangrove, the salt mangrove. Some mangrove trees grow to eighty feet in height ❑

37b. In the Colombian Caribbean may be found hundreds of volcanos of mud, formed when huge "bubbles" of hydrocarbides and gases are trapped beneath layers of mud and water. In October 1992 an earthquake in Murindó (Antioquia) caused the violent eruption of several of the area's volcanos. From just one of them eight thousand cubic feet of mud emerged in a mere five minutes. People usually use them for medicinal baths ❑

38/39. Cartagena of the Indies, included in the list of cultural properties considered to be the "Patrimony of Humanity," began to wall itself up in 1602 as protection against the attacks of English and French pirates and bucca-

neers determined to sack it. Their attacks against the city had started back in 1547. The construction of San Felipe de Barajas, the most important landmark of colonial military architecture in this part of the Americas, was begun in 1630 ❏

40. The mouth of Cartagena Bay was protected by the fortresses of San José and San Fernando, crossfire from which was capable of stopping short any ship seeking to storm its way in. The last siege Spaniards had to withstand was that of the British admiral Edward Vernon in 1741. Later on, in 1815, following the Declaration of Independence of Cartagena in 1811, Pablo Murillo, the Spanish "Peacemaker," besieged the town for 108 days. This brought it the title "Heroic City." ❏

41. Not far from the walled city, on a narrow arm of land (the peninsula of Bocagrande), the new Cartagena rises more and more boldly, a city of skyscrapers ready all year to welcome tourists proceeding from the farthest corners of the earth ❏

42. In the last thirty years the tropical jungles surrounding the Gulf of Urabá have been subjected to relentless deforestation in order to turn these lands over to banana production. The names Dabeiba, Mutatá, Chigorodó , Carepa, Apartadó, Currulao and Turbo, among others, are synonymous for Colombians with the rich and controversial Antiochian banana region ❏

43a. The coconut palm (along with bananas and fisheries) affords the inhabitant of the Caribbean his principal means of daily sustenance. As happens with the cow in other societies, no part of the coconut goes to waste. The "water," the "milk," and the "meat" are used by themselves or in innumerable fancy culinary specialties—with rice, with fish, with shellfish… The husks are used for fuel. The "leftovers" from grated coconut are used to feed pigs and domestic fowl. In an earlier period coconut oil was used for illumination. The palm fronds and some of the bark are used in different crafts and as roofing for huts ❏

43b. The Sinú River flows into the Bay of Cispatá on the west side of the Gulf of Morrosquillo, but only after flooding the lands bordering the last sixty miles of its course, lands covered with mangrove swamps, "observation gallery" jungles and rice paddies. This is the Momil region, famous for it archaeological remains, and here also is the city of Lorica (at a precipitous rivercrossing), nicknamed "Saudi Lorica" by some on account of the enormous influence of families of Middle Eastern origin who have settled in the Colombian Caribbean ❏

44. Between Tinajones Mouth (an artificial exit channel of the Sinú River opened up in 1938) and the Punta de la Rada (Roads Point) stretch the Playas del Viento (Beaches of the Wind), long and straight. The town of San Bernardo del Viento lies inland on a sort of inner island, surrounded on all sides by rice paddies and branches of the Sinú ❏

45, 46. The archipelago of San Bernardo breaks through the sea's surface off Tolú, in the Gulf of Morrosquillo. It comprises ten coral islands (resembling in this the Rosario Islands off Cartagena) originally covered with mangrove swamps and other kinds of vegetation adapted to salt water. Costly vacation homes are being built at present on some of the San Bernardo islands. Most of the fishermen who make up the native population of the archipelago have grouped together on the islet of Poblado ❏

47. The island of Providencia, of volcanic origin (in contrast to San Andrés, which is coral) was populated in the first half of the seventeenth century by

English Puritans and traders, followers of Cromwell opposed to Charles I. The highest point on the island is no more than 1,150 feet above sea level. The archipelago, the main island territory of Colombia and the only one where the language is English, acquired departmental status in the 1991 constitution. It consists of the islands of San Andrés, Providencia and Santa Catalina and of islets like Cayo Cangrejo (Crab Key), a paradise for explorers of the sea bottom ❏

48, 49. The archipelago of San Andrés and Providencia in the Colombian Caribbean includes, in addition, a series of coral formations, small islands and shoals: Roncador (Snorer), Quitasueño (Keep-you-awake), Bajo Nuevo (New Shoal), Alicia, Serrana, Serranilla and Albuquerque. According to the geographer James Parsons, several of the islands already carried these names on navigational charts in 1527. Navigators must have been very well acquainted with these snags on which their ships risked running aground ❏

PACIFIC COAST

50, 59. Utria is one of several small bays on the Gulf of Tribugá. It has been declared a National Nature Preserve. Together with Gorgona, it is one of the few places in the Colombian Pacific where coral reefs are found. (Generally on the Pacific coast there are no white sands of coraline origin as there are on the islands and beaches of the Atlantic.) In contrast to what one finds on the Atlantic shore, which is framed by a smooth broad plain, on the Pacific side the jungle often reaches the water's edge. The Pacific tides cause the sea to advance and retreat a distance of several city blocks. The tides also make the very full rivers of the Pacific coast increase or decrease in rate of flow and in some cases the waters actually move "upstream" when high tide prevents their running out ❏

53. The Atrato is one of the world's rivers with the greatest volume of water in proportion to its length and, after the Amazon, the greatest in South America. It pours over 175,000 cubic feet of water per second into the Caribbean and at some places reaches a depth of over 375 feet. It is an umbilical cord connecting the Pacific and Atlantic coasts. Hence, together with the San Juan River, it has been proposed for an interocean canal ❏

54. The waters of this region, one of the wettest on the planet, plunge down the Darién Range in the cataracts of Tilupo,Tendal and La Tigra (The Tigress). The largest of these, Tilupo Falls, drops 360 feet. The Los Catíos National Park, named for the native community that inhabits it, is located on the Panamanian-Colombian border, over the wild and miry Tapón del Diablo (The Devil's Bottle-stopper) which blocks the Pan American Highway's passage. It is thought that the first human migrations to settle present-day South America took this way in ❏

55. The Pacific Coast has two well differentiated sections. First, from the Ecuadorian border to Cape Corrientes: here the "Pacific Platform" is broad and swampy. Secondly, from Cape Corrientes to the Panamanian frontier, where the Baudó and Saltos Ranges form a steep constricted coastline. Some geographers maintain that the contiguous Baudó, Saltos and Darién Ranges actually constitute a fourth longitudinal Colombian cordillera ❏

56. The old Cali-Buenaventura Highway crosses the basins of the Archicayá and Zabaleta Rivers that flow into the Pacific. To this day the traveler must pass under rounded cascades among enormous ferns and water arum leaves,

beside rivers and ravines with deep, transparent, waters. It is a zone that would seem to be resistant to the destruction of nature by human action ❑

57, 58. Cieza de León once spoke of a land where the Indians "had houses and living space high in the trees because everything is water below." This was in reference to the Lower Atrato (or "Great River of Darién") in the Department of Chocó. As a river the Atrato refuses to keep to a single bed: it forms arms that reach out and explore, deep in the jungle, quagmires or sinkholes, floodplains, swamps that drink in the waters of one of the rainiest areas on the planet; as well as numerous mouths through which it pours out its waters into the Gulf of Urabá on the Atlantic coast ❑

60/61. Downward along the coast from the Colombian-Panamanian border on the Pacific Ocean, the Saltos Range pushes up to around 1,650 feet, then sinks into the sea, forming points of land and bays. Going from north to south, the first of these is called Punta Ardita (Squirrel Point), then come Coredó or Humboldt Bay, then Point or Cape Marzo further along Octavia Bay, then Punta Cruces, Cupica, Nabugá. On the Gulf of Cupica is Puerto Escondido (Hidden Harbor), a fishing village that is a landing-place for smugglers ❑

62. The main Pacific Coast town of the Department of Nariño is Tumaco. It population, mostly black, lives for the most part in wooden palefitte structures built in tidal waters. In the part of Colombia where the Tumaco River flows into the sea the concept of "mainland" is rather vague. The variable deltas of the rivers, the phenomenon of the El Niño current, the not infrequent earthquakes and seaquakes with ensuing "black waves" (the local term for tidal wave) and human interference with the ecosystems (particularly the destruction of the mangrove swamps) create shifting borderlines between sea and land and precarious living conditions ❑

63. Four degrees of longitude west of the Pacific coast of Colombia, off the Department of Valle, appear the islet of Malpelo (one and a half miles long by two thirds of a mile broad) and its ten adjoining rock masses. In these rock formations, barren of vegetation, marine and bird life abound. Malpelo marks the westernmost fringe of Colombian territory on the Pacific ❑

64, 65. Buenaventura, on the edge of the Pacific platform, is the main Colombian port on that ocean and the South American port that handles the largest volumes of freight ❑

66. The city of Quibdó, capital of the Department of Chocó founded by Manuel Cañizales in 1690, has close to fifty thousand residents. It grew up on the banks of the Atrato as a center of trade in platinum and gold ❑

67. On the outer ridges of the Baudó Range, which drop off into the Pacific, one finds Solano Bay, also called Port Mutis on the curious ground that if the famous botanist José Celestino Mutis never visited the spot, he ought to have! ❑

COFFEE-PRODUCING ZONE

68. The planting of coffee on a large scale began at the end of the nineteenth century in the so-called "Old Caldas" region on terrain of volcanic origin occupying the slopes of the present-day National Park of the Snow-

peaks. This land, now included in the Departments of Caldas, Quindío and Risaralda, forms an omnipresent crazy quilt of plantations that grow fifty per cent of all Colombian coffee ❑

71. Santa Fe de Antioquia, founded by Jorge Robledo in 1541 in the Arví Valley, on the banks of the Tonusco and Cauca Rivers, is the principal one of a series of settlements in the area, the only one to have retained its colonial architecture. Among the surrounding settlements are Anzá, Buriticá, San Jerónimo, Sabanalarga and Sopetrán. The Spaniards went about here looking for "pleasures," a geological term denoting gold deposits, which were very numerous in the area ❑

72/73. Despite the droughts which have affected Colombia in recent years, the country prides itself on possessing enormous water resources and generating the larger part of its energy from hydroelectric plants. Particularly noteworthy are those of Guatapé and San Carlos in of Antioquia ❑

74. El Peñol, according to geologists, is an immense quartzose diorite dome that spreads out over the municipalities of Guatapé and El Peñol. The present population of the area, having been forced to change their means of livelihood when their lands were flooded to form the artificial lake have now turned El Peñol into a tourist attraction ❑

75. Although guadua woods have not escaped the merciless exploitation to which other botanical species have been subjected, one still frequently finds in Antioquia, in Old Caldas and in the Cauca river valley what the chronicler Cieza de León called "very large, dense groves of palm trees." Country people say that anyone having a patch of gourds and a guadua grove may marry because he will be able to make a set of dishes from the gourds and his furniture and house from the guadua wood ❑

76/77, 78. The metropolitan area of Medellín takes in the municipalities of Envigado, Sabaneta, Bello (seat of the textile industry), Itagüí and Copacabana. It includes some twelve university centers, among which the University of Antioquia stands out with its fourteen faculties and 24,000 students. Medellín was first founded by Francisco Herrera Campuzano in 1616 under the name of San Lorenzo de Aburrá. The capital of Antioquia, it is today a metropolis of three million, one of the four largest cities in Colombia ❑

79. A new center of development is growing up around the municipality of Rionegro, an hour overland from Medellín, with the José María Córdova airport and a thriving floricultural industry particularly noteworthy ❑

80, 81. The broad Magdalena valley in the Department of Tolima is fundamentally given over to industrialized agriculture with the most up-to-date equipment: cotton, rice, sorghum, sesame and soya. This may well be the region of Colombia in which chemical fertilizers and insecticides are most intensively applied by aerial spraying ❑

82/83. *A picturesque view unfolds on the approach to Quindío Mountain in the vicinity of Ibagué ... Above a great mass of granite rock appears the truncated cone of Tolima, perpetually snow-covered, resembling in shape Cotopaxi and Cayambe [in Ecuador]. The little Combeima stream, whose waters mingle with those of the Coello River, winds through a narrow valley, cutting a path through a grove of palm trees. Off in the distance one can make out part of the city of Ibagué, the great valley of the Magdalena, and the eastern chain of the Andes.*
Alexander von Humboldt (1801) ❑

84, 87. The wax-palm (Ceroxylon quindiuense), declared the "national tree" of Colombia, grows at over 8,200 feet of altitude above sea level on the same "thermic floor" as the mist forest. Wax-palms have been found at close to 13,000 feet. There still remain impressive stands of wax-palm, the largest in the Departments of Tolima and Quindío, then on down through the Cocora Valley, in Anaime and Salento, with some in Santo Domingo, on the Cauca-Tolima border, and in Antioquia. The wax-palm grows very slowly and reaches heights of close to two hundred feet, evidence of the tremendous age of the existing specimens. On its fruit many bird species feed, as well as the spectacled bear (Tremarctos ornatus) ❏

85. The snow-covered range, which is the great Cordillera of the Andes, is seven leagues from the towns of this province. High up in it is a volcano that in clear weather sends up clouds of smoke. And many rivers arise in this range... These rivers flow down in the wintertime, valleys are formed–although, as I have said, they consist of canebrakes–and in them are fruit trees of the types customarily found in this region and large palm trees...
Cieza de León (1527) ❏

86. The National Federation of Coffee-growers, until recently one of the most powerful Colombian enterprises, has its most important centers for experimentation and development in the Chinchiná region of the Department of Caldas ❏

88/89. The coffee-growing region of the Central Cordillera starts to the north of the Department of the Cauca Valley, covers the Departments of Quindío, Risaralda and Caldas, takes in the mountainous part of Tolima and ends in Antioquia. It produces half of all Colombian coffee. Coffee production on a massive scale began in Colombia at the end of the nineteenth century. Cities like Armenia, Manizales and Pereira owe their prosperity to it. In the area surrounding them coffee is planted obsessively, even on roadsides and on the edges of ravines. Passage from a mining economy, the dominant one in Colombia until the eighteenth century, to a coffee-growing one meant establishing new human settlements, clearing out native vegetation, and led to a heyday of new types of business and small industry catering to the needs of the large masses of humanity connected with planting, upkeep of the coffee plantations and picking or harvesting, activities in the hands of women for the most part. Other agricultural products are closely bound up with coffee, which produces foreign exchange but no foodstuffs: corn, beans, bananas in some part, the mainstays of Antioquian culture. Colombia's foreign trade depended almost entirely on coffee until recently, when a diversification of exports has come about ❏

SOUTHERN ANDES

11, 112, 113a. The Andean region of the Department of Nariño is studded with volcanos. The main ones are Chiles, Cumbal, Azufral and Galeras. This last, chosen by vulcanologists as "the volcano of the decade" as a result of the careful scientific oversight of which it has been the object, has been in almost continuous eruption for nearly five years. The city of Pasto is rapidly mounting its slopes. Those of the other volcanos in the area are also dotted with indigenous and peasant communities ❏

90, 114, 115. Where the Departments of Huila, Tolima and Cauca come together rise the highest altitudes in the Colombian Andes–to just a few

yards below those of the peaks of the Sierra Nevada of Santa Marta. The snow-capped Huila Volcano (18,860 feet above sea level possesses, moreover, the largest ice-cap of the Central Cordillera. On its slopes, in the direction of the Department of Cauca, is the Tierradentro indigenous area. There are several theories as to the origin of the word "Huila." Some say that in the speech of the natives it means "blushing woman," an allusion to the reflections of the evening light on the snow. For others it is the name of a plant that grows on the volcano's slopes ❏

93, 102. The Betania Dam, part of the electrical linkage which brings energy to the Southwest of Colombia, detains the Magdalena River before it goes through Neiva. At this point the Magdalena has already taken in the waters of the Páez River, which picks up the run-off from the snow-covered Huila volcano as it drops toward Tierradentro ❏

94/95, 96, 97. Cali, capital of the Department of Valle, is the main center of economic activity in the Colombian Southwest. In part it owes its prominence of the last fifty years to the agroindustrial production of sugar and to its closeness to the port of Buenaventura. Founded in 1536 by Sebastián de Belalcázar, today it posseses several institutions of higher education, the main one being the Universidad del Valle. A few minutes to the north is Yambo, one of the principal Colombian centers of heavy industry ❏

98, 99. 125 miles long and twelve wide, the valley of the Cauca River is given over to agroindustrial production: sugarcane primarily in the south; in the north, sorghum, soya, vineyards and fruit orchards. The ecology and economy of the region began to change drastically when sugarcane was introduced on a large scale as an answer to the Cuban Revolution. The main sugar mills in Colombia are found in the Departments of Cauca and Valle ❏

100. From the highway that ascends the coal fields and chalky terrain of the Western Cordillera between Buga and Buenaventura one can see the Calima Reservoir which occupies lands inhabited between the seventh and fifteenth centuries of our era by a culture famous for its craftsmanship and pottery. This is a favorite vacation spot for the city of Cali ❏

101. The Silvia region in the eastern part of the Department of Cauca is inhabited largely by Guambian Indians who strikingly retain their ancestral language and customs, thanks to a high level of political and communal organization ❏

103, 107. In geography books the Colombian Massif, and more particularly the Páramo de las Papas (Potato Tableland), are referred to as the "Starburst of Colombian Rivers." Among the mosses and humus of its vegetable sponges and its many small lakes with their ever-changing perimeters rise the Magdalena and Cauca Rivers, which flow northward; the Patía, which bathes the Pacific coast; and the Caquetá, which flows into the Amazon. Mauricio Puerta, the anthropologist, also asserts that the Massif is "a strategic nerve-center for the meeting, crossing and dispersal of cultures." Down the slopes of the Cordillera, toward the Departments of Huila and Cauca, are found the ceremonial centers of San Agustín and Tierradentro ❏

104. Popayán today is a city of nearly 200,000 inhabitants. Following the earthquake that destroyed it in 1983, it has been rebuilt better and safer than before and has expanded in area and population. It has not, however, lost its particular individuality and its patina of chalkstone and tile. Its main economic and humane activity still centers about the University of Cauca ❏

105. In the last few decades the exploitation of oil has brought a burst of activity to the economy of the Department of Huila, one of the principal producers of rice, cotton and orchard fruits. The city of Neiva, founded in 1612 by Diego Ospina, became a capital city when Huila separated from Tolima, though the area is still closely bound to what had been "Greater Tolima." Neiva is a point of departure for numerous cultural and ecological attractions: the Archaeological Preserve of San Agustín, the Betania Dam, the Barrens of Tatacoa, the Cueva de los Guácharos (Moaners Cave) National Park, the approach to the Department of Cauca by the La Plata and Puracé road. Settlement of the jungles of Caquetá and in part those of Putumayo proceeds of necessity through Huila. The Magdalena River rises in the lake of the same name in the Colombian Massif on the border between Cauca and Huila and enters the Caribbean near Barranquilla at the end of a course of nearly a thousand miles. The Andean region of Colombia might well be named the "Magdalena Basin." The river drains the waters of over 100,000 square miles of Colombian territory, including those that feed it through the Cauca, its main tributary ❏

106. Scattered through territory once held sacred, one finds impressive figures hewn out of rock by the pre-Hispanic culture that dwelt in San Agustín Preserve. Although little is known of the builders of this mysterious place, judging by these monolithic remains, they must have performed elaborate funeral rites ❏

108, 109. Despite the root meaning of the word "barrenlands," (desierto), one soon discovers that the Tatacoa ("The Vale of Sadness" in the words of the conquistador Jiménez de Quesada) is bursting with animal and vegetable life well adapted to the minimal humidity and the high temperatures ❏

110. Mt. Puracé, on one of whose spurs the city of Popayán is located, is one of several active volcanos in the Central Cordillera. its crater is 15,500 feet above sea level. It is part of the volcanic range of the Coconucos, to which Pan de Azúcar (Sugarloaf), 16,400 feet high, also belongs. Sugarloaf alone retains its snow cover throughout the year ❏

113b. Although there have been no known eruptions of Sotará Volcano in recorded history, it is still considered active. It does not require a trained eye to discover traces of liquid lava flows of ages ago. The peoples of its slopes fairly frequently hear its innards rumbling ❏

HIGH PLATEAU AND SANTANDERS

116. Nature has not treated the people of Santander gently. Many towns of the Andean section of this region are situated in very risky locations or at the edge of deep chasms. Pineapples are cultivated on unbelievable inclines. For the flocks of goats in the Chicamocha Canyon ("an enclave of arid-land vegetation"–thornbush and cactus) the force of gravity is a mere human convention that there is no reason to observe ❏

119. The region of Suesca, Cucunabá and Ubaté in the placid borderlands between Cundinamarca and Boyacá is marked by dairy farms, cattle ranches and lakes. An expert, Ernesto Guhl, states that "the Sabana has been a land inhabited by humans for thousands of years." Signs of human activity dating back 12,400 years have been found there. Of the Sabana Guhl says that for many years it was a "self-sufficient oasis out of touch with the world beyond." Today the rest of Colombia pays it tribute ❏

120, 123b. Relocated in "New" Guatavita are the inhabitants of the former town of the same name swallowed up by the artificial lake of Tominé. The industrial and urban growth of the Sabana requires more and more in the way of energy and reserves of water. Noteworthy among the latter are Tominé, El Sisga, El Guavio, Chuza, El Neusa and Chingaza. The setting-up of artificial lakes requires the channeling of rivers, the flooding of terrain, and other environmental and social alterations that have had the effect of noticeably changing the face of the Sabana ❏

121. The cliffs of Suesca are a taking-off place for fans of rock-climbing or of gliding over the Sabana. Since the advent of flower-raising for export in the area, close to 5,000 acres of ground have been covered over with greenhouses ❏

122, 132. Some of the most fertile soils of the entire South American continent are no doubt found on the Sabana of Bogotá. Unfortunately the growth of Santafé de Bogotá has meant a relentless invasion of them. It can be stated today that close to 125,000 acres of Sabana have been urbanized for a city that, contains a population of over seven million, all of whom demand all the services of a great metropolis ❏

123a. The boundaries between Santafé de Bogotá and its surrounding municipalities are being cast wider and wider. Chía, the place where the Muiscas or Chibchas worshiped the moon, until recently a typical village of the Sabana countryside, is on the verge of being swallowed up by urban growth and urban cultural patterns ❏

124/125. Some thousand feet above the already high city of Santafé de Bogotá rise the heights of Guadalupe and Monserrate, the latter an obligatory pilgrimage site for devout Bogotanos ❏

126. In 1536 on the Sabana of Bogotá–in lands, specifically, of the Muiscas, Indians of the Chibcha linguistic group–three European conquistadors encountered one another: Gonzalo Jiménez de Quesada, Sebastián de Belalcázar and Nicolás de Federmán. The first is recognized as the founder of Santafé de Bogotá, up above what he himself named "The Valley of the Alcazars," 8,700 feet above sea level. Santafé (renamed simply Bogotá by Simón Bolívar in a gesture of republican solidarity) gradually asserted itself as the indisputable seat of central power. This was possibly due to its position vis-à-vis the other natural regions, possibly to the abundance of the waters that ran off from the high surrounding plains or the salubriousness of the climate of the Sabana. Despite all attempts of recent years at decentralization, the country is still run from Bogotá, once again called Santafé, having been rechristened by the Constituent Assembly of 1991 in a gesture, now, of nostalgia. There the three powers of state are located: the Executive (the President of the Republic and the cabinet departments), the Legislative (the National Congress) and the Judicial (the Supreme Judicial Court, the Council of State, the Constitutional Court) ❏

I27. There coexist in Santafé de Bogotá a number of distinctive and easily distinguishable "cities." Some districts, conventionally speaking, have no reason to envy the great capitals of the world. In the so-called "International Center" are located some of the famous brick structures typifying that architectural language recognized the world over as Colombian ❏

128, 129, 130/131. Administered from Santafé de Bogotá are the bodies that oversee the country's institutions: the state's attorney's office, the treasury commission etc. The leading national newspapers are published there, the best-known public and private universities are there, economic power is exercised from there. It has been many years since Bogotá was the exclusive patrimony of the Bogotanos; the majority of its nearly seven million residents come from the other parts of the country ❑

133. *The Falls make an infinitely beautiful sight. I saw them first from the side, when I stretched out on a sandstone bank that the river leaves partially dry. Subsequently I observed them from some distance. Next to the Falls rises a rock wall very famous because it really seems to have been slashed vertically by the hand of an artist. The great naked profile of this rock wall forms a handsome contrast to the thickly wooded vegetation of the rocky chasm below.*
Alexander von Humboldt (1801) ❑

134. One of the most important places in the ceremonial life of the Muiscas or Chibchas was the pond of Guatavita, upon whose waters, on a raft, the Zipa and his princes covered themselves with gold dust. Several attempts have been made to drain it and the surrounding land has been "ransacked" in search of El Dorado (The Gilded One). Its almost complete roundness has given rise to the idea that it was formed by an aerolite in collision with the earth. According to other hypotheses, *the origin of the sacred pond was the collapse of an earthen "roof" over a void, which left a salt deposit to be dissolved in the course of centuries.* (Guhl) Near Guatavita, but many feet lower down, is the artificial lake of Tominé and Sequilé ❑

135. The high plateaux, as we know them, with their profusion of lakes, mosses and frailejón bushes *(Espeleitia* sp.) , are an ecosystem confined to the northwest corner of the South American continent. On the high plateau of Sumapaz (in the Eastern Cordillera)–the largest one known–a natural national park has been set up, comprising 388,000 acres of land in the Departments of Huila, Meta and Cundinamarca. The basins of the Bogotá and Sumapaz Rivers, which run westward toward the Magdalena, begin there, as do those of the Ariari, the Meta, the Duda and the Guaviare that drain the Eastern Plains country and flow into the Orinoco ❑

136. The Eastern Cordillera, the youngest of the Colombian cordilleras, was formed by an upward folding of the Guiana Shield as it pressed against the Andes. On the high plateau of Siecha, within Chingaza Nature Preserve, geological faults come to the surface as if in a life-sized textbook on Colombian mountain formation ❑

137. Until 1985, when the mines of El Cerrejón in La Guajira came into operation, the Departments of Boyacá and Cundinamarca produced more than thirty per cent of Colombian coal. Today El Cerrejón produces 64 percent and Cundinamarca and Boyacá about nine per cent each, in underground pits, many of them worked by human labor. The economy of Boyacá, otherwise the rural department par excellence, depends in large part on its coal mines, its coke ovens and its great steel works ❑

138/139. Tota Lake, in the municipality of Aquitania, is nearly 10,000 feet above sea level. This ecosystem, pardisal until a few decades ago, has become a focus today of a host of problems that threaten its very survival: the drying-up of its shores and the invasion of its water by onion-growing, excessive application of pesticides, the siphoning-off of water to meet the de-

mands of neighboring municipalities, the impact of the most polluting form of tourism, and the competition of the trout with native species ❑

140. It is theoretically maintained that, if one were to divide the existing Colombian water supply by the number of inhabitants, each person would be entitled to over a million and a half cubic feet a year. Hence Colombia, until recently, could boast that a high percentage of the electricity it generated was solely dependent on its water resources. The energy crisis of 1992 and early 1993 proved that, in the face of deforestation totalling nearly one and a half million acres yearly, the water supply, too, and with it the country is highly vulnerable ❑

141. The emeralds of greatest purity and size in the world are found in Colombia. For the pre-Hispanic peoples of Colombia emeralds symbolized the sacredness of Mother Earth. The Muzos are known to have worshiped them as precious stones descending from tutelary deities. Likewise, entering an emerald mine and working it was equivalent for the aboriginal to setting foot in a holy precinct surrounded by beliefs and mysteries ❑

142, 143. Near the barrens of La Candelaria is Villa de Leiva, a city founded in 1572 where viceroys relaxed in what was then a valley rich in waters and vegetation. The natural setting has been destroyed but the colonial architecture still stands nearly intact. In 1812, two years after the "Cry of Independence," the Congress of the United Provinces of New Granada was held in Villa de Leiva ❑

144, 149, 150. The fertile domains of the Zipa–the Sabana of Bogotá–turn into an attractive, rolling, picturesque landscape as one enters the lands of the Zaque in present-day Boyacá. In 1539 Gonzalo Suárez Rondón, one of the captains of Gonzalo Jiménez de Quesada, founded the city of Tunja, today a departmental capital, above the native town of Hunza. The Sogamoso region with its beautiful valley is among the most fertile in the department ❑

I45. In Boyacá, beside the most luminous greens in Colombia, stretches the desert of La Candelaria, where the abundance of fossils is a reminder that at one time it was a sea. Since the beginning of the eighteenth century there has been an Augustinian monastery in La Candelaria ❑

146. In Santander there still remain a few towns, like Socorro and San Gil, Girón and Barichara, with severe, angular town squares, cobblestone streets, whitewashed walls and roofs of earthen tile. "San Juan de los Caballeros de Girón," famous for its sweets and its cocoa and for its tobaccos hand-rolled by "cigarette girls," has been almost completely absorbed by Bucaramanga. On both sides of the throughway linking the two cities, numerous industrial plants fill a landscape that had earlier been monopolized by caney, cashew-nut and liquidambar trees ❑

147, 148. Barichara, birthplace of President Aquileo Parra and one of the best-preserved towns in Colombia (having for this reason been declared a national monument) is outstanding in its stone structures. The stonecutter's art reaches a culmination in the façades and the interior of the leading church ❑

151, 152. *...The Chicamocha and Suárez Rivers increase their speed on leaving their high tablelands, pick up the very copious waters of the high plateaux of Pisba and Guantiva and of the Cordillera de los Lloriqueos (Whimperers Range). (This is the upward route taken by the Spanish conquerors.) At one and the same time they mould the summits of the mountains of Santander and dig their own graves, a natural wonder which amazes*

and unnerves one. Finally they are transformed into the Sogamoso River...
Julio Carrizosa Umaña (1981) ❑

153a. The estoraques or "residual towers" are a result of lengthy processes of geological erosion that little by little carve what is left of the affected terrain into whimsical shapes. On the tablelands of Bucaramanga and in North Santander one commonly encounters vast stretches covered with these estoraques, like great phantasmagoric cities ❑

153b. *While in zones like the Cauca River valley long straight highways line the flatlands through which the river slowly and carefully meanders, in the canyon of the Chicamocha footpaths descend in meanders to a river which slashes the mountains as sheer as with a machete: Ah, those days when engineering was a self-denying form of lyric poetry...*
(Gustavo Wilches Castro) ❑

154, 155, 156, 157. The Eastern Cordillera reaches its greatest heights in the twenty snow-covered peaks of the Sierra Nevada of Cocuy, Chita or Güicán, an area twenty-five miles wide which claims the greatest ice-mass north of the equator in South America. Lakes of glacial origin have been observed there, more than three hundred bodies of water, eighty rivers and canyons, and all the species of felines found in Colombia. At the base of the Sierra live the Tunebo Indians, the closest relatives of the Muiscas of the Sabana. The natural national park which protects the Sierra Nevada del Cocuy–in existence as such only since 1977–covers nearly 900,000 acres of land in the Departments of Boyacá, Casanare and Arauca. Rivers rise there that flow westward to the Magdalena basin (through Gallinazo and the Chicamocha) and eastward to the Arauca and the Casanare, tributaries of the Orinoco ❑

PLAINS AND JUNGLE

4, 168, 181, 182/183. Regarding the rivers of the Plains country, Julio Carrizosa Umaña writes: *The principal rivers of the Orinoco basin are the Arauca, the Casanare, the Meta, the Vichada, the Guaviare and the Inírida. However, in among these giants, are a number of others that in the rainy season swell to almost their size. Such are the North Cravo River, the Ariporo, the Pauto, the South Cravo, the Cusiana and Upía, northwestern tributaries of the Meta. South of the Meta, almost all waters join forces in gullies and streams, to flow towards the Tomo, Vichada and Guaviare Rivers...* ❑

158. As is the case with all the great rivers of the Eastern Plains, over half the 435 miles of the Vichada, a tributary of the Orinoco, are navigable. The savannahs of the Colombian Orinoco region are not uniform. One finds patches of jungle out on the Plain, "observation gallery" jungles lining the watercourses, coconut palm groves (morichales), plains which remain under water much of the year. Each one of these ecosystems has its own specialized fauna ❑

161. For Colombians the Tupí-Guaraní name "Araracuara," which means "nest of macaws," brings to mind a penal colony that functioned there between 1938 and 1971. Before that the land had belonged to the Arana Firm and been the setting of a mass extermination of Indians taken as slaves by Peruvian rubber dealers. In this region today, on the banks of the Caquetá River, the Araracuara Corporation, devoted to scientific research and to conservation of the Amazonian environment, is in operation ❑

162. The petroleum industry is radically changing the economy of the Plains country, especially in departments like Casanare and Arauca. Their capitals, Yopal and Arauca respectively, are being transformed into important centers of economic activity. Over half of all Colombian oil is pumped there ❑

163. Between the colonial period and the present the political status of Casanare has gone through many changes: Autonomous Province of the Plains of Casanare, Independent Province, part of the Sovereign State of Boyacá, National Territory, Department (until 1873, when it reverted to the category of National Territory), District, part of the territory of San Martín, Special Commissariat, part of the defunct department of Tundama, Civil and Military Chieftaincy (subordinate first to Villavicencio, then to Tunja, Boyacá), District once more, and, with the Constitution of 1991, Department again. Yopal, its capital, rises on the banks of the Cravo Sur River ❑

164. The Eastern Cordillera terminates on a piedmont plain in a series of bluffs from which descend the many rivers rising in the Andes. The waters that feed the Cusiana River come down from the Bluff of San Martín ❑

165, 166, 171b. The "Campaign of Liberation" was carried out to a large extent by country people recruited by Simón Bolívar on the Colombian and Venezuelan plains. Half-naked and poorly armed, the plainsmen, in an epoch-making feat, mounted the Eastern Cordillera via the Pisba Highlands. These "untamable centaurs," as the Colombian national anthem calls them, routed the Spaniards in 1819. Today the culture of the plains people–whether at work or at play–is still closely bound up with their daily dealings with horses and cattle ❑

167. The first cattle ranches on the plains were established by Jesuit missionaries who reached the area in the seventeenth century. Today the central part of Colombia and in particular the seven million inhabitants of Santafé de Bogotá and its environs depend on the Plains to supply them with meat. Two local races of livestock are found in the area–the San Martín and the Casanare breeds–, products of more than four hundred years of adaptation to the milieu ❑

169. *As geographers conceive the Orinoco country, it extends from the eastern massif of the Cordillera de los Andes to the Guaviare River, and its characteristic features are the smooth expanse of plain cut by broad, leisurely rivers, the lonesome wind, the vast hills bristling with palm trees that smell of cedar and vanilla and resound with the gurgle of wandering watercourses...*
Eduardo Carranza (1981) ❑

170. When the rivers withdraw from the flood zones of the jungles and savannahs, different species of birds come in search of the spoils to which they have become adapted: fishing birds seeking out the fish caught in puddles; carrion birds looking for the corpses of drowned animals; insectivores, for the little insects swarming around the vegetation or over the muddy ground. As the word garza (heron) suggests, the garceros are areas in which the different species of this bird congregate ❑

171a. The chigüiro or capibara *(Hidrochaeris hidrochaeris)* is the mammal most characteristic of the Eastern Plains country, the largest rodent on earth. It is remarkable in its ability to convert vegetable matter, particularly straw, into animal protein. Its meat is much sought after and its hide is used for leather goods. At one point its very survival was threatened; it was hunted en masse from helicopters and small planes. Today it is also being reproduced on animal farms ❑

172/173. The rivers that water the Colombian Eastern Plains country draw their waters from: the Sierra Nevada of El Cocuy (rivers such as the tributaries of the Margua, which turns into the Arauca); from the Farallones de Medina (such rivers as the Humea, the Guaitiquía and the Guayuriba, which become the Meta); and from the Massif of Sumapaz (such as the Duda and the Ariari). The Macarena Range rises out of a triangle formed by the Guayabero, Duda and Güéjar Rivers. The Vichada River, like the Tomo, rises right on the Plains. According to Guhl, the Guaviare, with its length of 745 miles ,"has often, since colonial days, been considered the source of the Orinoco." ❑

174. In the Amazon region, biodiversity is not confined to cultures, flora and fauna; it also takes in water. The jungle is traversed by rivers of "white" water laden with sediments from the Andes; by rivers of deep transparent water the color of dark beer, that flow over quartz sands; by amber, green or red rivers according to the composition of their beds or the algae they contain. The Caquetá River (in Brazilian, the Japurá), which rises in the Colombian Massif between the departments of Huila and Cauca and empties into the Amazon, is nearly 1400 miles long. Where the bed constricts, torrents, narrows or rapids are formed ❑

175a. Anthropologists maintain that the mestizo (mixed race) town of La Pedrera near the point where the Caquetá River enters Brazilian territory at the mouth of the Apaporis is the focal point of some of the most extreme disintegration of native cultures to be found in this part of the Amazon basin. Upstream on the Caquetá one reaches Araracuara. Together with La Chorrera (on the Igará-Paraná River) this was the headquarters of the shady Arana Firm that at the beginning of this century engaged in the exploitation of rubber with Indian slave labor ❑

176. The Naquen Ridge in Guainía is one of those mountains that occasionally disturb the perfect horizontality of the Amazon country. Scientists maintain that it is geologically related to the tepuyes of Venezuela as the Chiribiquete Ridge in Caquetá, which rises almost 5,000 feet above the jungle, the Mesas (Tabletops) of Iguaje in Guaviare and the Macarena Range ❑

177. The natural preserve of the Macarena Range in the Department of Meta marks the western edge of the Guiana Shield. It is a conflation of characteristics of the Amazon and Orinoco regions and the Andes; this gives rise to unique biogeographic phenomena. Today the Macarena is the setting for a clash among numerous interconnected interests: more than 25,000 settlers, coca crops, scientific research, environmental concerns, guerrilla activity. Colombian mega-diversity expresses itself in human conflict, too ❑

178. The Apaporis River is formed from the confluence of the Tunia and Ajaijú Rivers, which emerge from the Chiribiquete region of the Department of Guainía. It flows into the Caquetá River at a point which serves to mark the northern end of the imaginary line (Apaporis-Tabatinga) that constitutes the eastern boundary of the Amazonian Trapezoid on the Colombian-Brazilian border ❑

179. Seventy thousand contiguous square miles of jungle (nine times the size of El Salvador and six times that of Belgium) have been formally declared the "communal property" of fifty indigenous groups in the zone. This amounts to half of the Colombian Amazonian territory. Noteworthy in the Amazonian region are the Tuparro, Amacayacú, La Paya, Cahuinari and Chiribiquete national parks and the "unique natural areas" of Nukak and Puinaway in the departments of Guaviare and Guainía ❑

180. On the list of natural treasures that have been named "The Eighth Wonder of the World" (their inclusion is attributed by some to Humboldt), the Rapids of Maipures (known in the indigenous language as Quituna) have a special place. They are formed by the Orinoco River as it runs across emergent formations of pre-Cambrian crystalline rock covered with plants. Continuous navigation of the Orinoco is possible only up to this point. The Rapids are located at the eastern edge of the Tuparro National Park, inhabited by Guahibo Indians. Not far away, on the other side of the Venezuelan border, is Puerto Ayacucho ❑